NOËL NOIR
1976

à Clive le dou...

un petit souvenir
de notre mystique ménage à trois

Georges le basilic et "Monsieur 666"

" Sadisme – c'est le vrai amour "
C. Foss Oeuvres Philosophiques Tome IX. 345.

MAX ERNST

UNE SEMAINE DE BONTÉ
A SURREALISTIC NOVEL IN COLLAGE

DOVER PUBLICATIONS, INC., NEW YORK

This Dover edition, first published in 1976, is an unabridged
republication of the work originally published in five volumes
by the Editions Jeanne Bucher, Paris, 1934, in an edition lim-
ited to 828 sets. The entire text has been translated specially
for the present edition by Stanley Appelbaum, and there is a
new Publisher's Note.

International Standard Book Number: 0-486-23252-2
Library of Congress Catalog Card Number: 75-17362

Manufactured in the United States of America
Dover Publications, Inc., 180 Varick Street
New York, N.Y. 10014

PUBLISHER'S NOTE

Oneiric visions and erotic fantasies were the stock in trade of the Surrealists. For artists concerned with the free association of images, with the meaningful reassemblage of disparate objects, and with the play element in art, collage was the quintessentially appropriate technique. Raised to a significant art form by the Cubists and Futurists, given new potentialities by the Expressionists in Germany and Russia and the Dadaists throughout Europe, collage reached its height among the Surrealists (many of whom had been Dadaists earlier), and Max Ernst is generally recognized as its greatest exponent.

Born in the Rhineland in 1891 and a self-taught painter, Ernst was exhibiting in Cologne by 1913, in which year he met Jean Arp, soon to be one of the founders of Dada in Zurich. In 1919 Ernst became one of the Cologne representatives of Dada, and in the same year became intrigued with the images to be found in mail-order catalogues. He moved to Paris in 1922, and before the year was out published two works in collaboration with the outstanding poet Paul Eluard: *Répétitions* and *Les malheurs des immortels,* the beginning of the series of collage books that was to culminate in *Une semaine de bonté* (others were *La femme 100 têtes* in 1929 and *Rêve d'une petite fille qui voulut entrer au Carmel* in 1930). In his individual collages Ernst used paint and the most diverse materials, and the act of pasting was not always a part of the creation, but in these publications he relied solely on cutting and pasting pictures from old books and catalogues. The printing process concealed the joins completely, and the results are incredibly effective.

Une semaine de bonté was finished in three weeks during the artist's visit with friends in Italy in 1933. The fateful events of that year in Ernst's homeland, including the Nazis' condemnation of his work, may account for the mood of catastrophe that pervades this collage "novel."

The *Semaine* appeared in five booklets in the course of the year 1934. All five were printed by Georges Duval and published by the Editions Jeanne Bucher in Paris in a limited edition totaling 828 sets. The first booklet, "Sunday," in a purple paper cover, bears the *achevé d'imprimer* (date on which printing was completed) 15 April; the second, "Monday," in a green cover, is dated 16 April; the third, "Tuesday," in a red cover, is dated 2 July; the fourth, "Wednesday," in a royal blue cover, is also dated 2 July; the fifth, completing the "Week," in a yellow cover, is dated 1 December.

In his earliest collage books Ernst generally made up completely new scenes out of many separate pieces, but for most of *Une semaine de bonté* he used complete existing illustrations as base-pictures, altering them with pasted-on additions. His base-pictures were chiefly the relatively crude and usually lurid wood-engraved illustrations of French popular fiction that were plentiful in the books and periodicals of the late nineteenth century. The subject matter of such literature was torrid love, torture, *crimes passionnels* and the subsequent incarcerations and executions (by guillotine), hatreds and jealousies among the very wealthy and the very indigent: the inferior spawn of Eugène Sue and Emile Zola. Ernst made his trip to Italy with a suitcase full of such pages.

The art historian Werner Spies has identified three of the base-pictures (those for pages 20, 169 and 170) as illustrations from the 1883 novel *Les damnées de Paris* by Jules Mary. It is also known that Ernst stopped at Milan on his way to his friends' place in Italy, and there purchased a Doré volume (said to have been used in the "Cour du Dragon" sequence). By adroit manipulation of elements in these pictures, he created a phantasmagoric "novel" that touches secret springs of laughter and horror.

Ernst's "Week of Kindness" is also a collage of concepts and language. Instead of the traditional seven deadly sins (*péchés capitaux*), we have deadly elements (*éléments capitaux*); and while two of Ernst's elements, water and fire, belong to the traditional four, he gives us seven and includes five unusual ones. The "examples" of the elements also appear to be quite capricious, but even there we find some subtle relationships. Each section of the work is preceded by an epigraph from the writings of a Dadaist or Surrealist (Ernst's friends Arp and Eluard; Tzara, the co-founder of Dada; Breton) or an adoptive forebear of the Surrealists (Jarry, nineteenth-century author of *Ubu roi*). In the present edition, each bit of titling or text is translated into English on the page following its appearance in French.

As we begin the "Week" (with Sunday), we find that the "example" of the "element" mud is the Lion of Belfort. This is the name of a patriotic statue by Frédéric-Auguste Bartholdi (sculptor of *Liberty Enlightening the World*) erected in the town of Belfort in eastern France after the Franco-Prussian War. Many of the figures in this section of Ernst's "novel" have the head of a lion. (Ernst's most illustrious predecessor in the creation of animal-men was the French artist Grandville, 1803–1847, much revered by the Surrealists.)

On Monday, the watery element pervades every picture, whether the locale is a bedroom or a city street: an anxiety-dream situation and perhaps an allusion to Noah's flood.

On Tuesday, large or small dragons (sometimes bats or serpents) are almost universally present, or else wings sprout from people's backs. The odd details found within the picture frames on the walls of rooms are also reminiscent of Grandville. The Cour du Dragon formerly opened off the Rue du Dragon in Paris (between St. Germain des Prés and St. Sulpice). Ernst's hosts in Italy had a mediocre "old-master" painting of St. George and the dragon over their mantelpiece, and during his stay Ernst painted a replacement for it. It is likely that this dragon inspired those in the *Semaine*.

On Wednesday, the "example" of the "element" blood is Oedipus—is this not because his marriage violated the direst taboo associated with consanguinity? The Eluard epigraph, with its reference to "mamma," ties in with the Oedipus legend. The other epigraph is an extract from a *complainte*, a type of popular ballad commemorating a notorious crime or catastrophe. *Complaintes*, which used to be printed on broadsheets and chanted by street singers who hawked the sheets, are the equivalents in verse of the illustrations Ernst was using in *Une semaine de bonté*. The leading figures in the pages of this section have birds' heads; Ernst claimed to have a bird-headed visitant named Loplop (often portrayed in his work) who made revelations to him. The Sphinx, also associated with Oedipus, makes a brief guest appearance.

In "The Rooster's Laughter" at least one rooster or rooster-headed being appears in every picture. The heads of many of the figures in "Easter Island" are shaped like the stone heads of the idols discovered on that island in the southeastern Pacific.

The "Three Visible Poems" are the most abstract section of the work and include some of the most haunting inspirations. The Eluard epigraph to the "First Visible Poem" could well serve as the motto for the entire book: "And I object to the love of ready-made images in place of images to be made." (In 1947 Ernst and Eluard published further "visible poems.")

In "The Key to Songs" the work ends vertiginously with a series of falling figures.

A book of this sort, appealing equally to the emotions and the intellect, can be freely interpreted by each reader according to his own experiences, by the

lights of his own mental baggage. No full "reading" seems ever to have been published, but the psychologist Dieter Wyss, in his book *Der Surrealismus* (1950), has provided a strict post-Freudian analysis of the "Lion of Belfort" section: the lion-headed figure in its various guises represents a lust for power in the superego; the woman who (in this interpretation) gradually submits to the lion's blandishments, sinks into vice and is finally destroyed, is identified as the "psyche" or "anima"; and the fully human male who undergoes much suffering and is eventually guillotined, is the psychoanalytic subject or patient, presumably the artist himself. If Wyss's somewhat casuistical and simplistic reasoning is not fully convincing, his picture-by-picture analysis is nevertheless absorbing and abounds in finely observed details.

From its first publication, *Une semaine de bonté* has been highly admired, and a stimulus to further creation. Most notably, some of its plates (particularly pages 49 and 50) inspired Hans Richter's 1946 film *Desire* (Ernst also wrote the dialogue and acted in it), released in 1947 as the first part of the avant-garde episode film *Dreams That Money Can Buy*.

CONTENTS

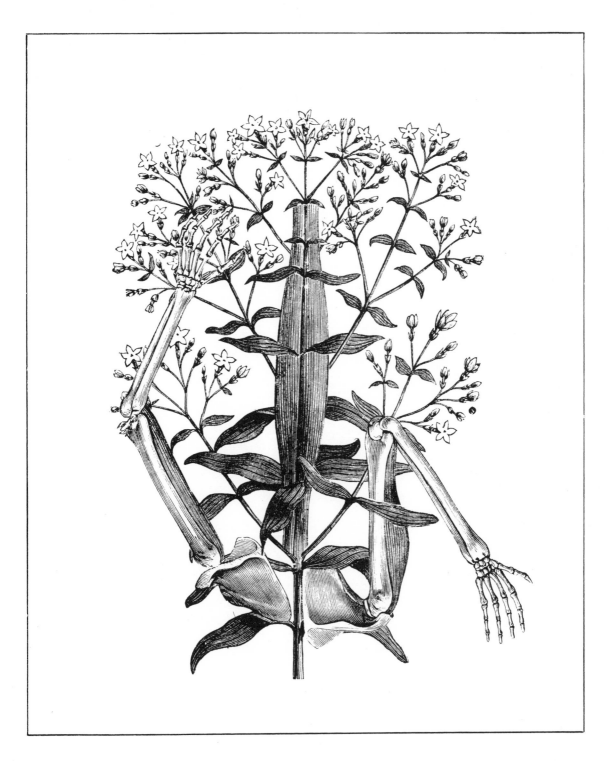

Illustration (= page 181) used on the cardboard slipcase that contained the five volumes of the original edition. The picture, reduced, was printed on green paper.

MAX ERNST

UNE SEMAINE DE BONTÉ
OU
LES SEPT ÉLÉMENTS CAPITAUX

ROMAN

PREMIER CAHIER

DIMANCHE

ÉLÉMENT :

LA BOUE

EXEMPLE :

LE LION DE BELFORT

« L'hermine est un animal très sale.
Elle est en soi-même un drap de lit précieux,
mais comme elle n'en a pas de paire de
rechange, elle fait la lessive avec sa langue. »

Alfred JARRY (*L'amour absolu*).

MAX ERNST

A WEEK OF KINDNESS

OR

THE SEVEN DEADLY ELEMENTS

NOVEL

FIRST BOOK

SUNDAY

ELEMENT:

MUD

EXAMPLE:

THE LION OF BELFORT

"The ermine is a very dirty animal. In itself it is a precious bedsheet, but as it has no change of linen, it does its laundry with its tongue." (Alfred Jarry, *L'amour absolu*)

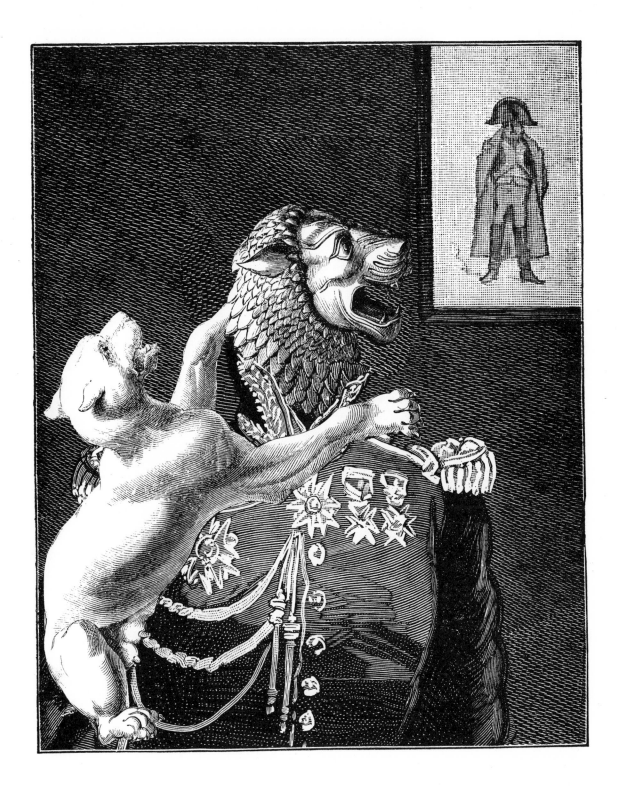

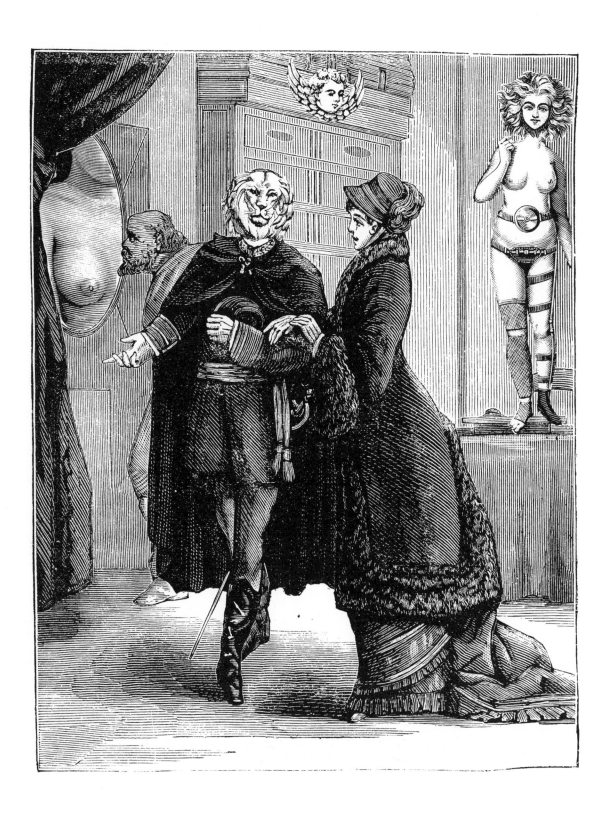

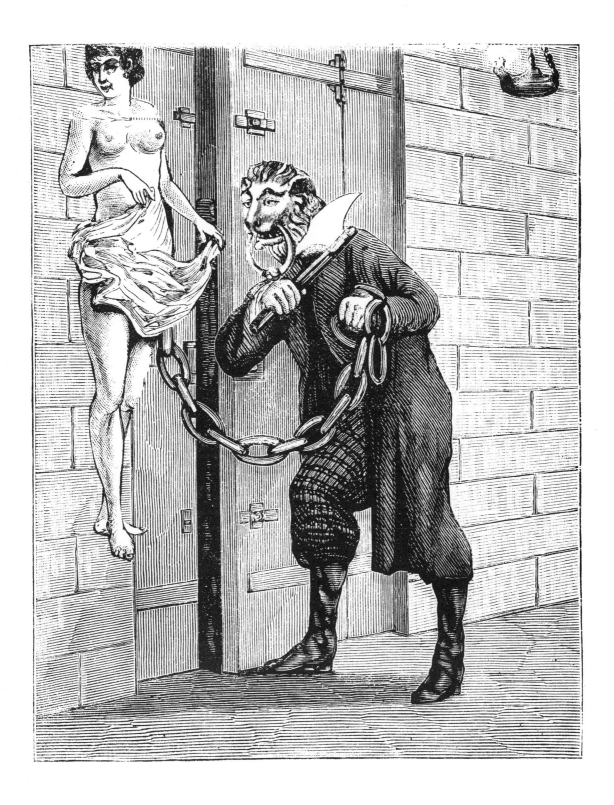

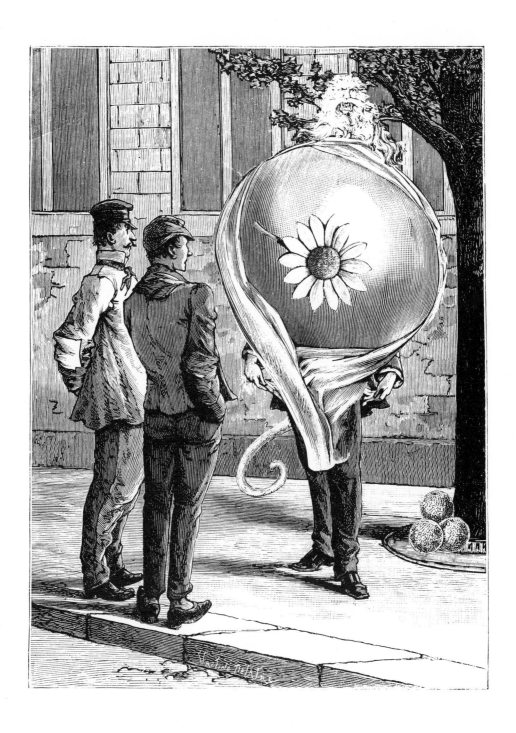

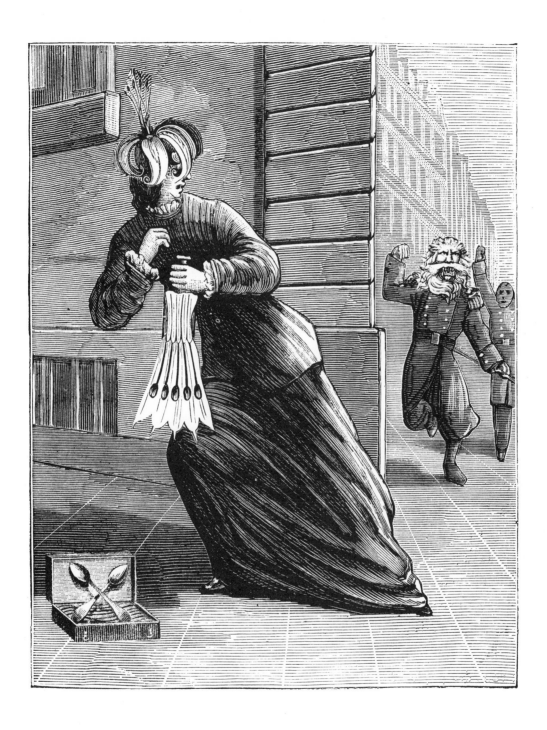

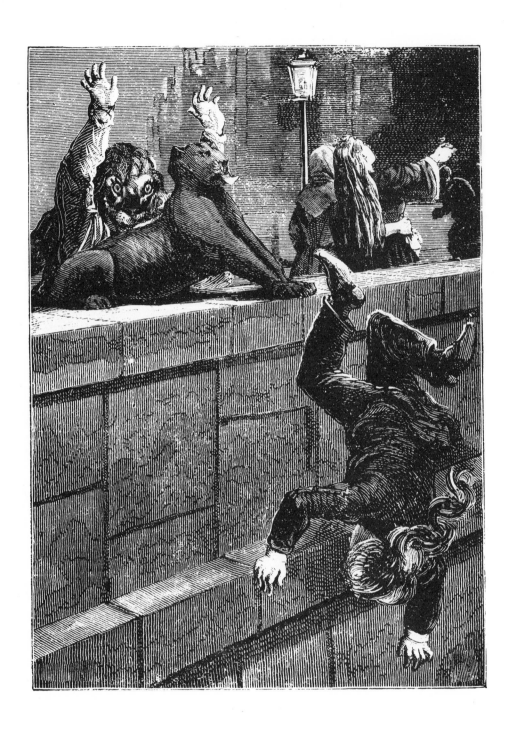

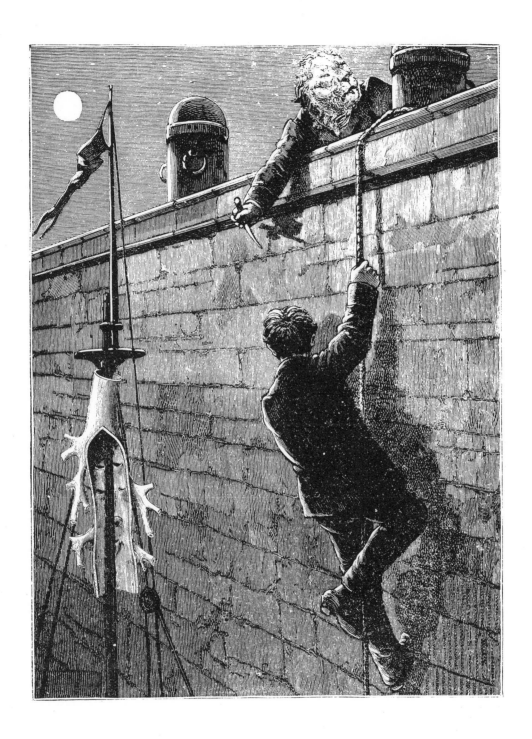

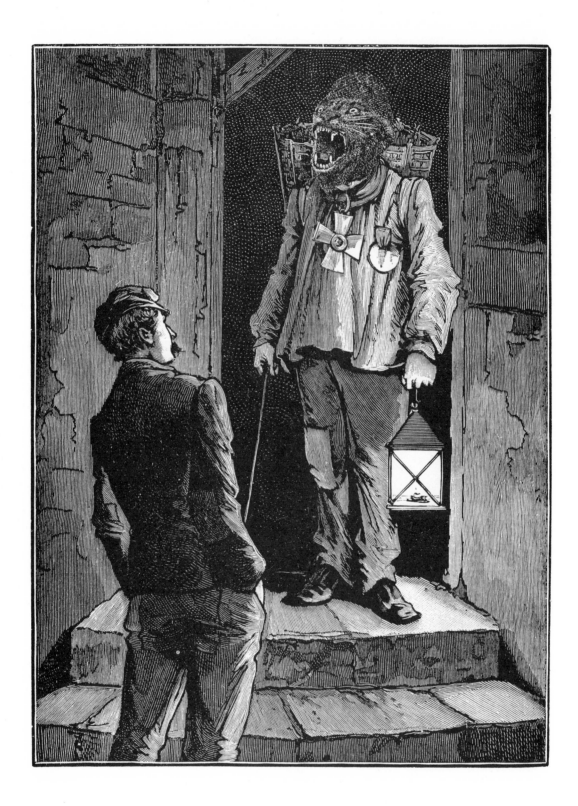

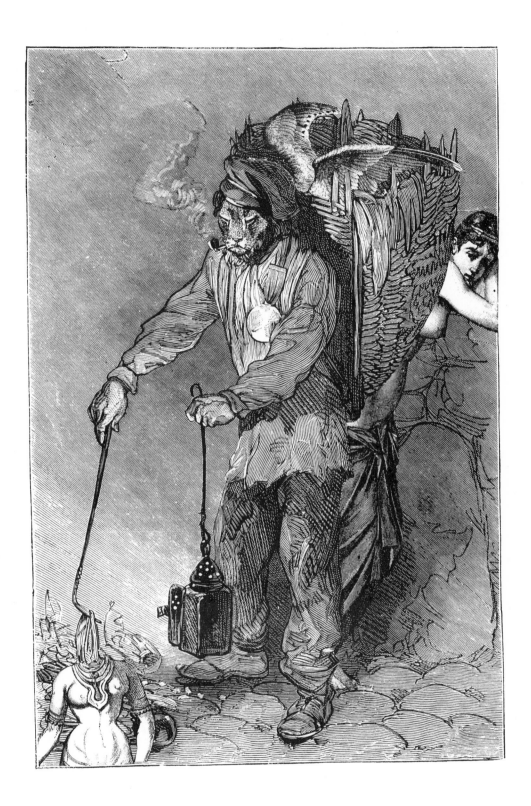

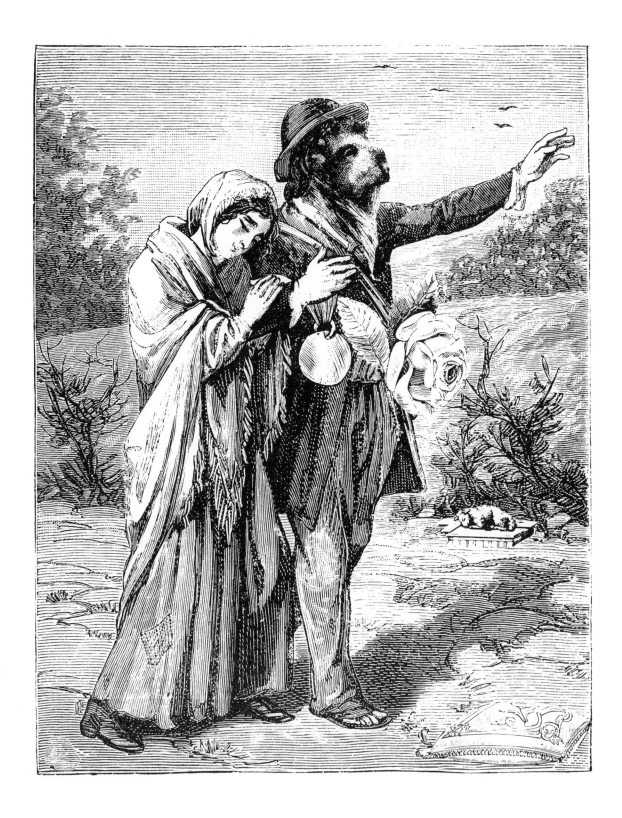

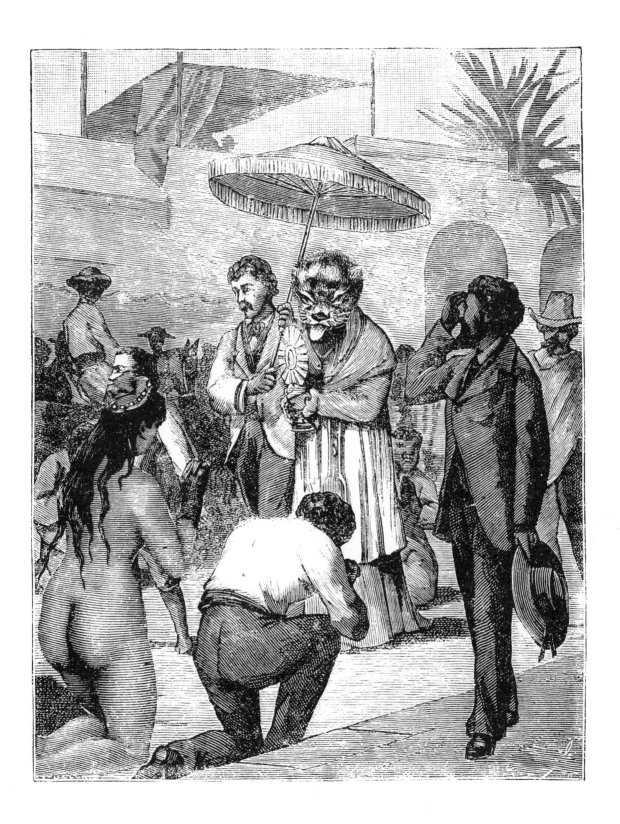

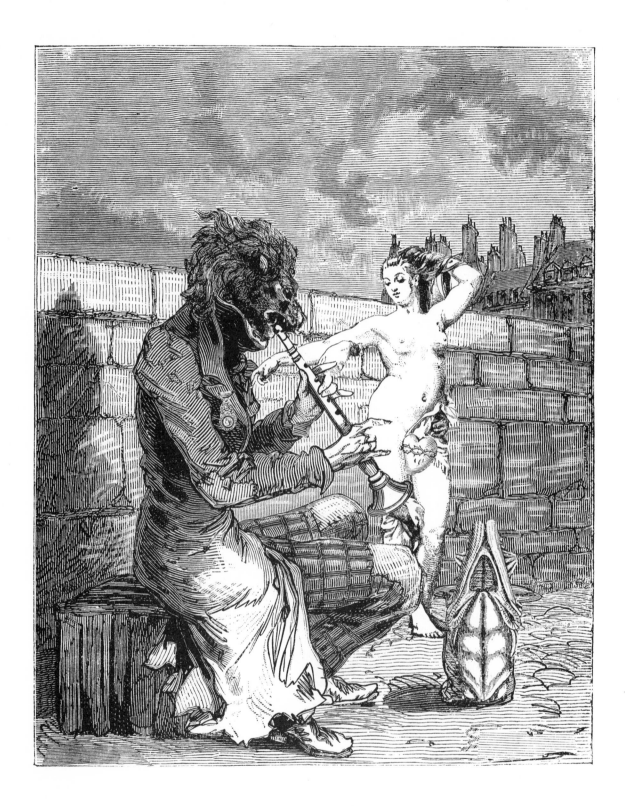

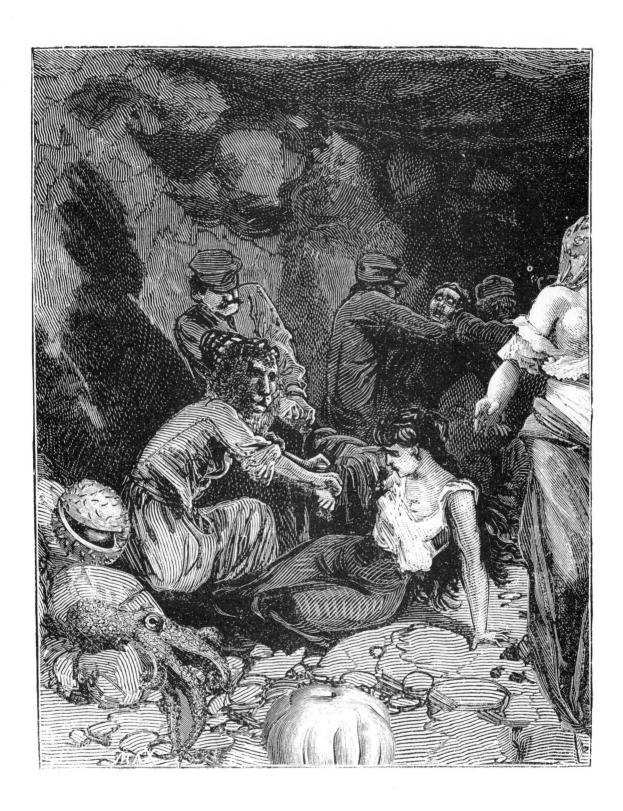

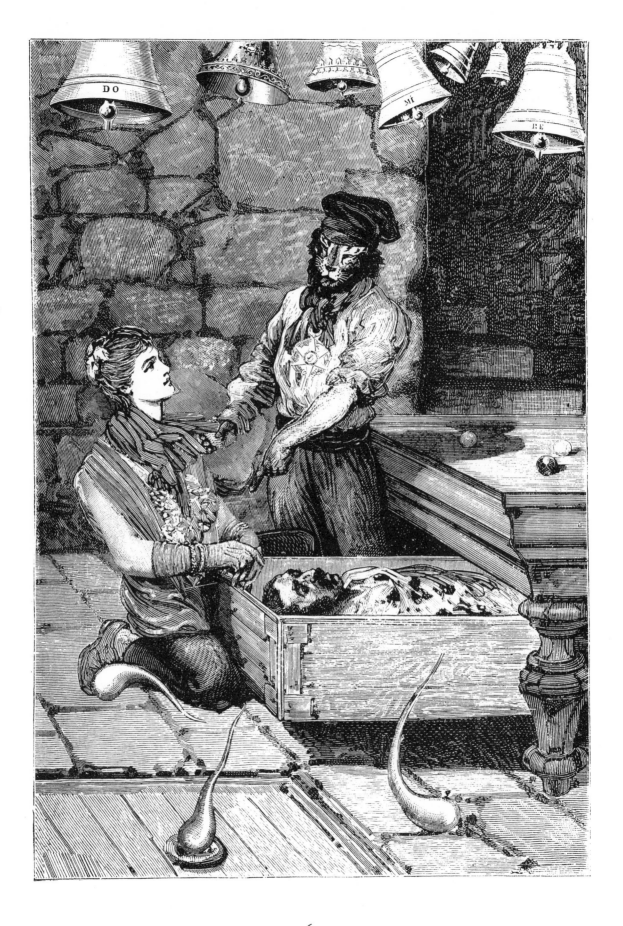

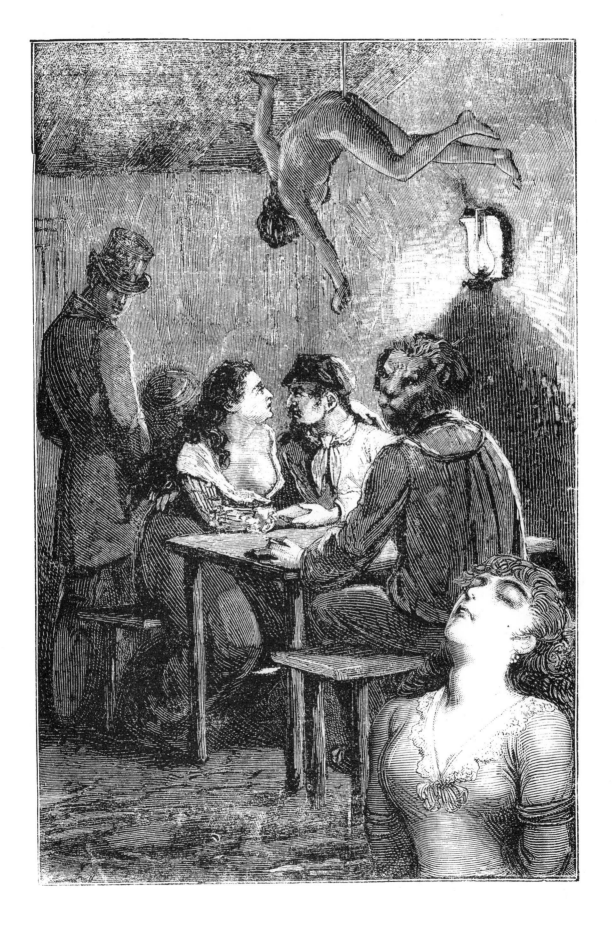

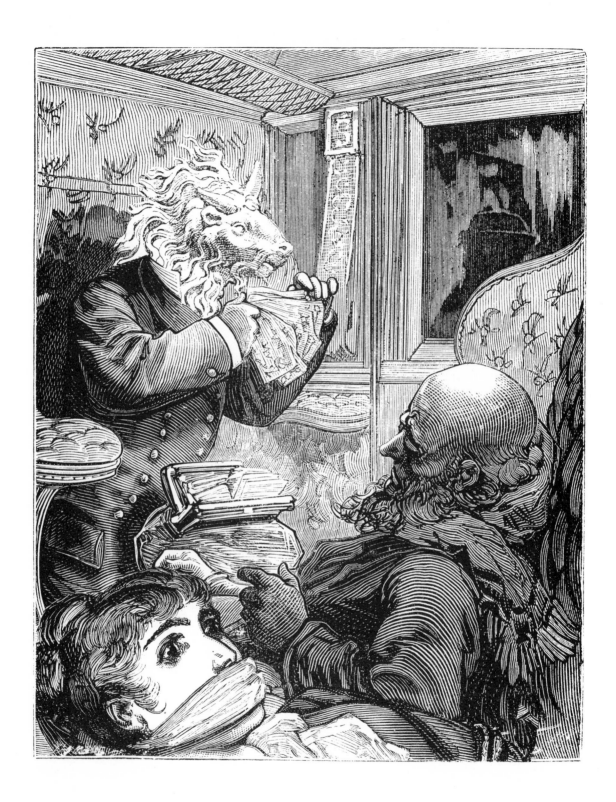

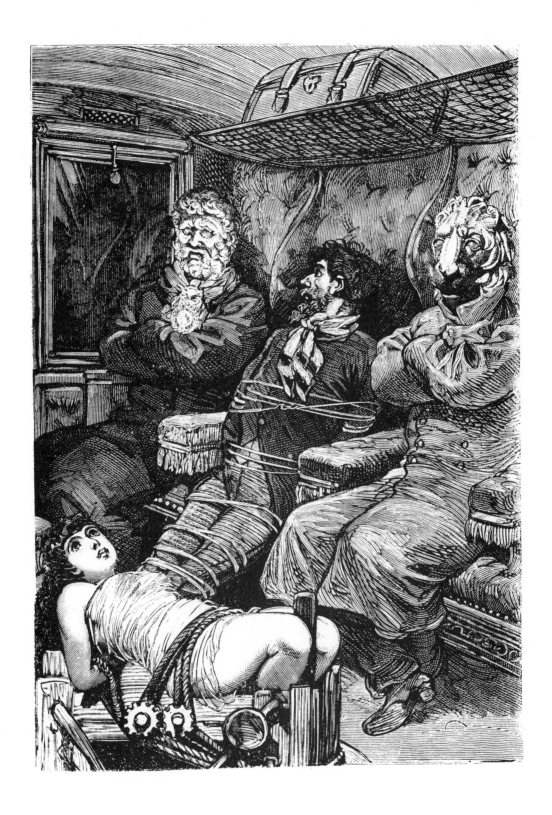

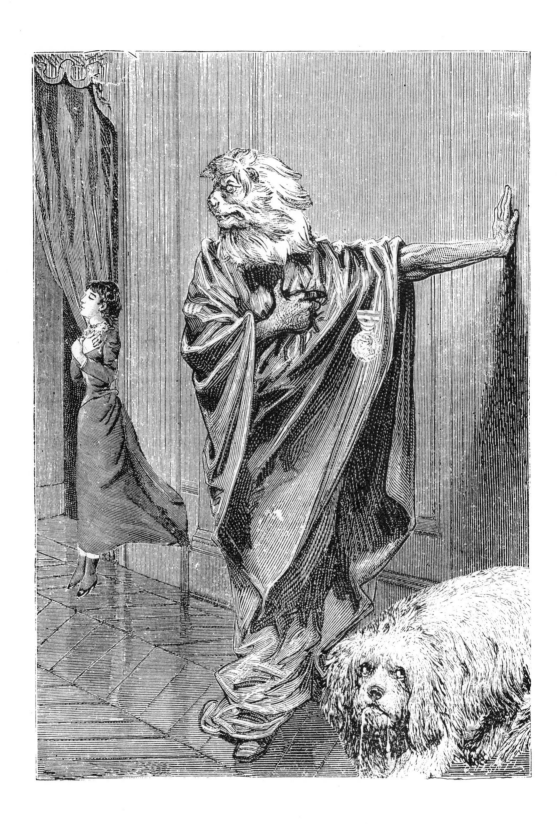

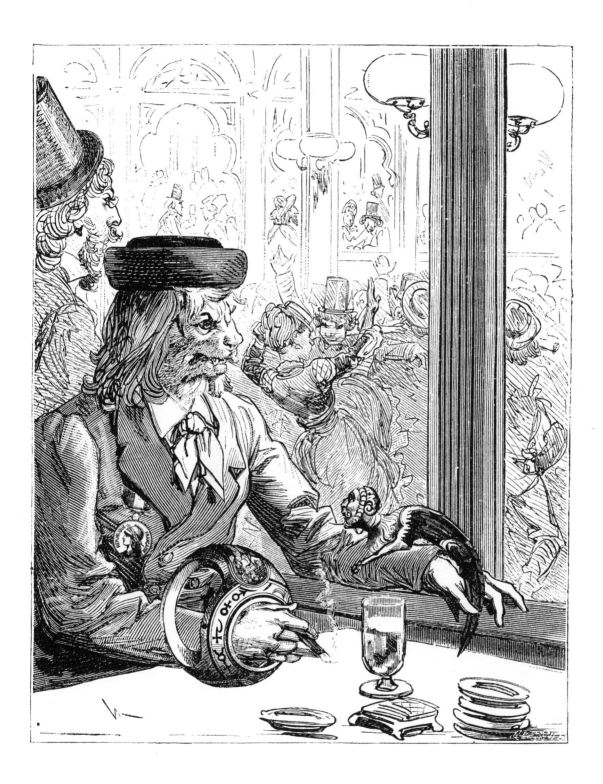

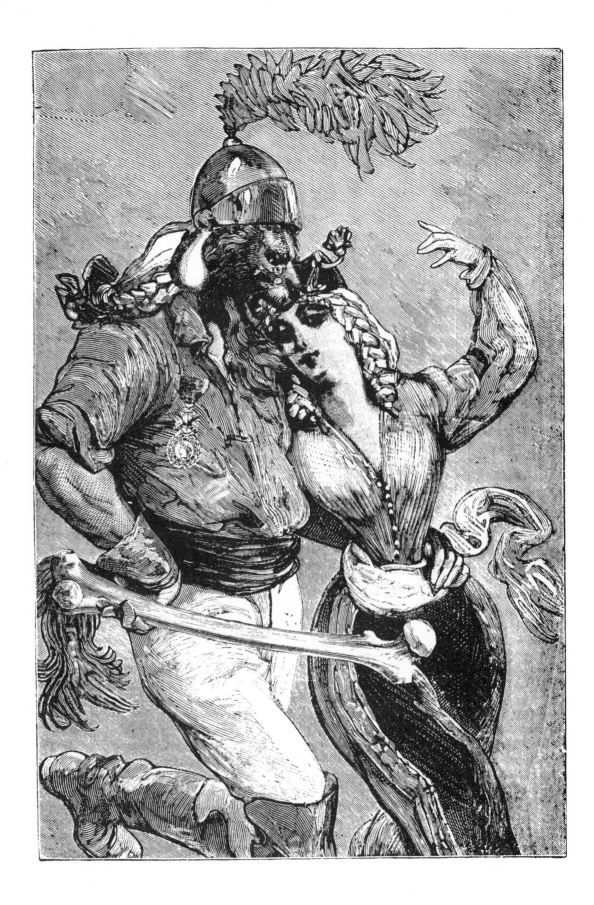

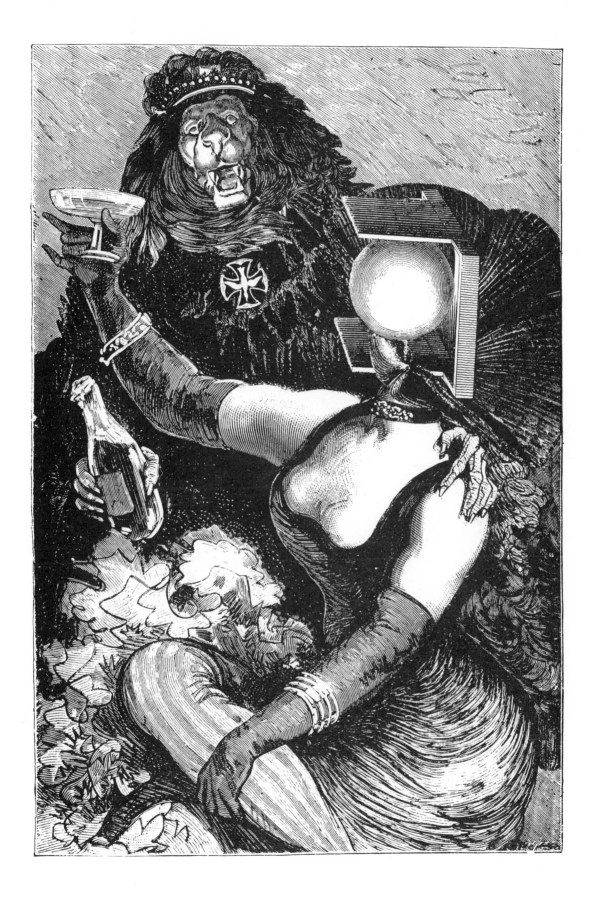

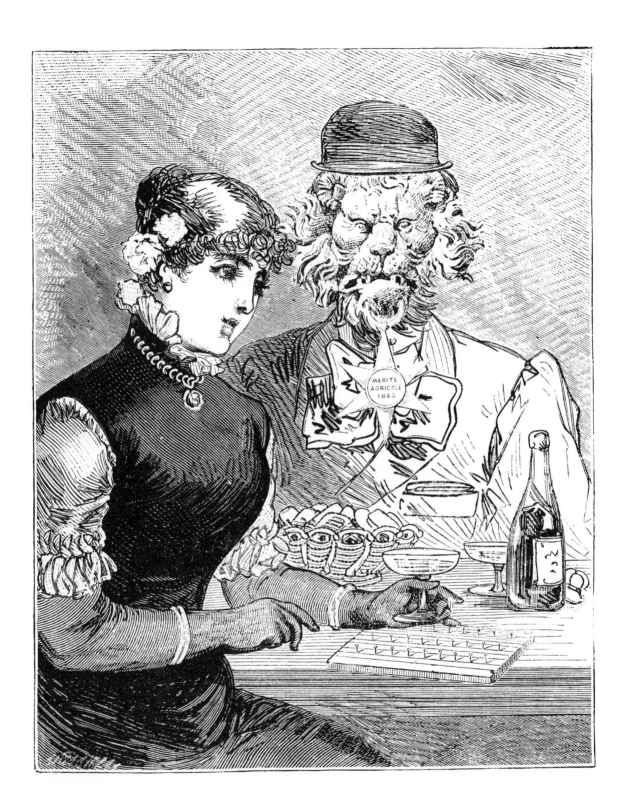

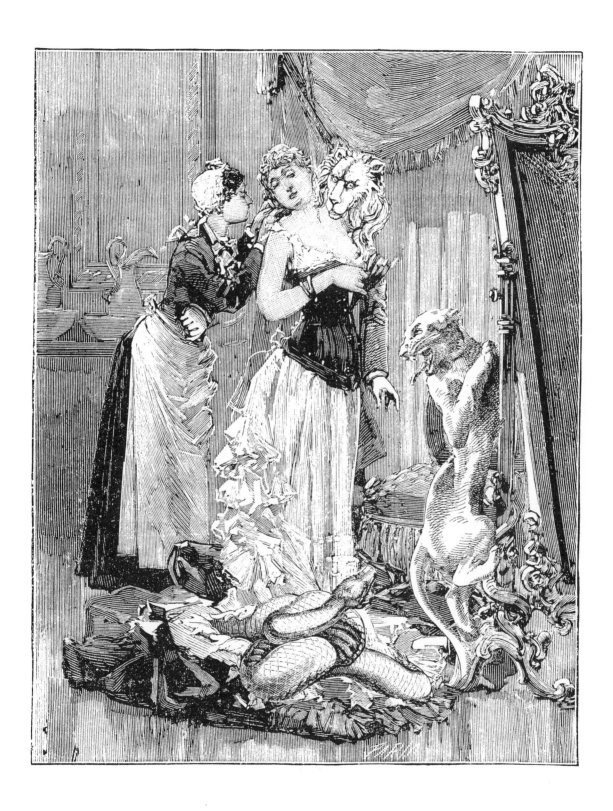

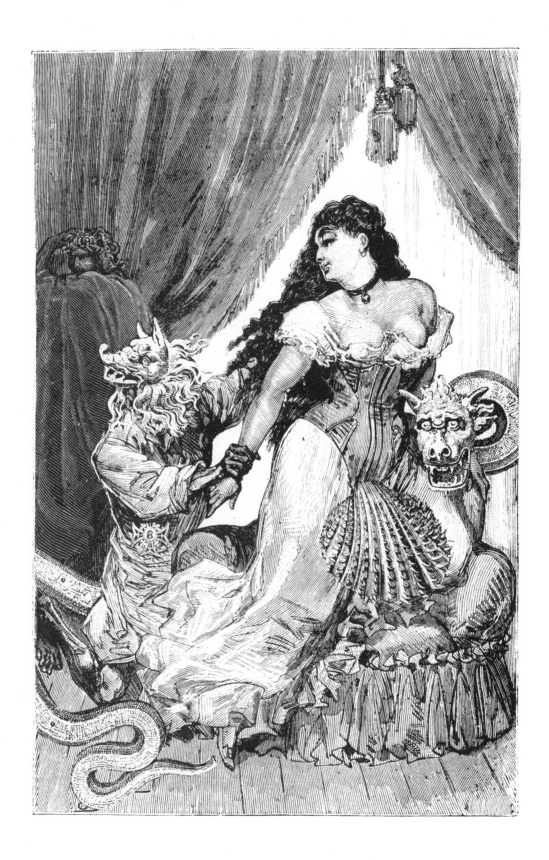

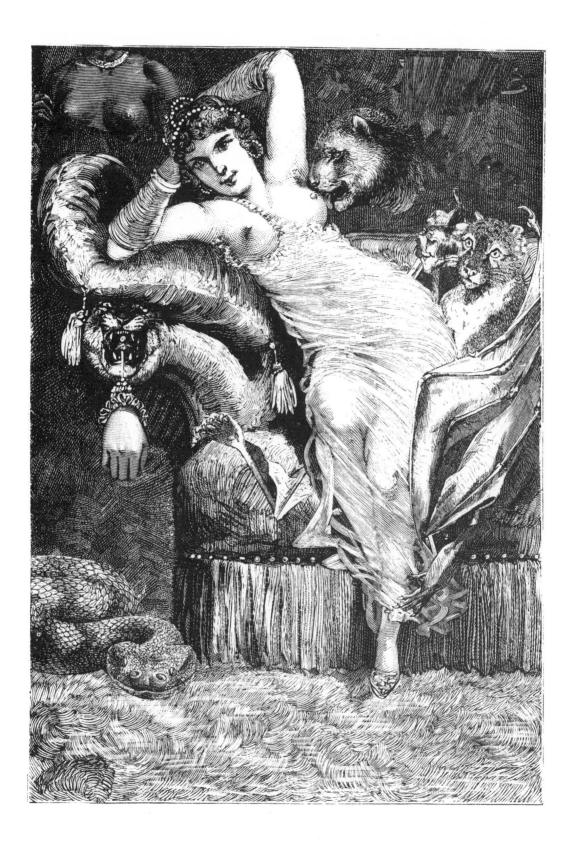

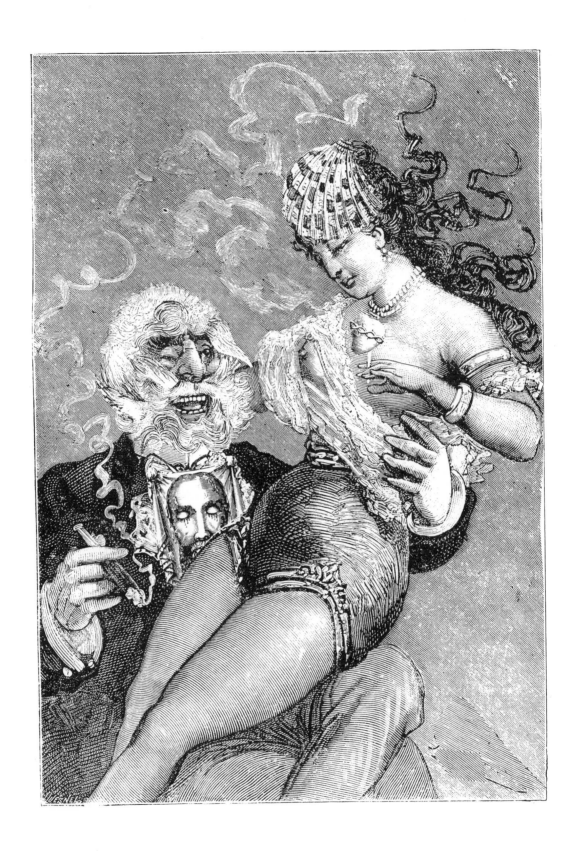

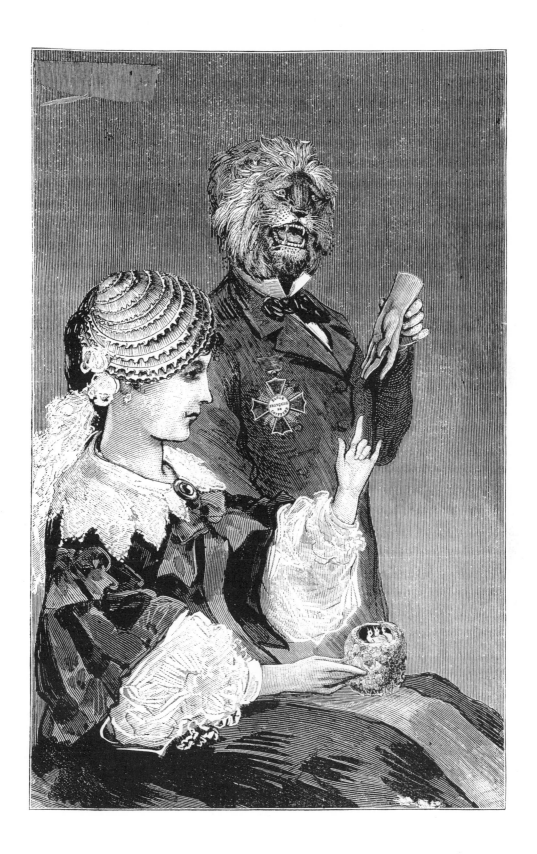

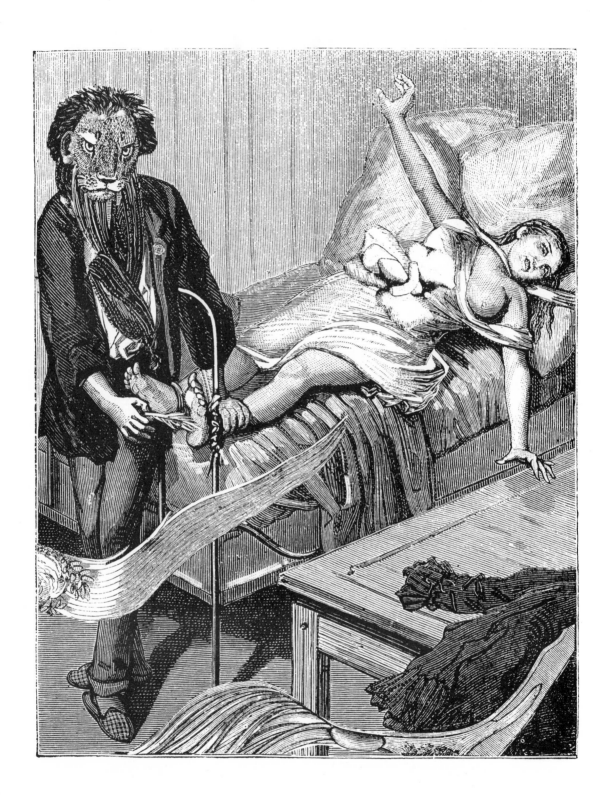

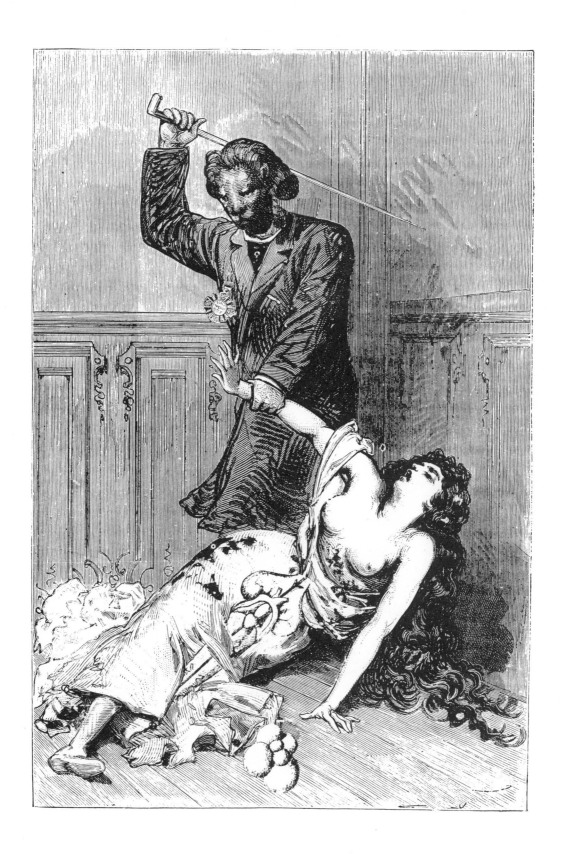

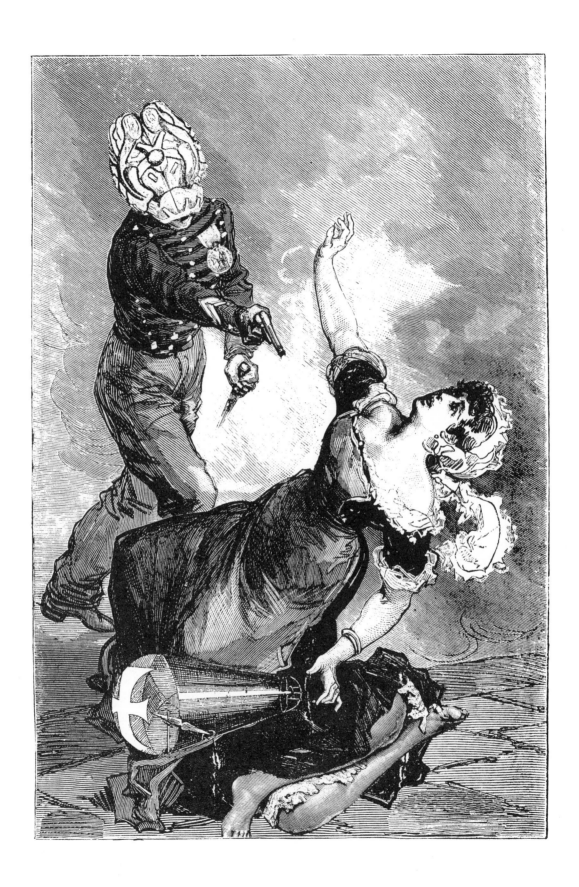

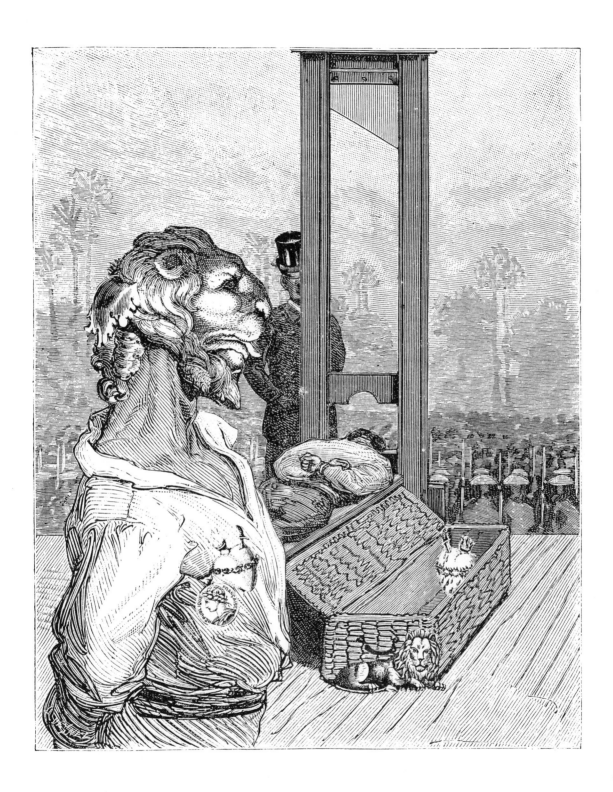

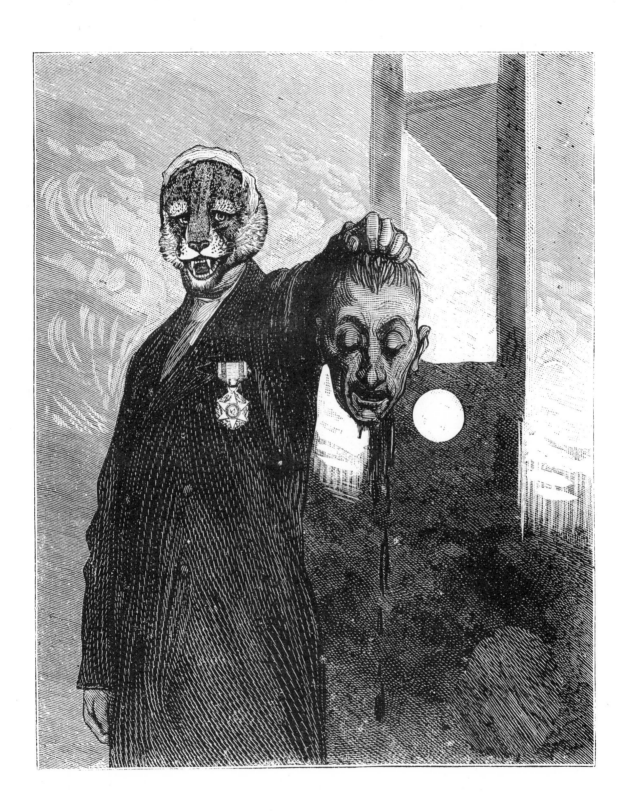

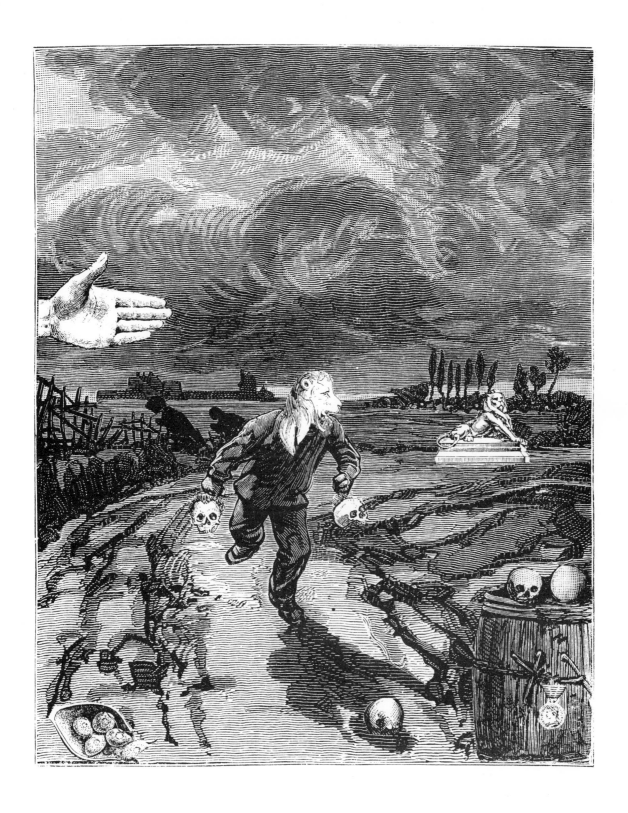

35

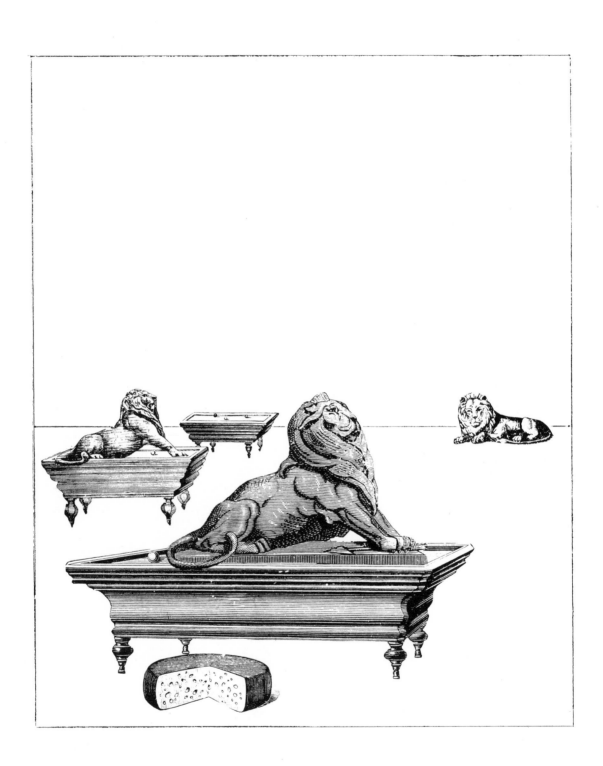

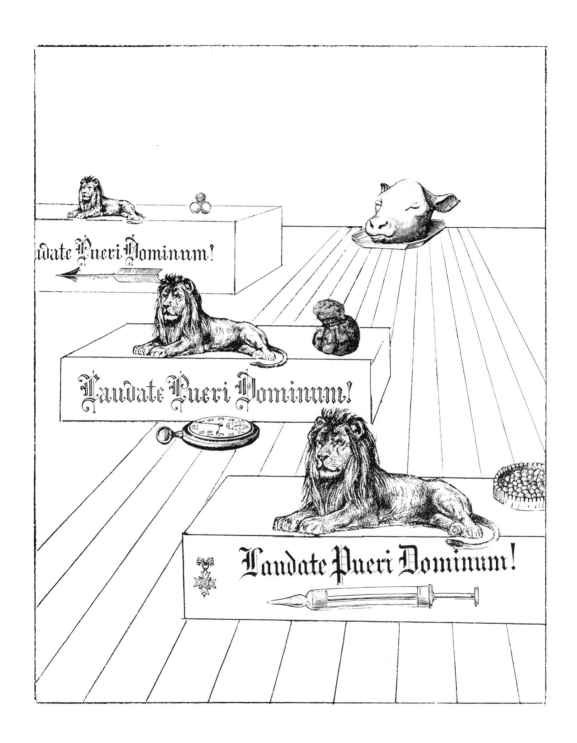

MAX ERNST

UNE SEMAINE DE BONTÉ
OU
LES SEPT ÉLÉMENTS CAPITAUX

ROMAN

DEUXIÈME CAHIER
LUNDI
ÉLÉMENT :
L'EAU
EXEMPLE :

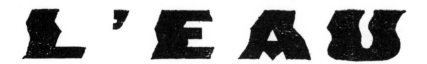

> « *D.* — Que voyez-vous ?
> *R.* — De l'eau.
> *D.* — De quelle couleur est cette eau ?
> *R.* — De l'eau. »

Benjamin PÉRET *endormi.*

MAX ERNST

A WEEK OF KINDNESS

OR

THE SEVEN DEADLY ELEMENTS

NOVEL

SECOND BOOK

MONDAY

ELEMENT:

WATER

EXAMPLE:

WATER

"D. —What do you see?
R. —Water.
D. —What color is this water?
R. —The color of water."
(Benjamin Péret, *endormi*)

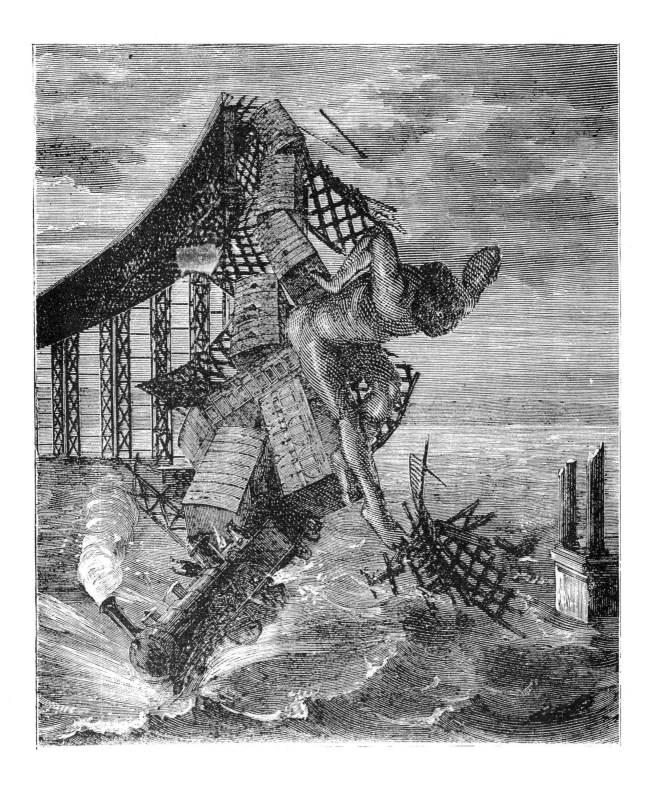

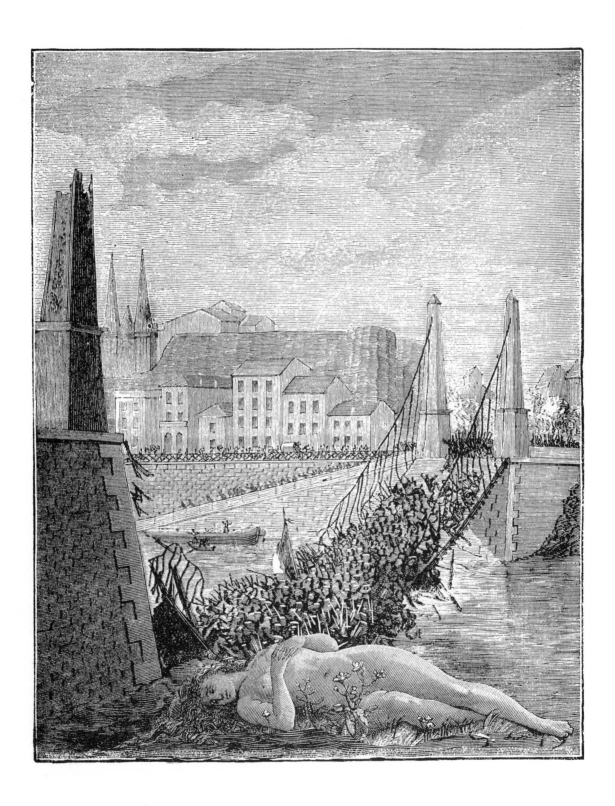

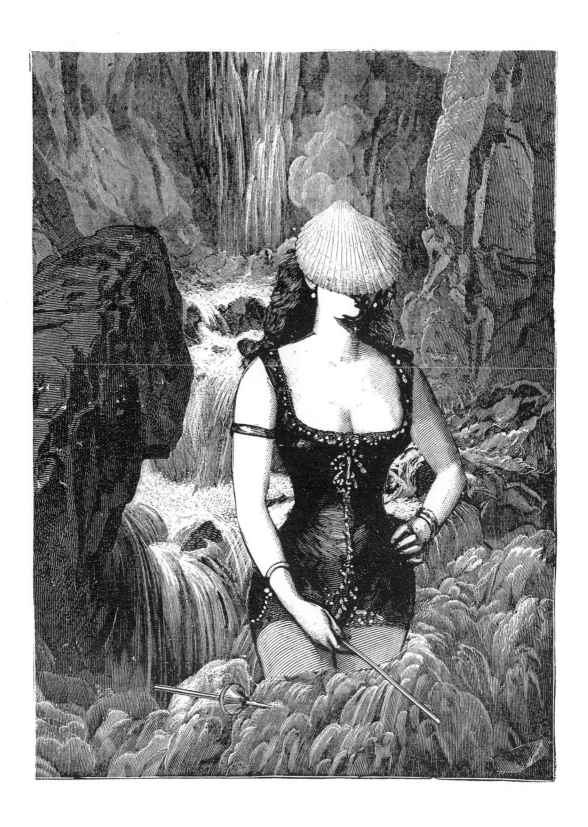

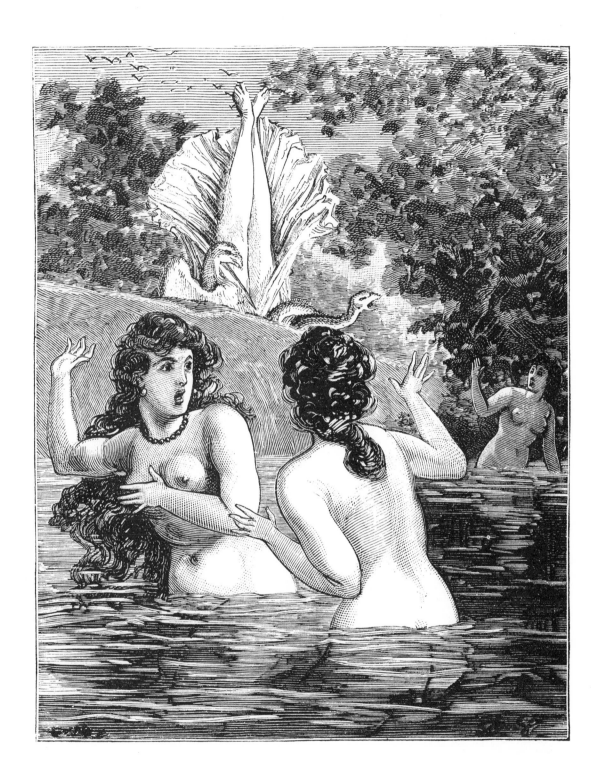

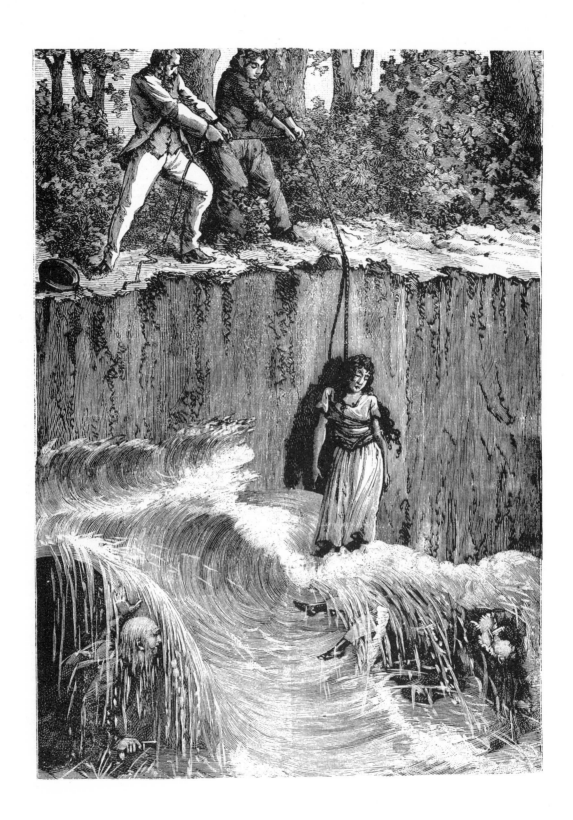

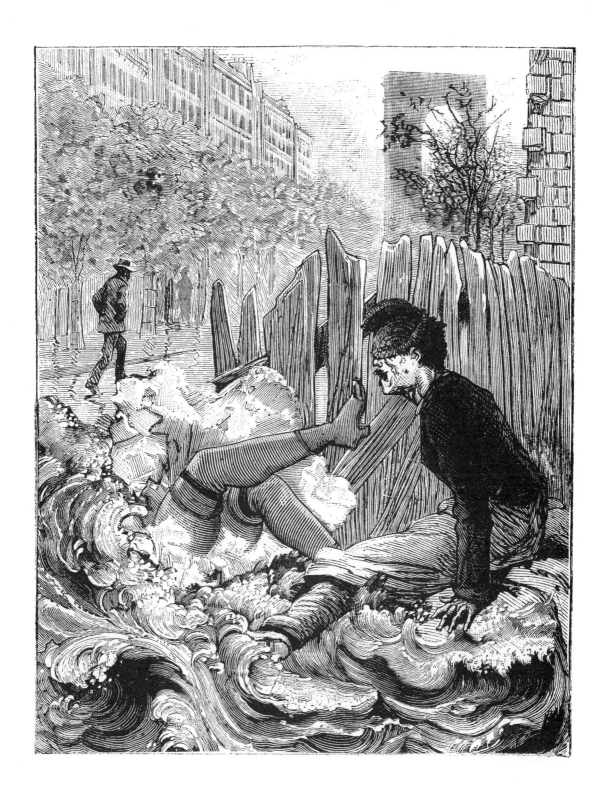

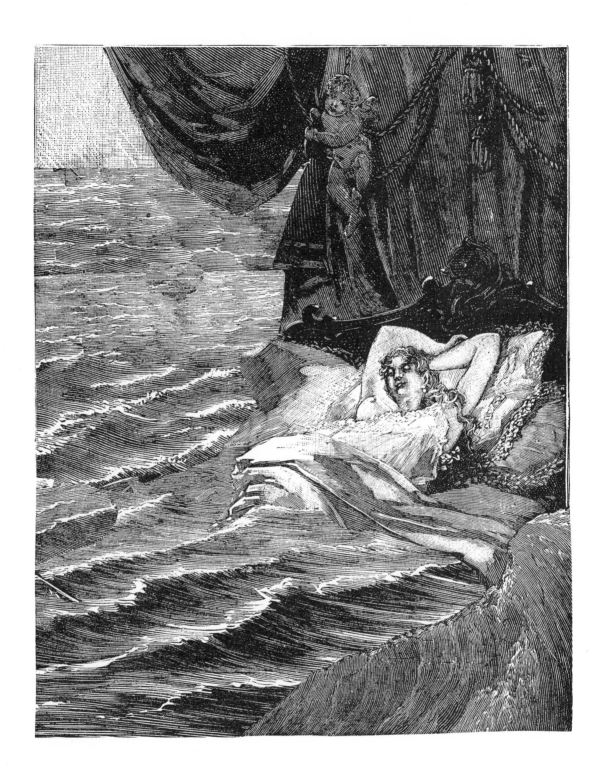

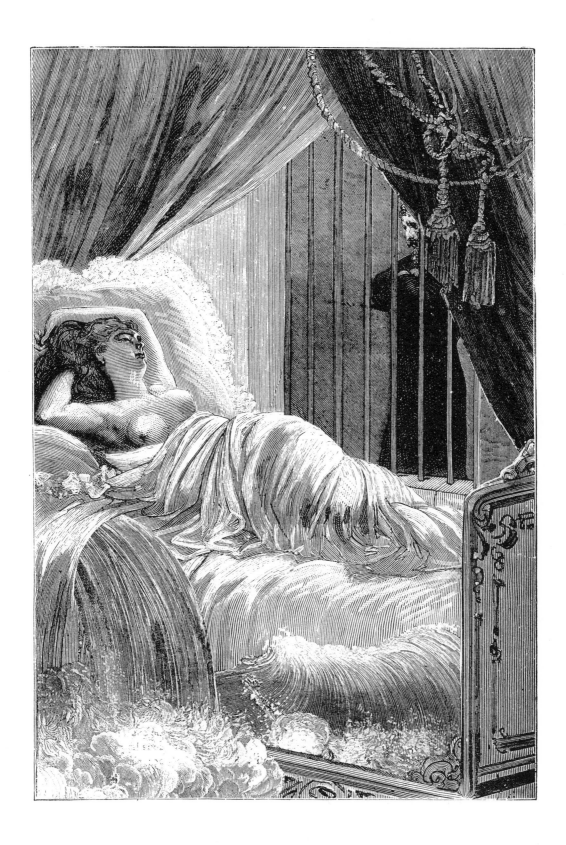

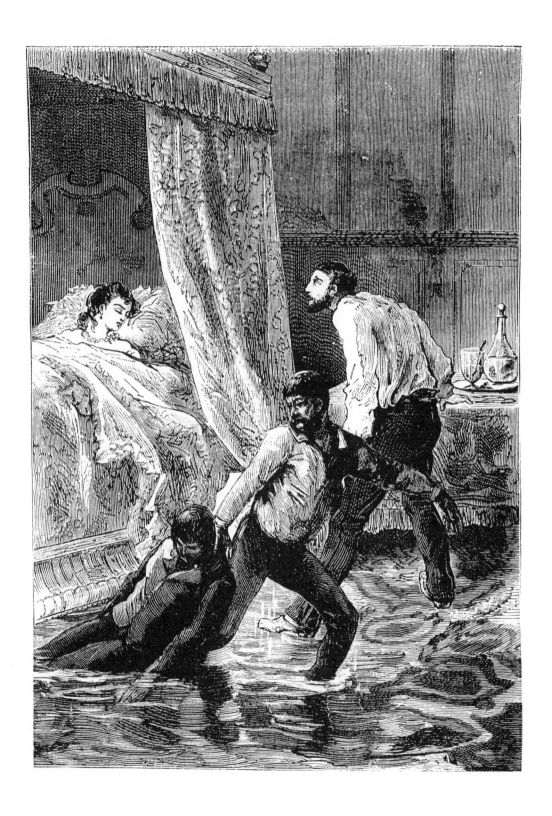

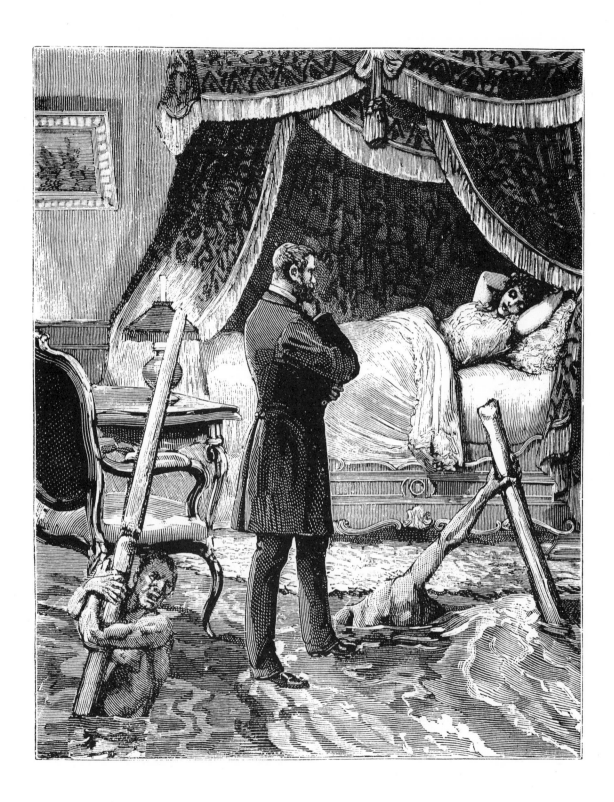

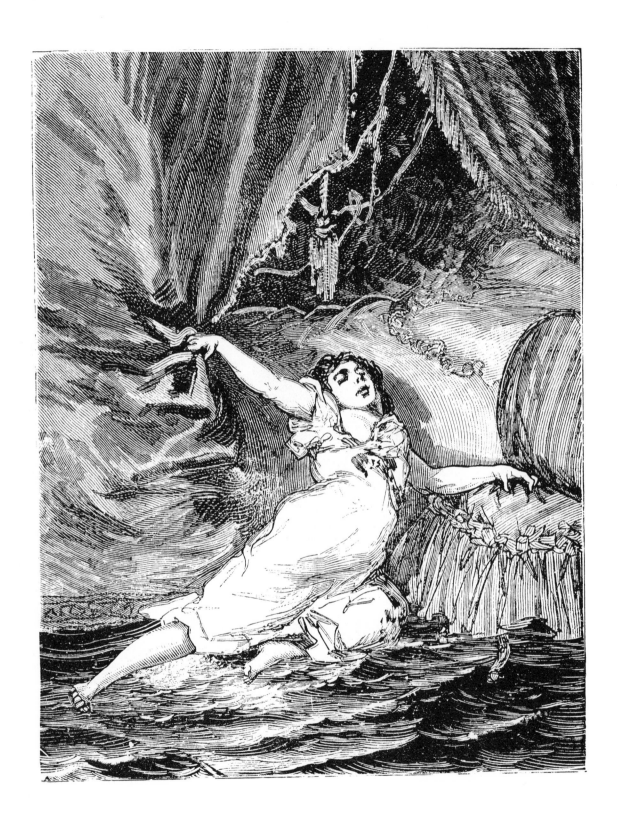

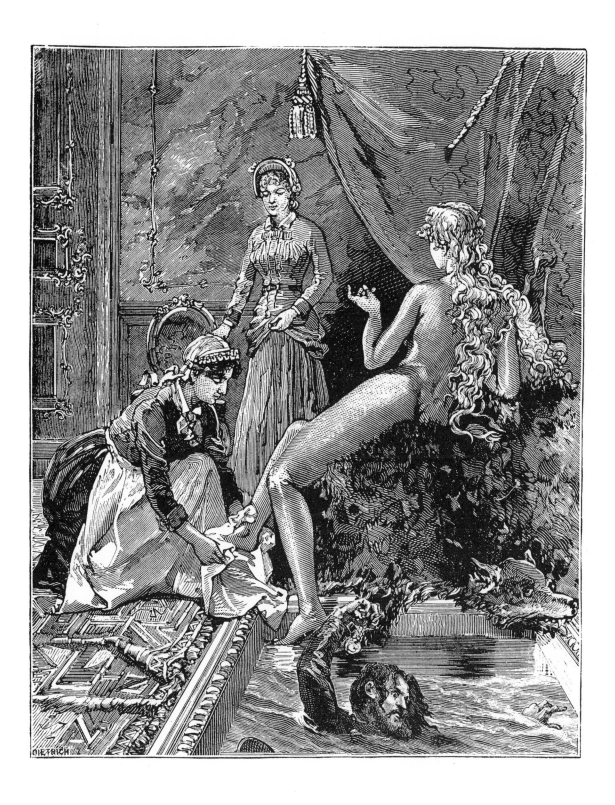

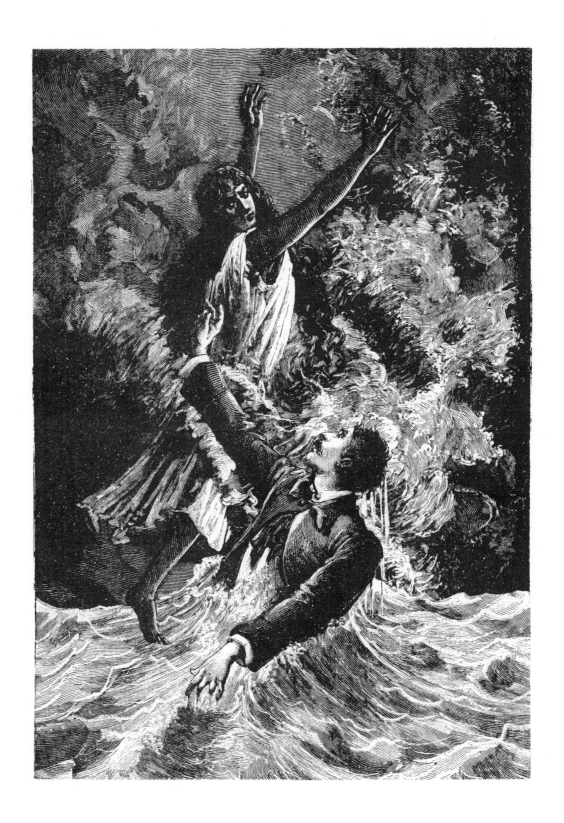

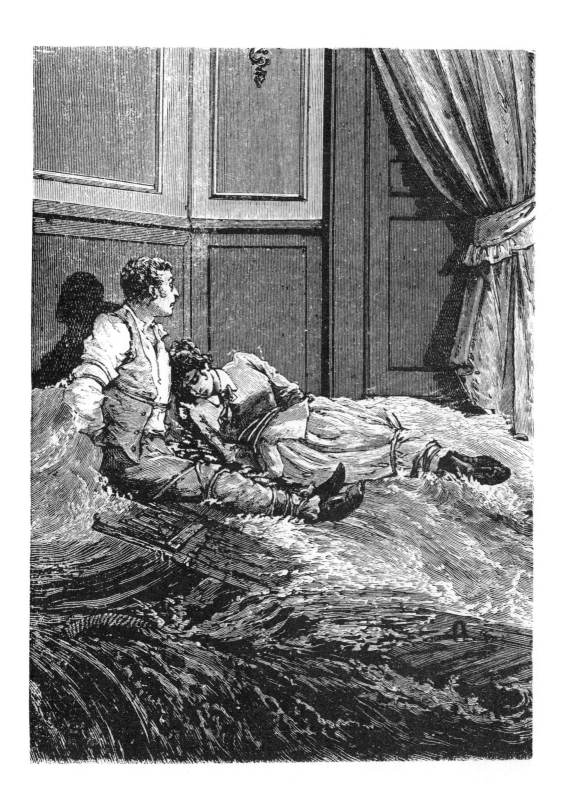

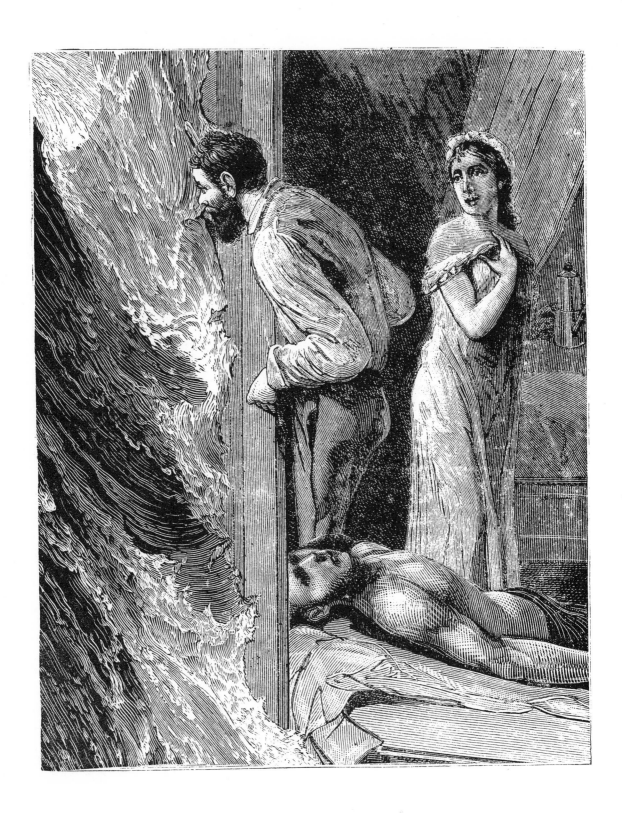

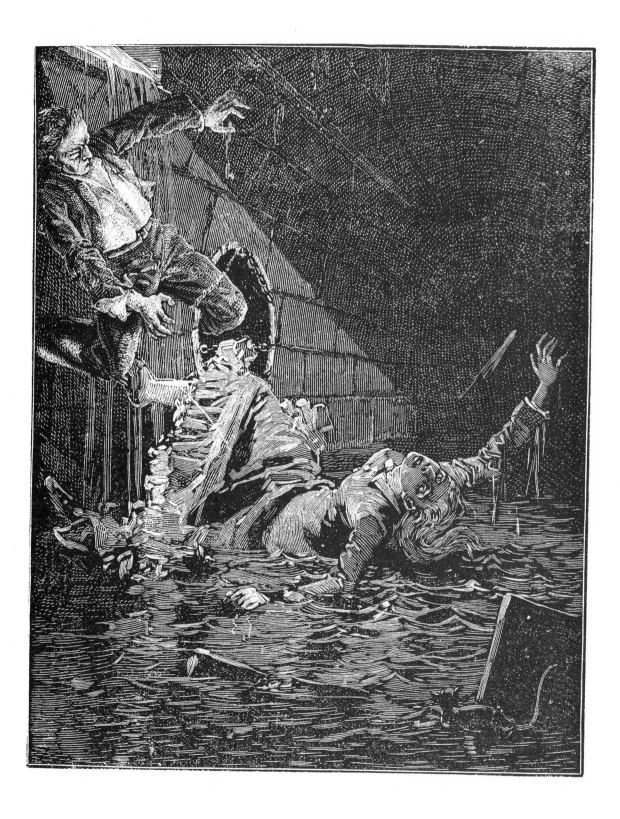

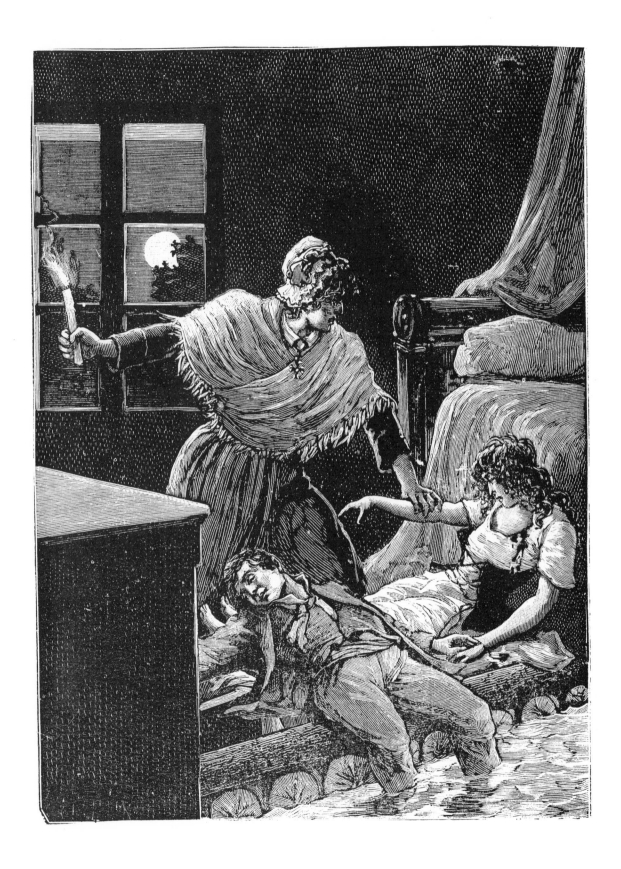

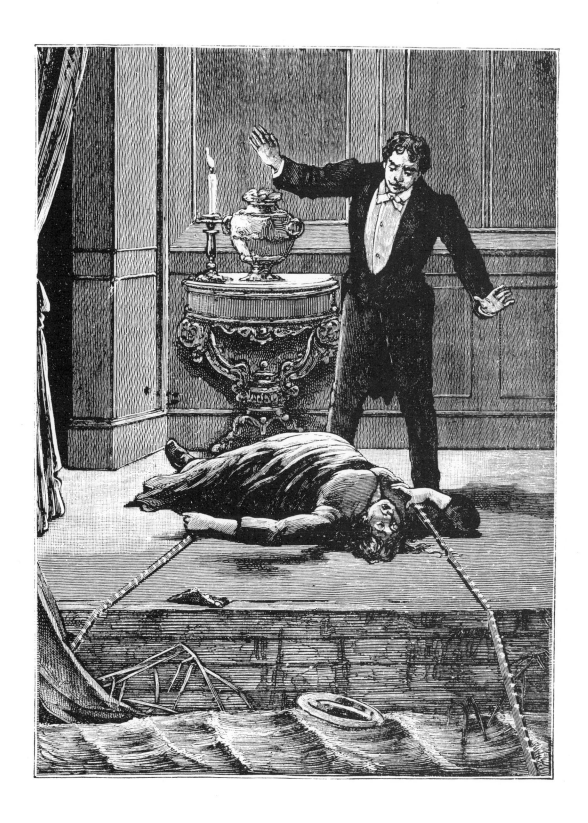

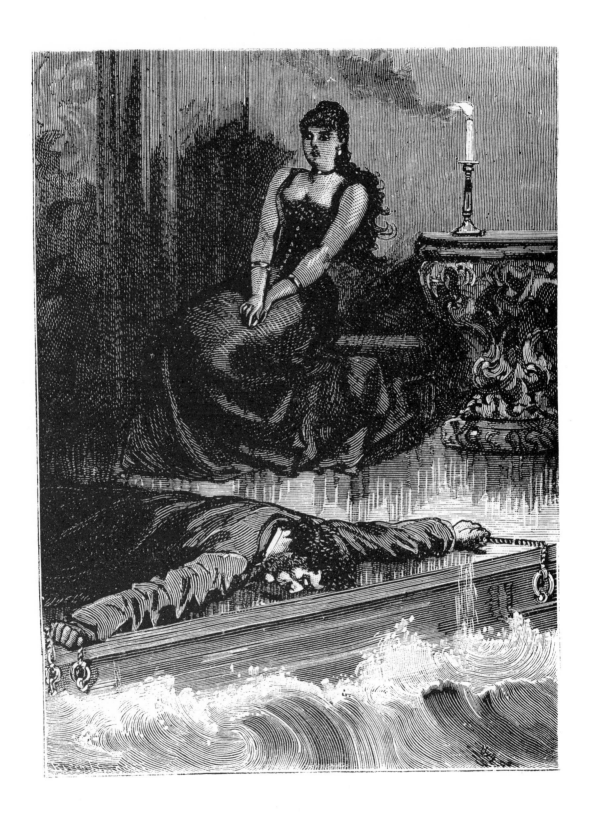

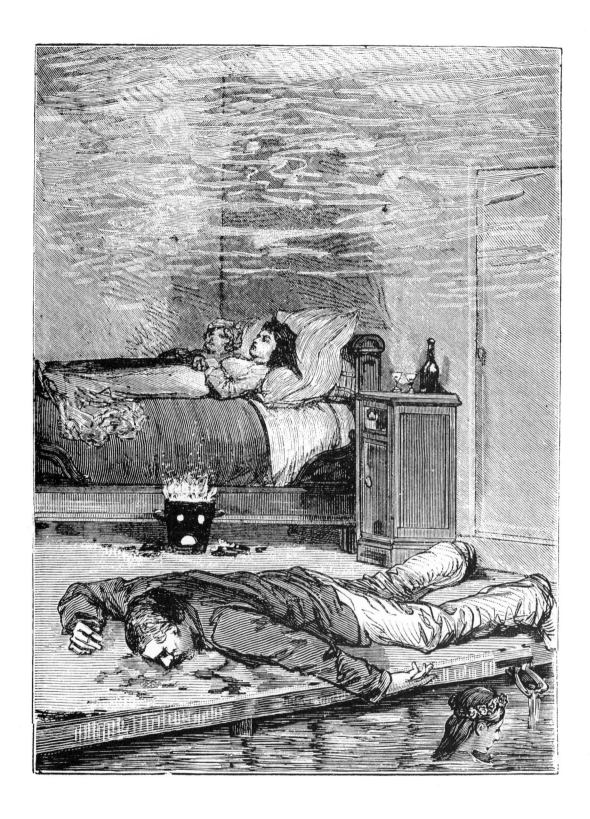

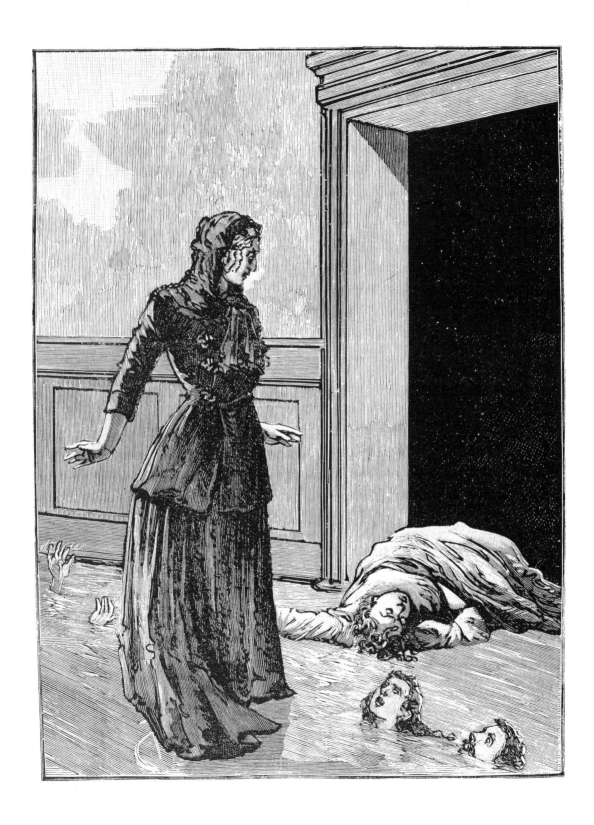

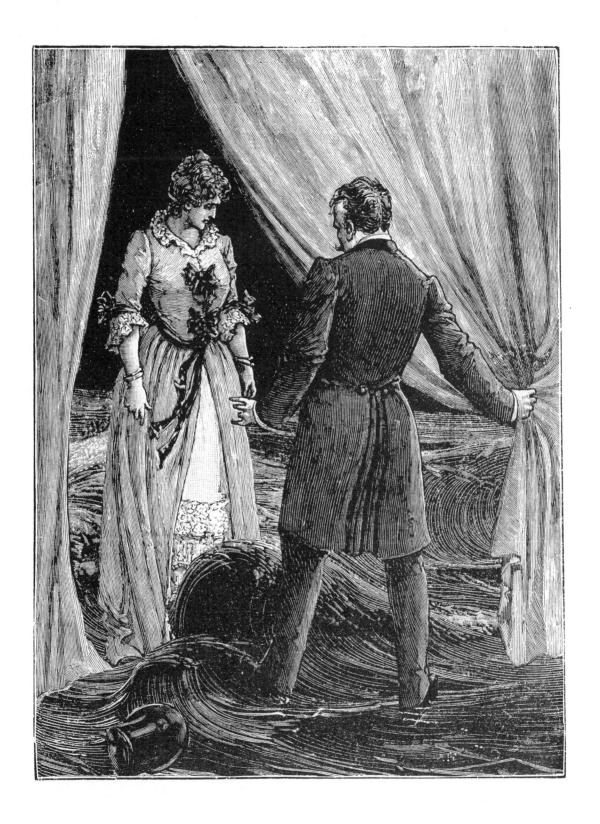

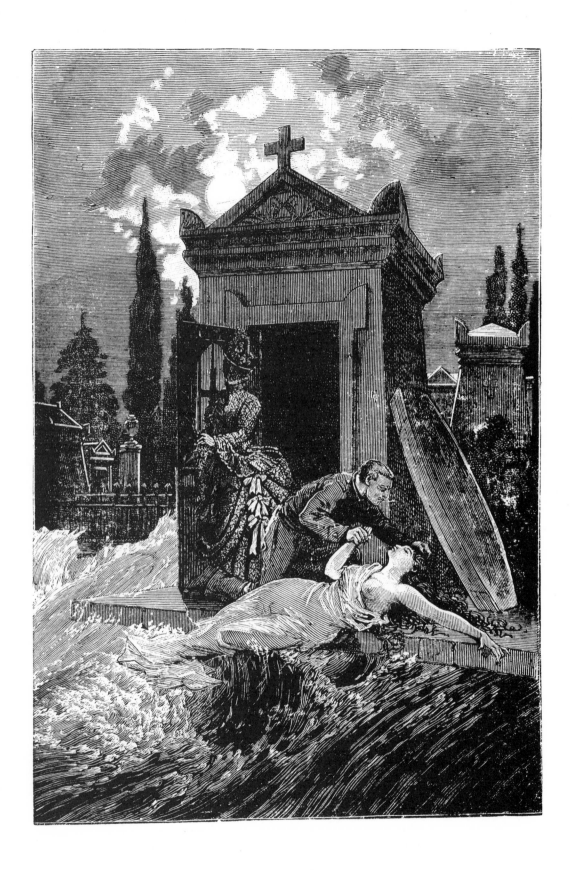

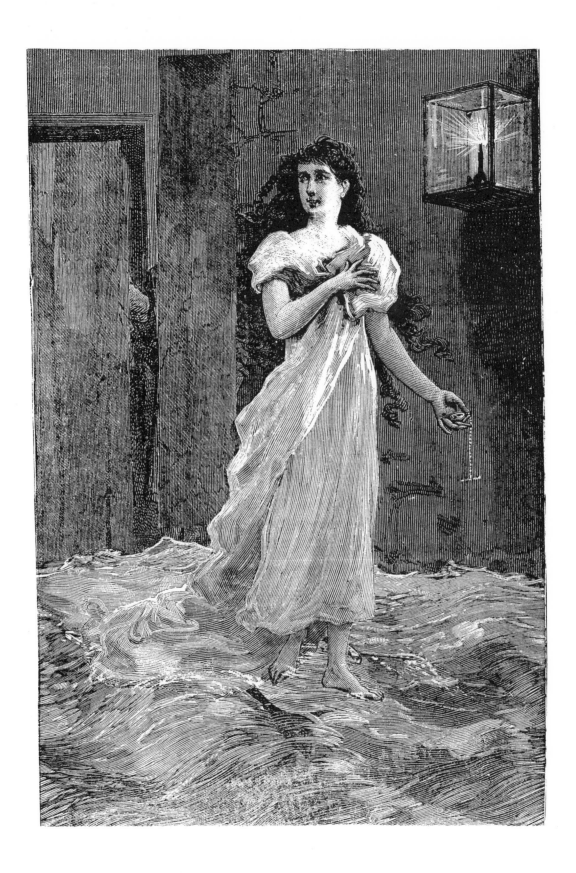

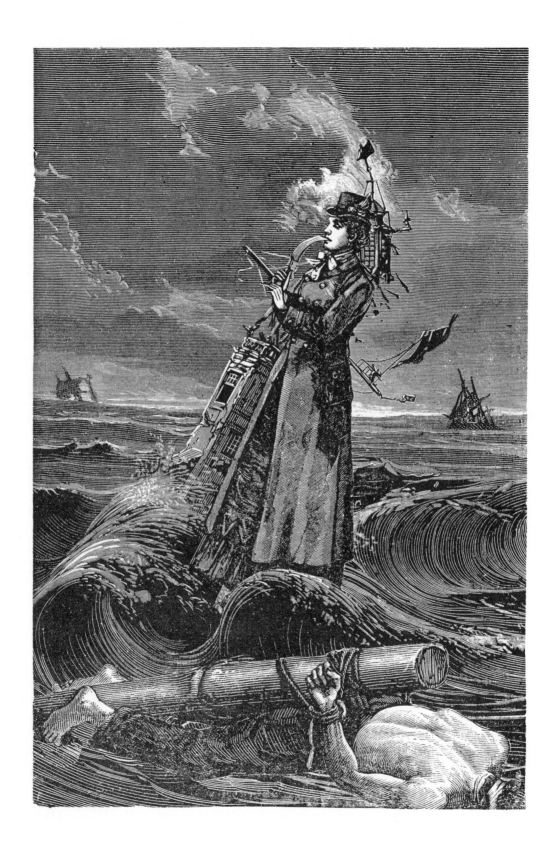

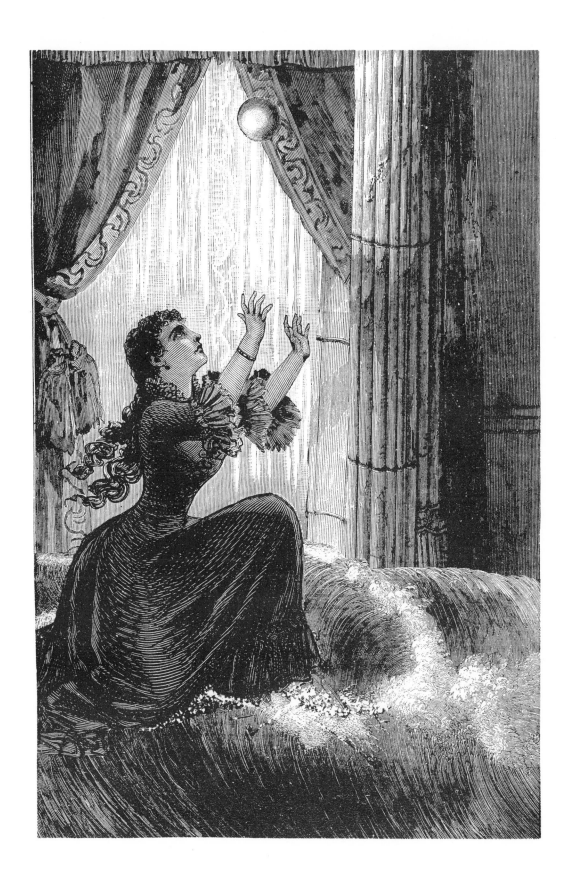

MAX ERNST

UNE SEMAINE DE BONTÉ

OU

LES SEPT ÉLÉMENTS CAPITAUX

ROMAN

TROISIÈME CAHIER

MARDI

ÉLÉMENT :

LE FEU

EXEMPLE :

LA COUR DU DRAGON

« Je voyais que la marquise de Verneuil tenait une chienne chaude. Il vint deux personnages qui étaient d'une même apparence ; l'un portait un collier d'or et l'autre avait la gorge toute remplie de salive, autrement dit de crachat, et ils voulaient avoir tous les deux la chienne. Celui qui voulait mettre le collier d'or à la chienne, se faisait mordre par elle ; et quand la chienne eut reçu le collier, elle devint demoiselle, et quand elle eut posé le collier, elle redevint chienne. Le personnage qui avait le crachat à la gorge lui cracha dessus et la chienne le suivit et se rendit à lui. » Comte de Permission (*Visions*).

« Entrez dit-il et la lumière se fit personne n'avait frappé. »

Tristan TZARA (*Où boivent les loups*).

MAX ERNST

A WEEK OF KINDNESS

OR

THE SEVEN DEADLY ELEMENTS

NOVEL

THIRD BOOK

TUESDAY

ELEMENT:

FIRE

EXAMPLE:

THE COURT OF THE DRAGON

"I saw that the Marquise de Verneuil was holding a bitch in heat. Two people arrived who resembled each other; one was carrying a gold collar and the other had his throat filled with saliva, also called spittle, and both wanted to have the bitch. The man who wanted to put the gold collar on the bitch was bitten by it; and when the bitch had received the collar, it became a young lady, and when she had put aside the collar, she became a bitch again. The person who had spittle in his throat spat it onto her and the bitch followed him and yielded to him."

(Comte de Permission, *Visions*)

"Enter he said and there was light no one had knocked."

(Tristan Tzara, *Où boivent les loups*)

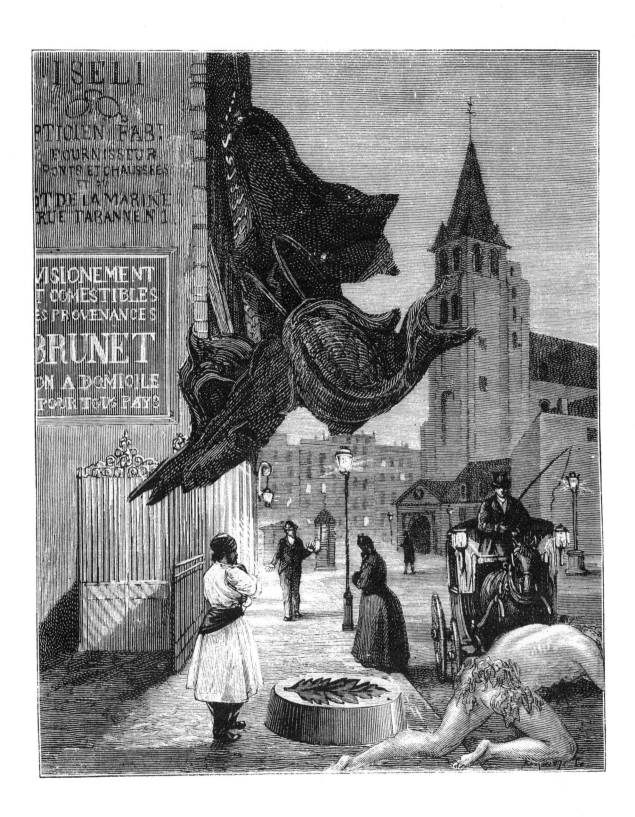

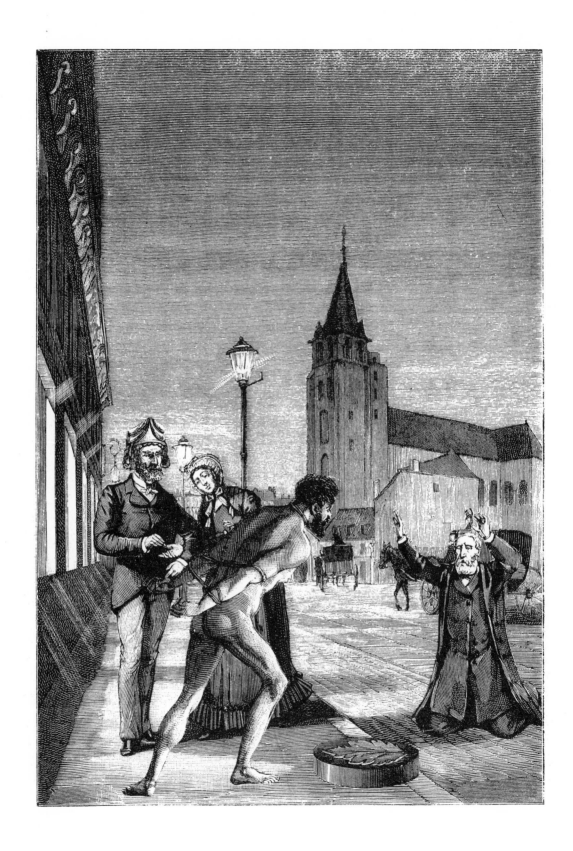

72

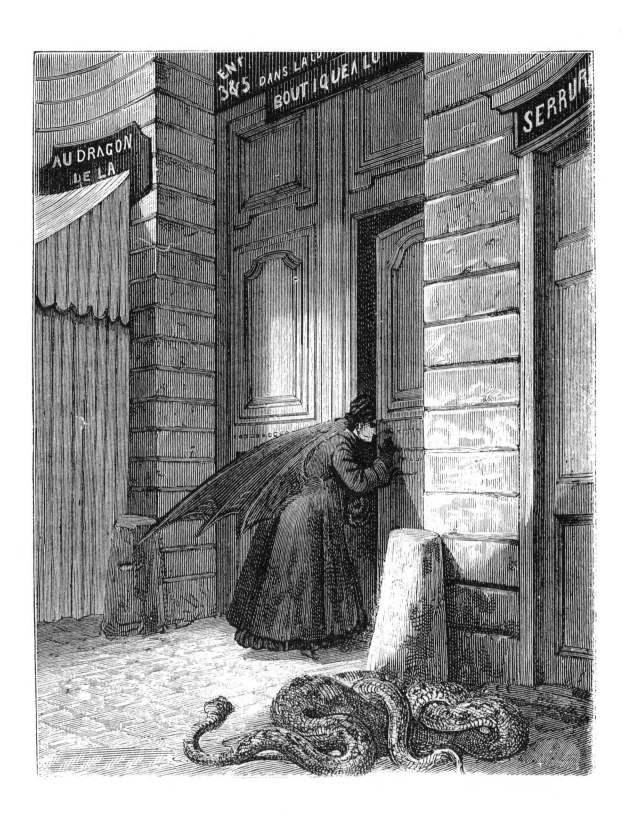

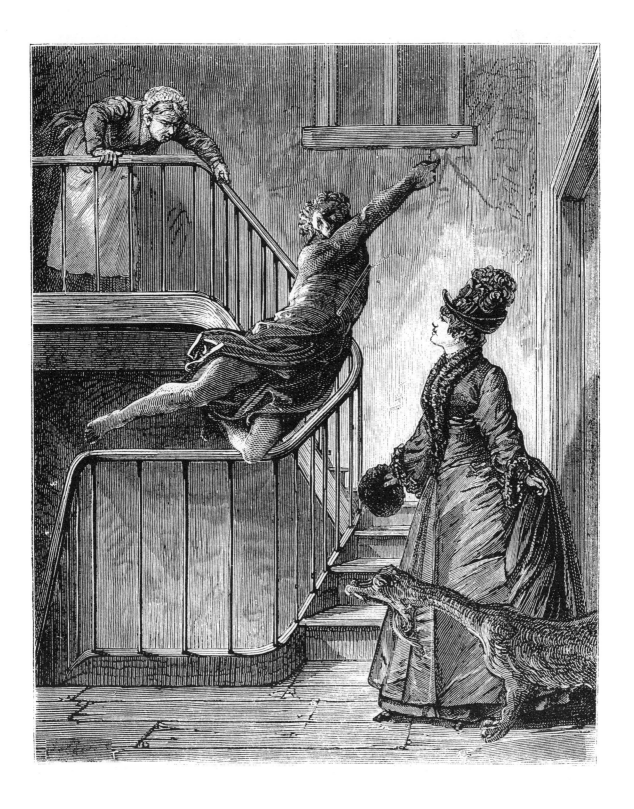

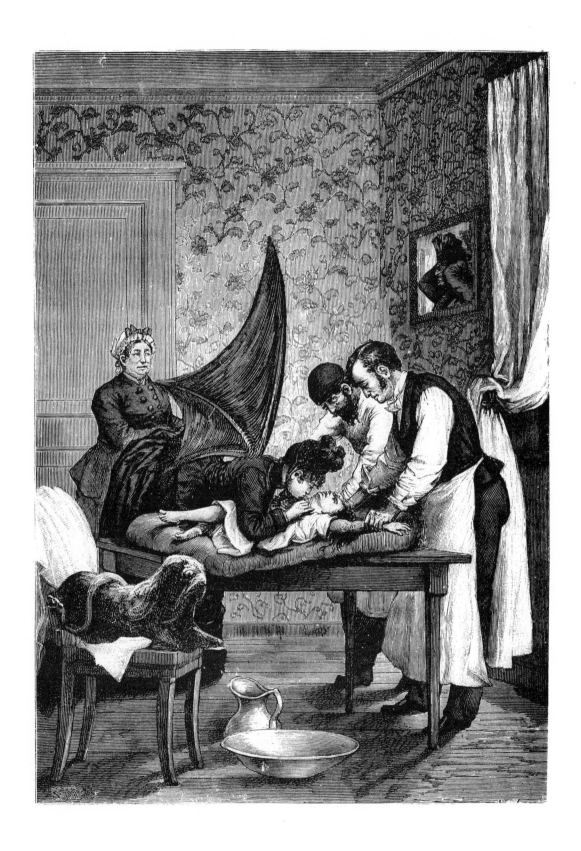

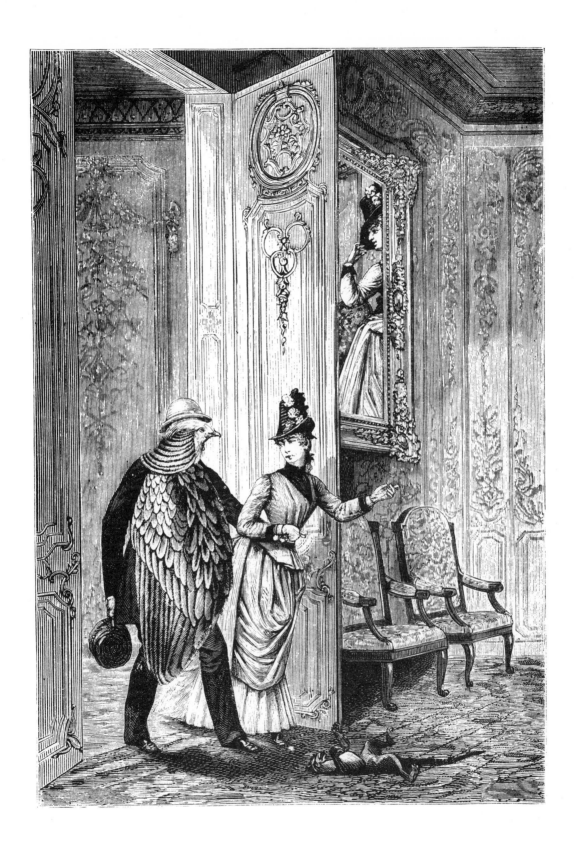

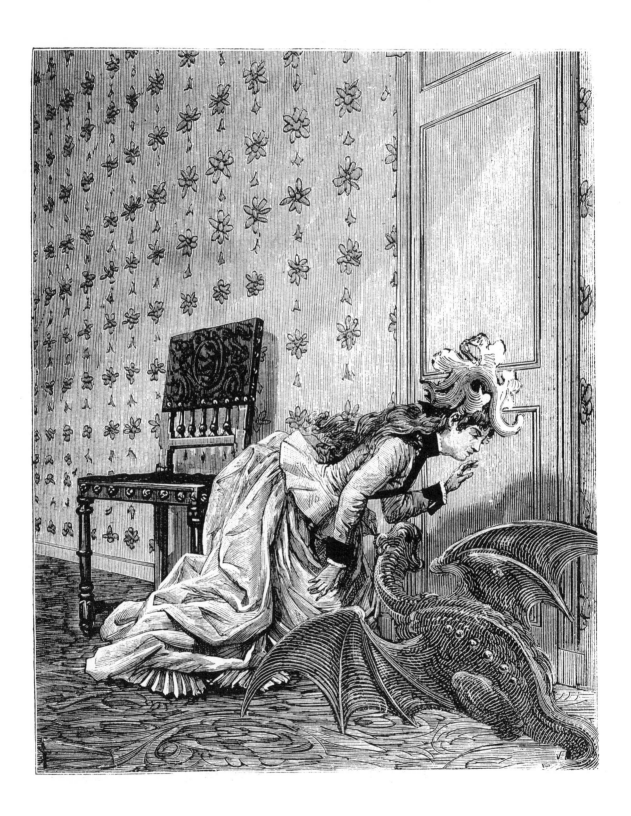

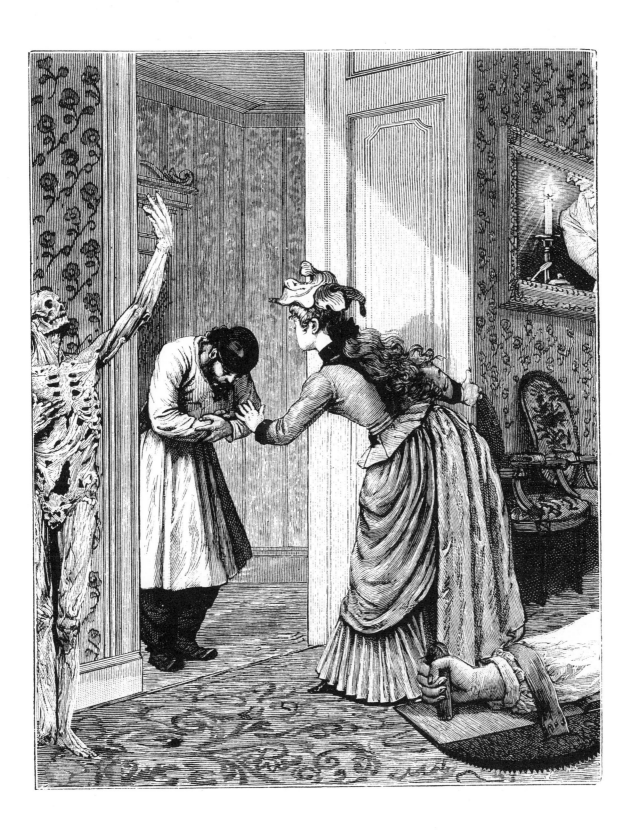

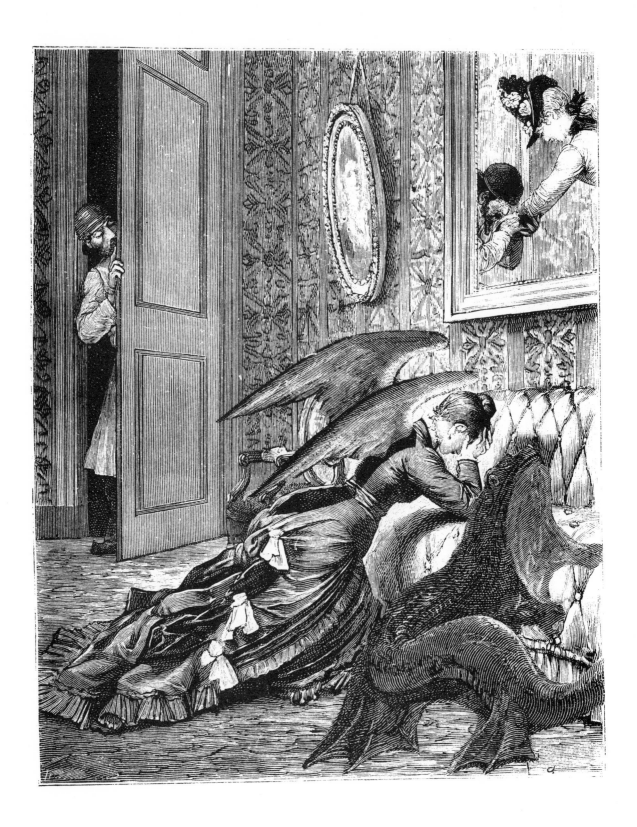

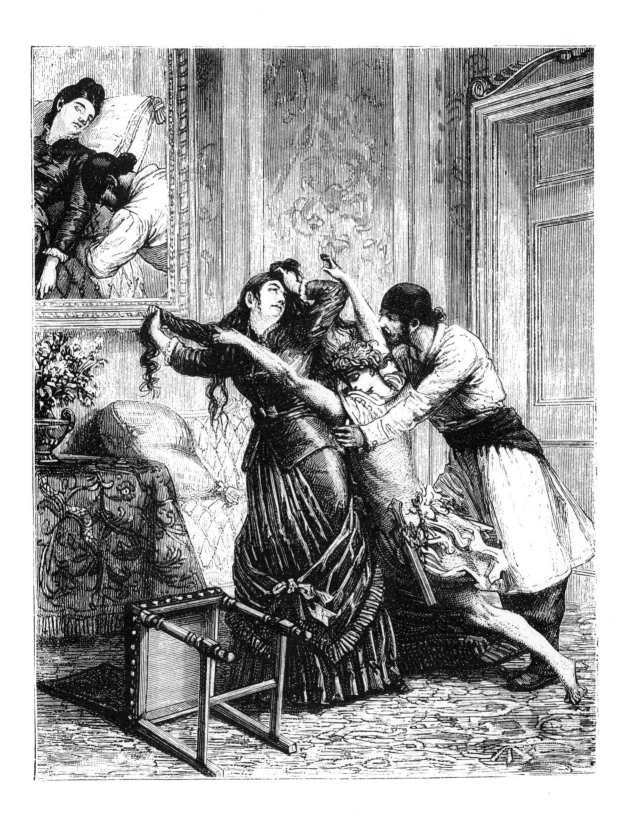

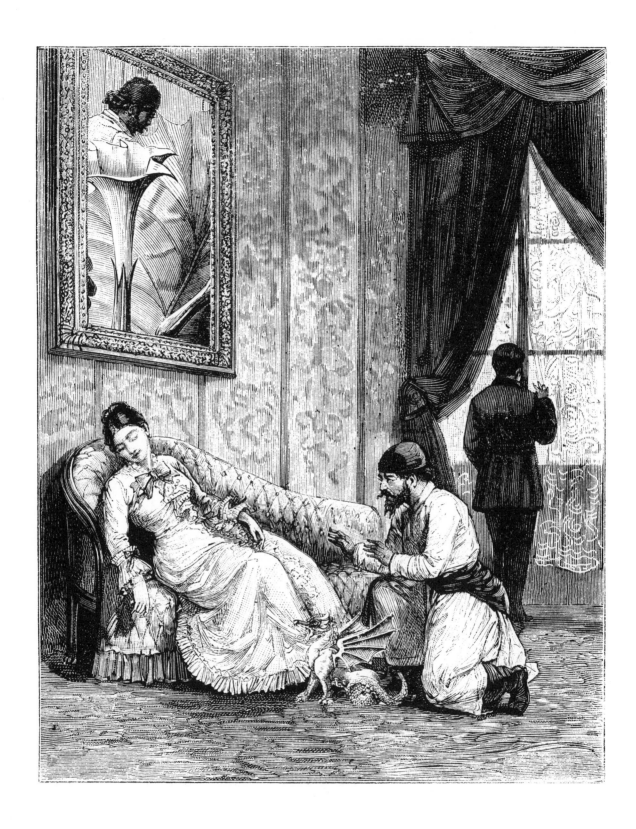

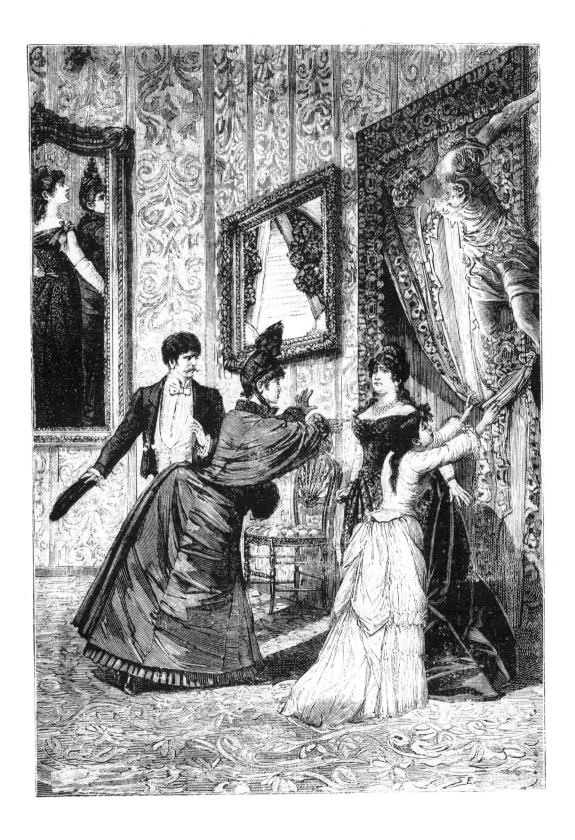

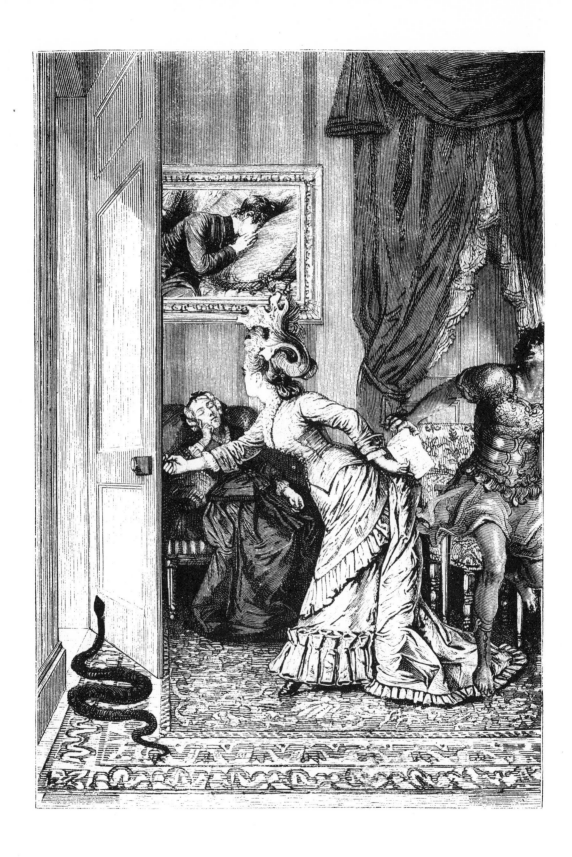

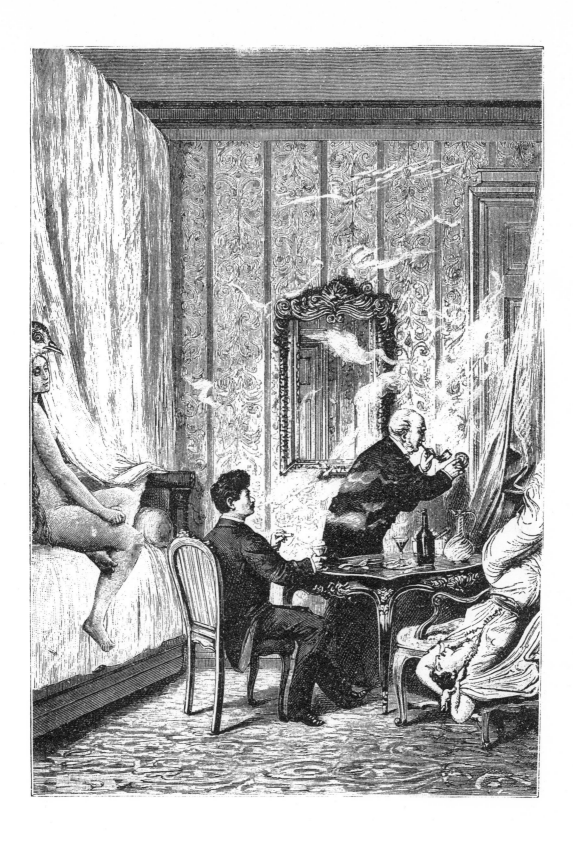

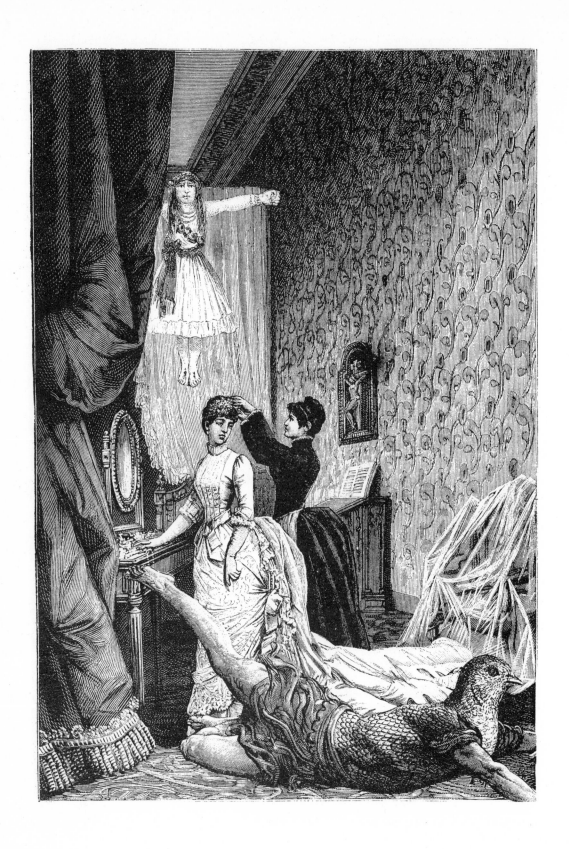

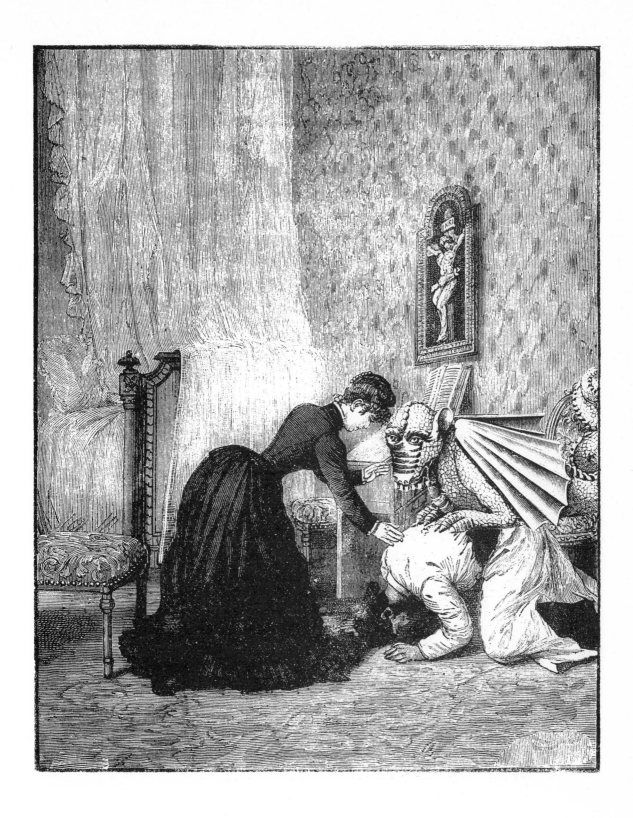

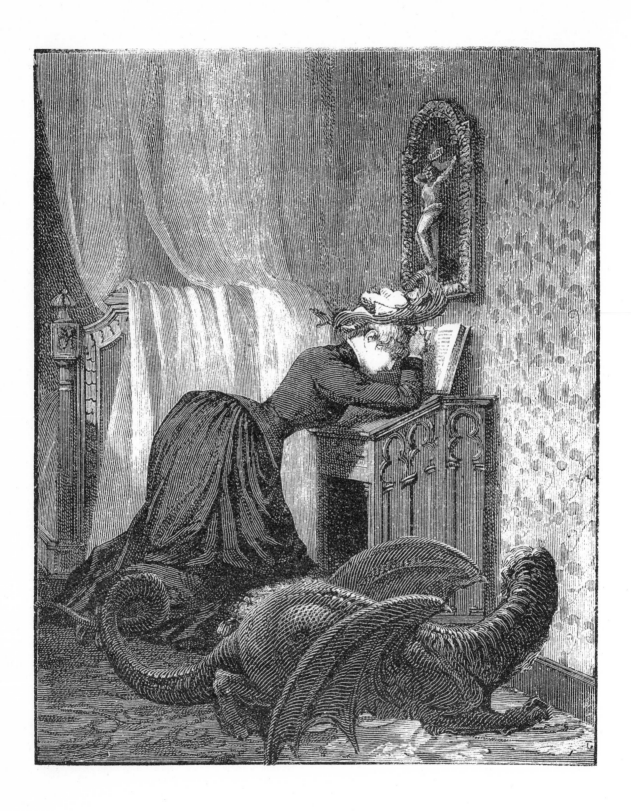

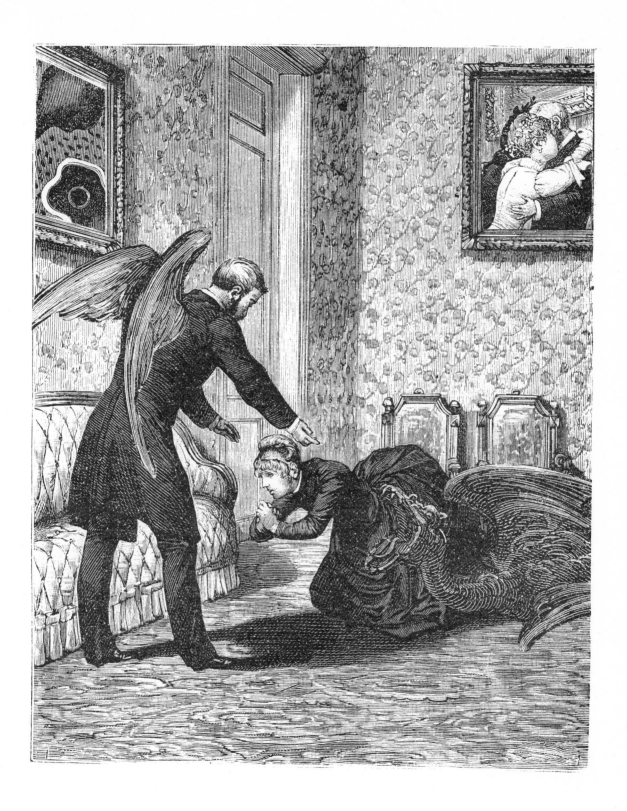

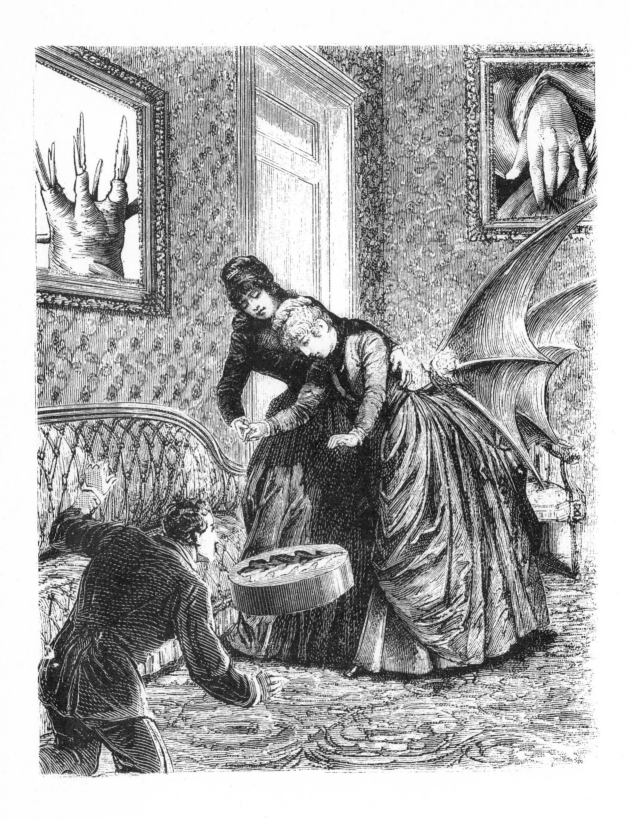

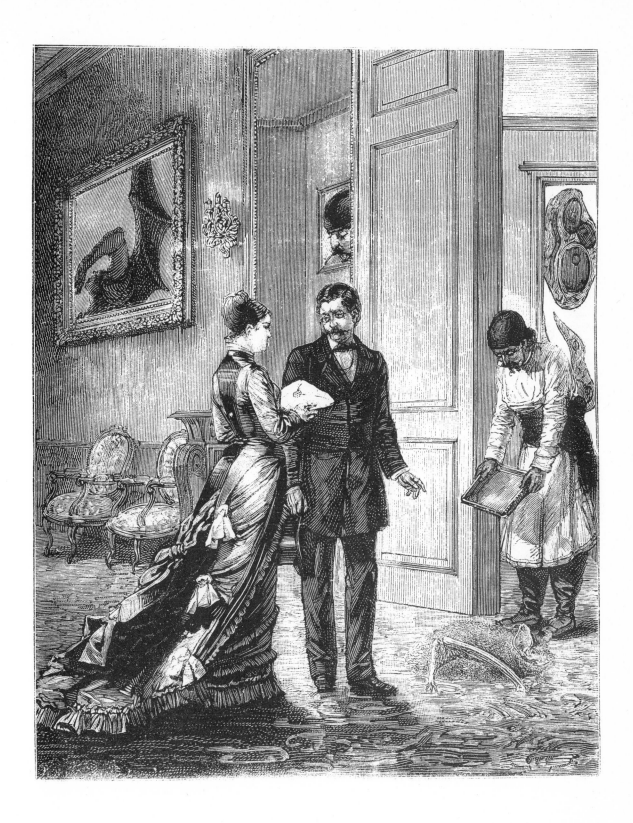

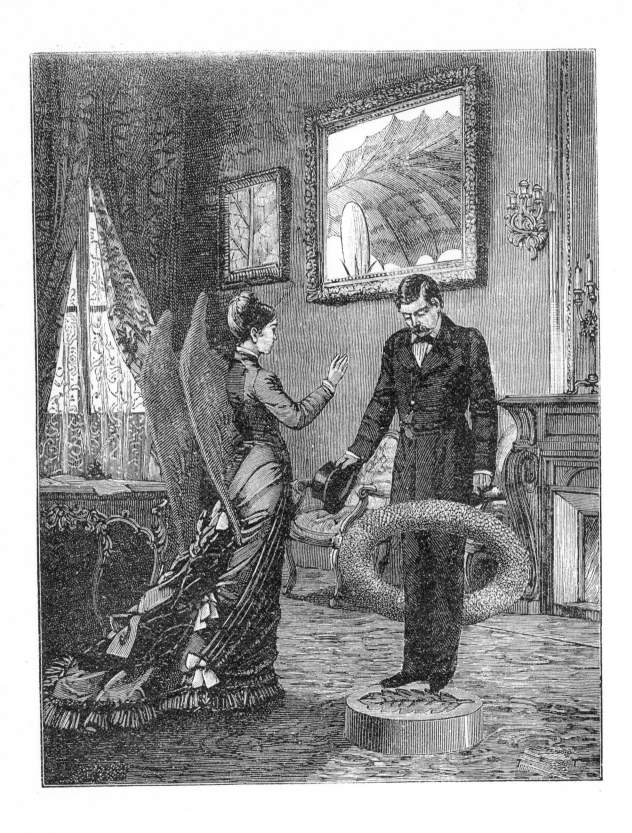

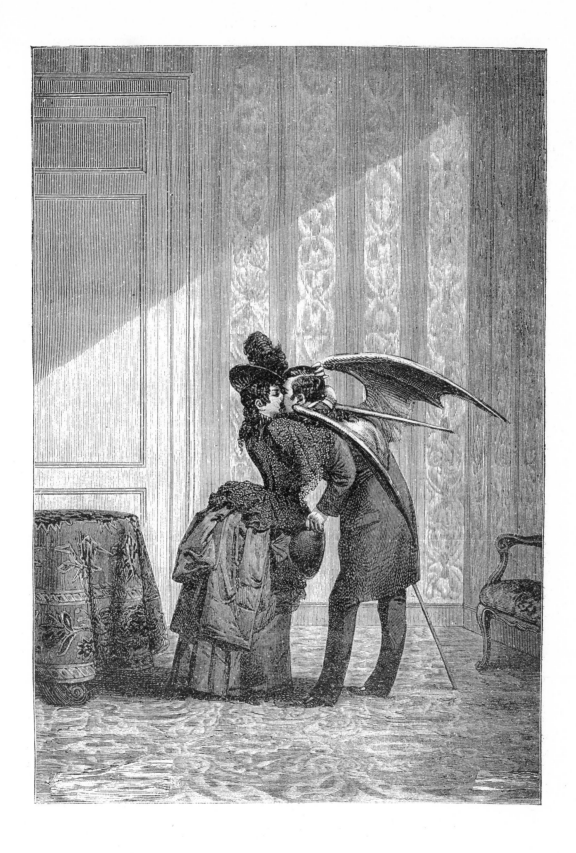

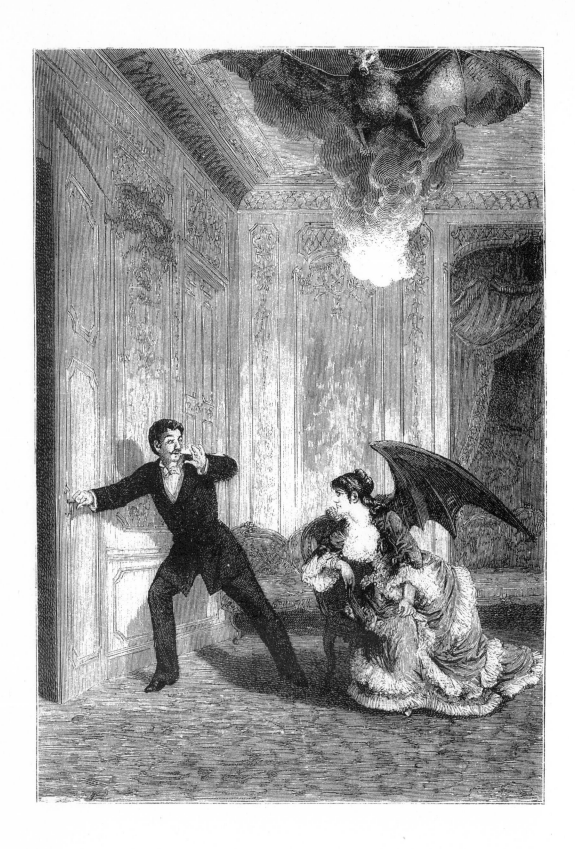

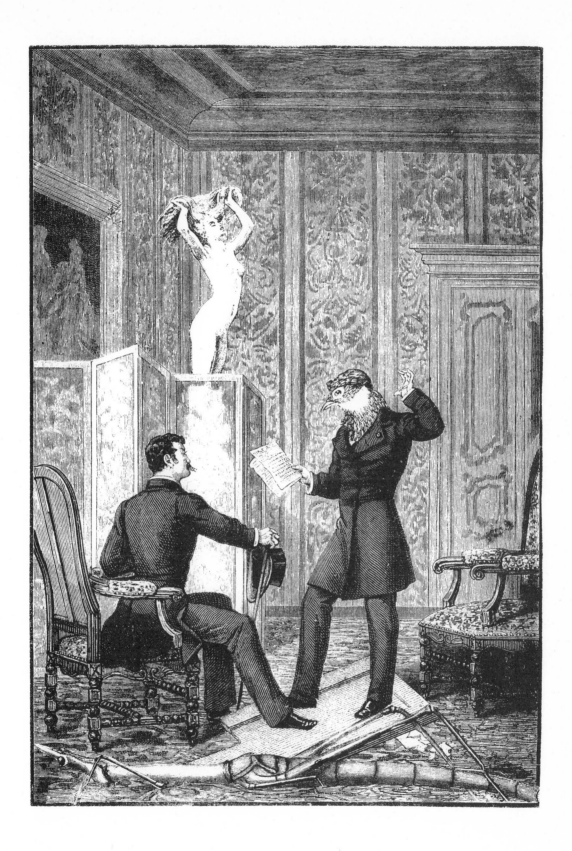

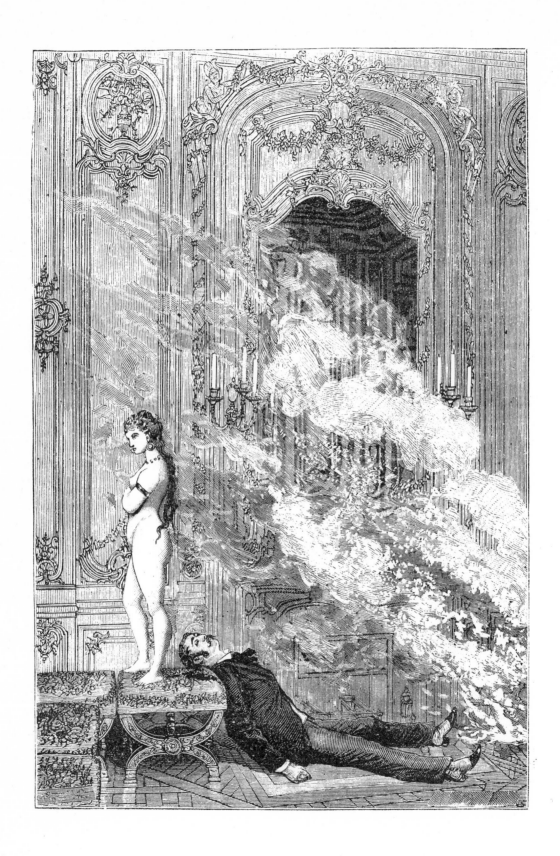

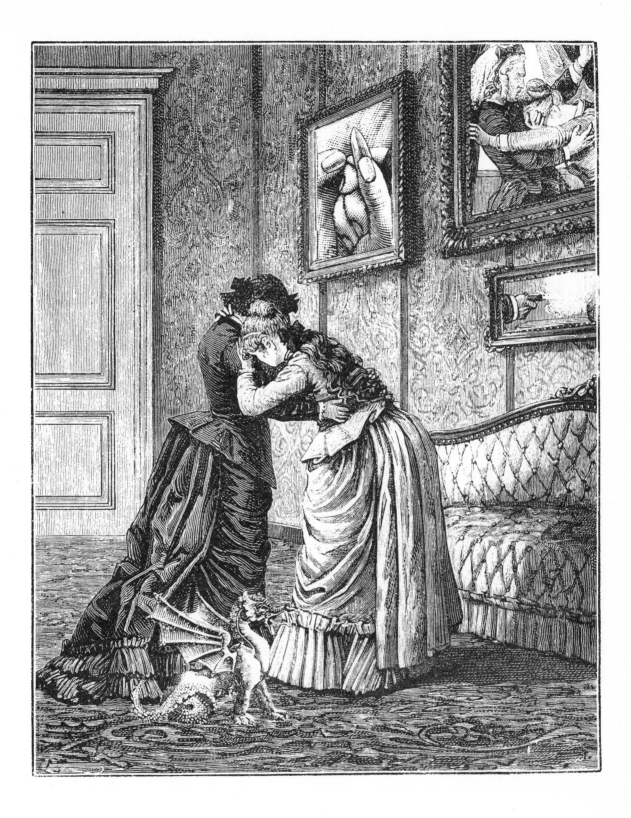

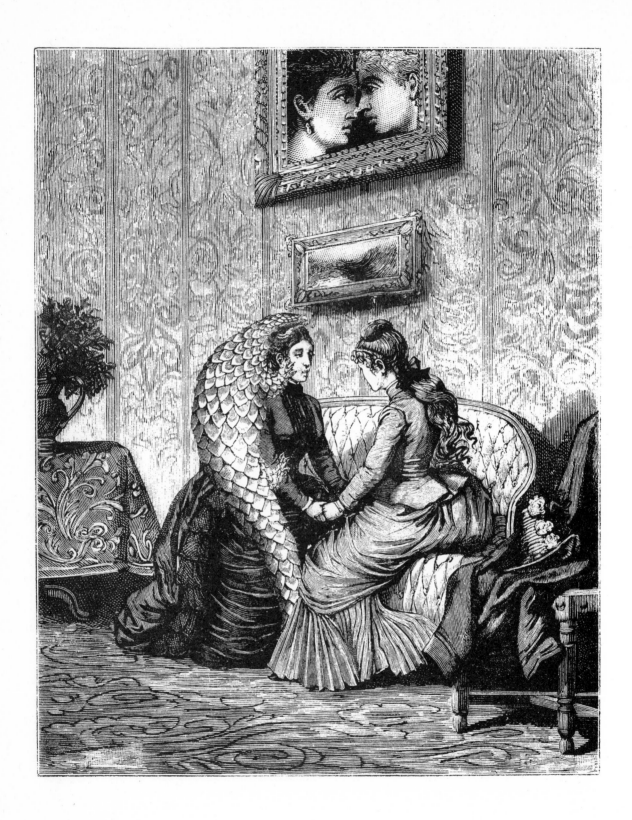

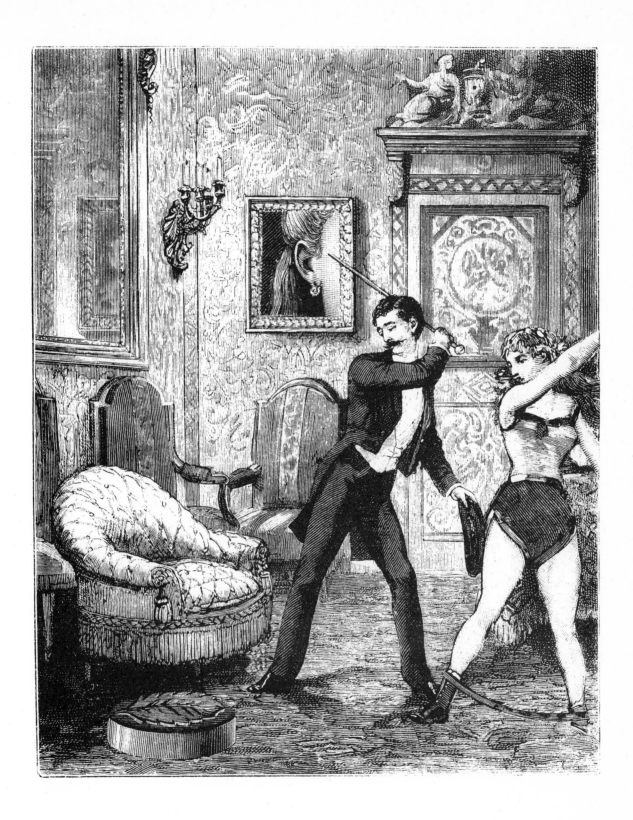

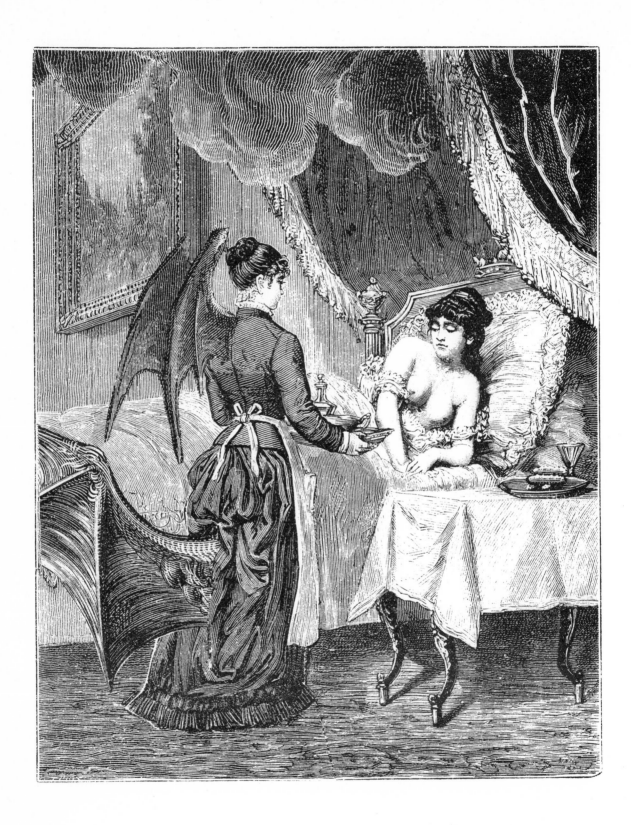

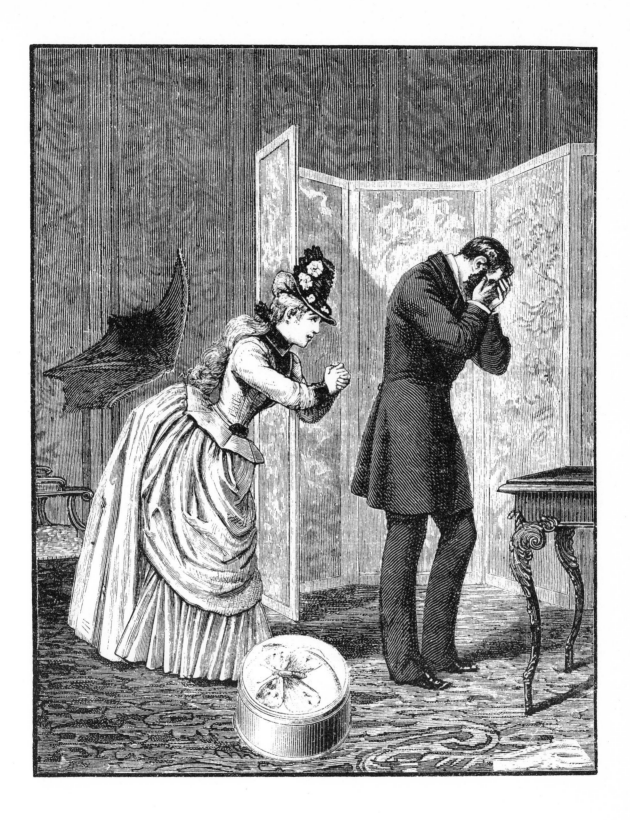

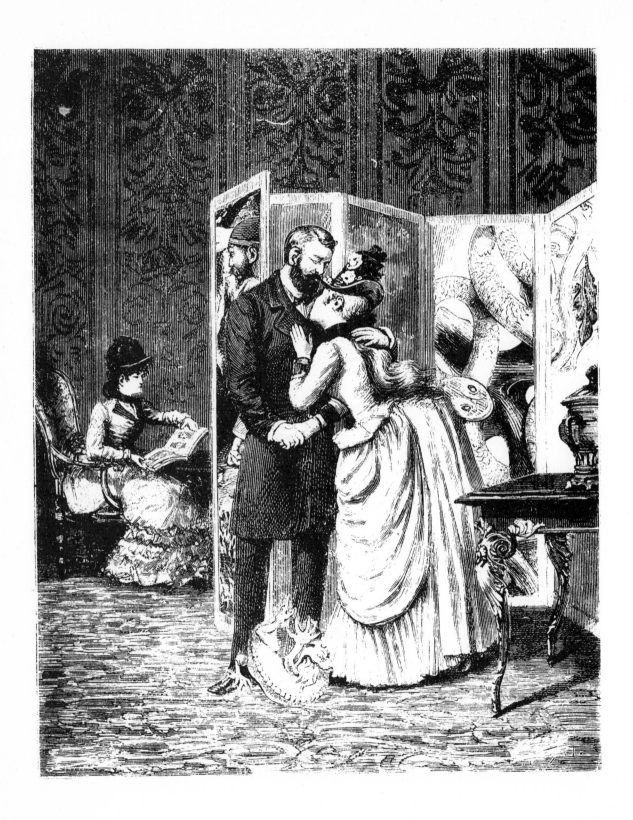

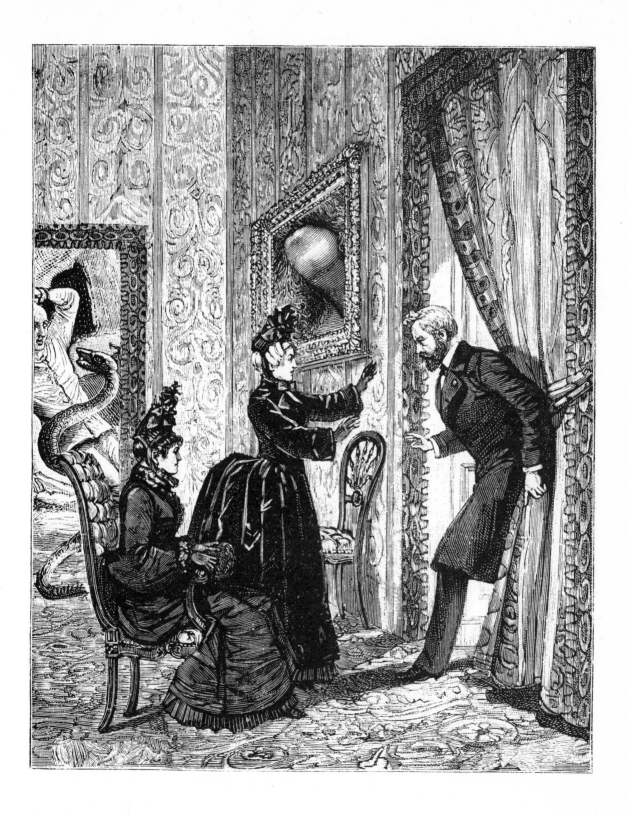

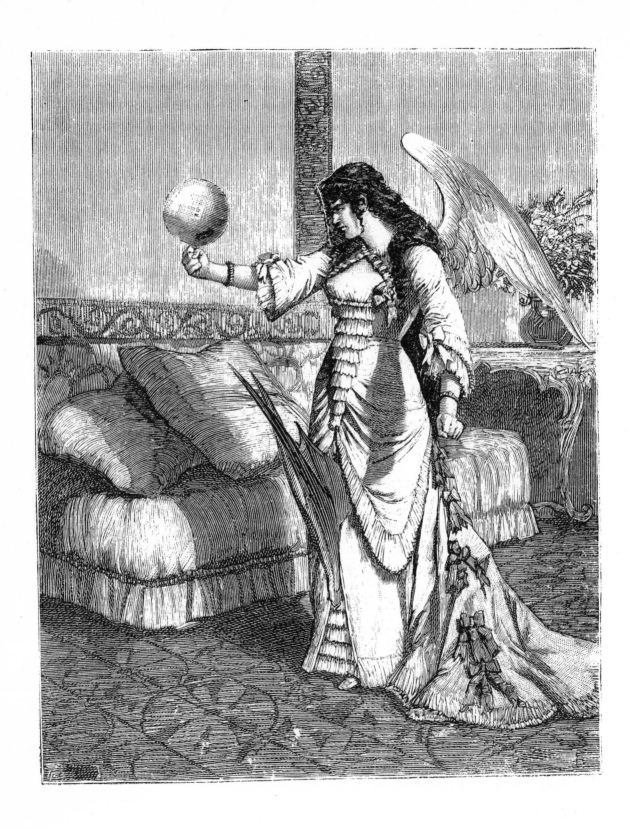

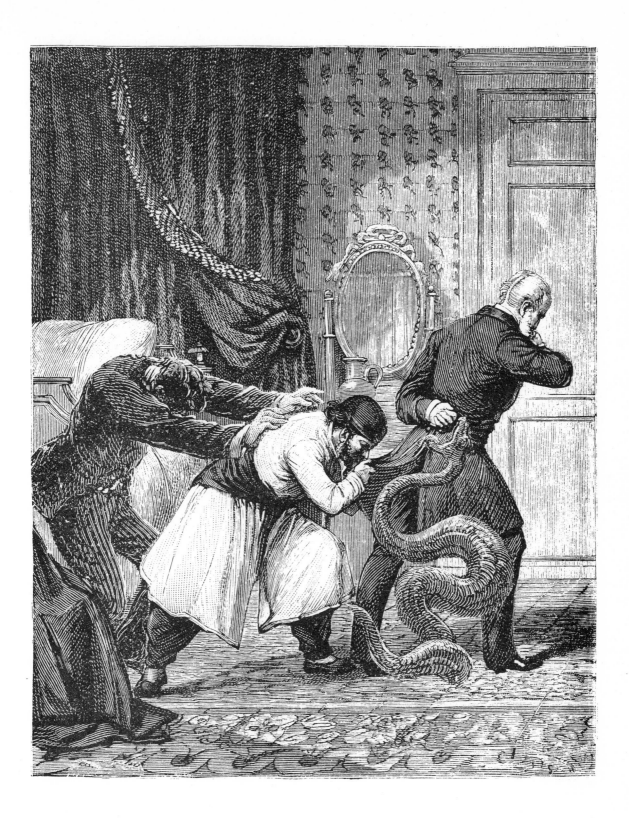

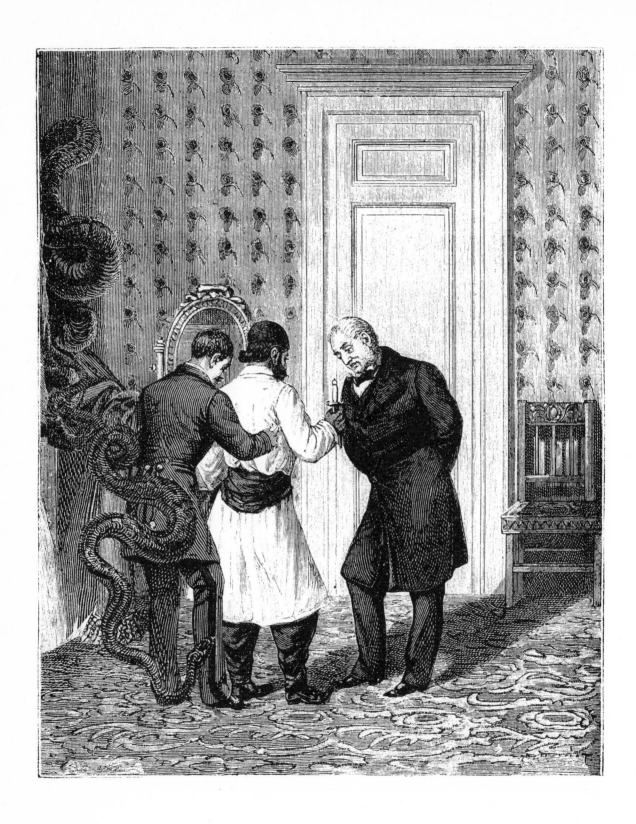

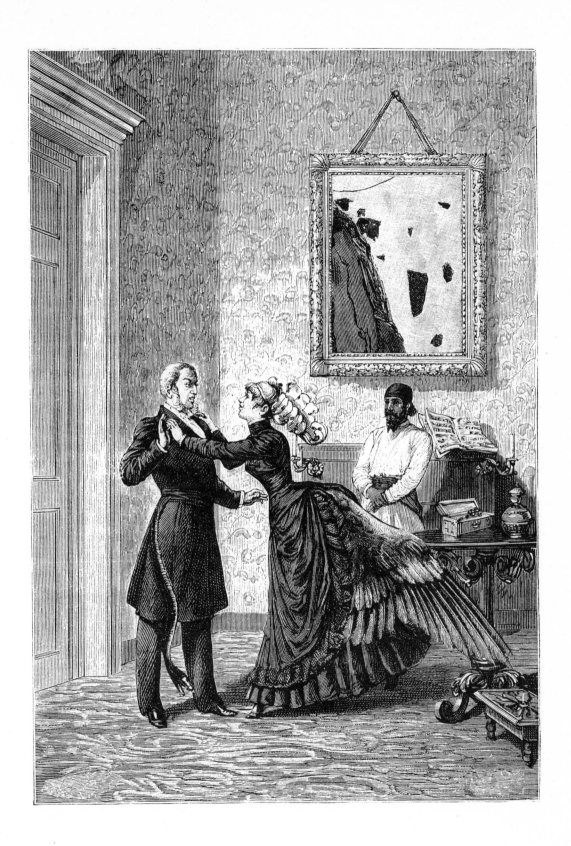

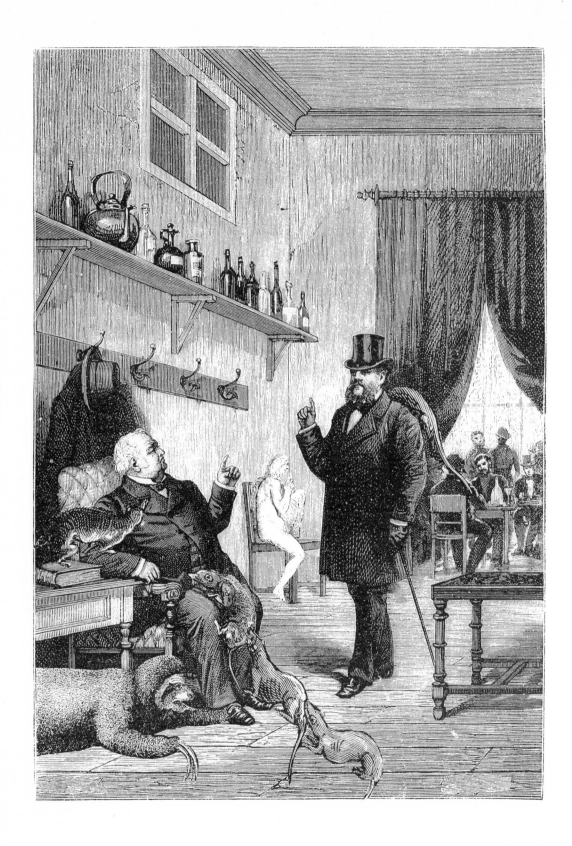

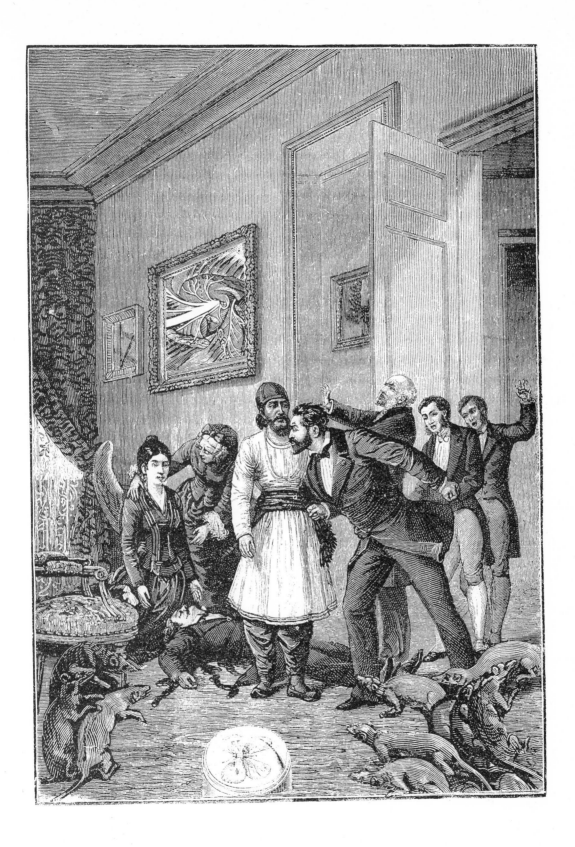

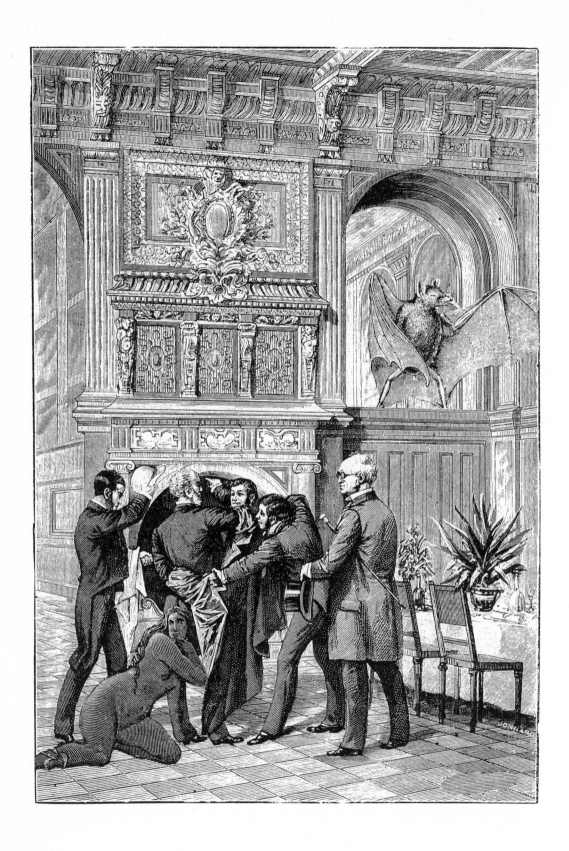

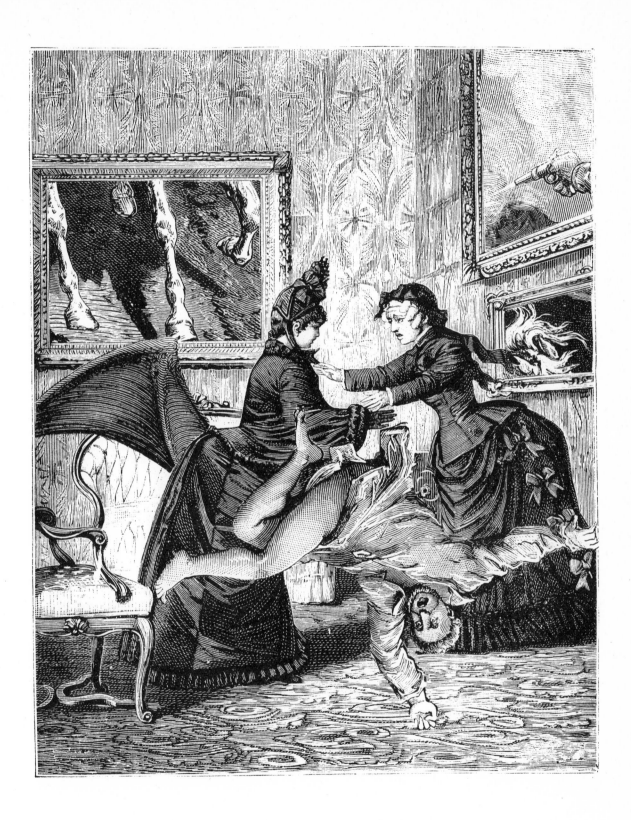

III

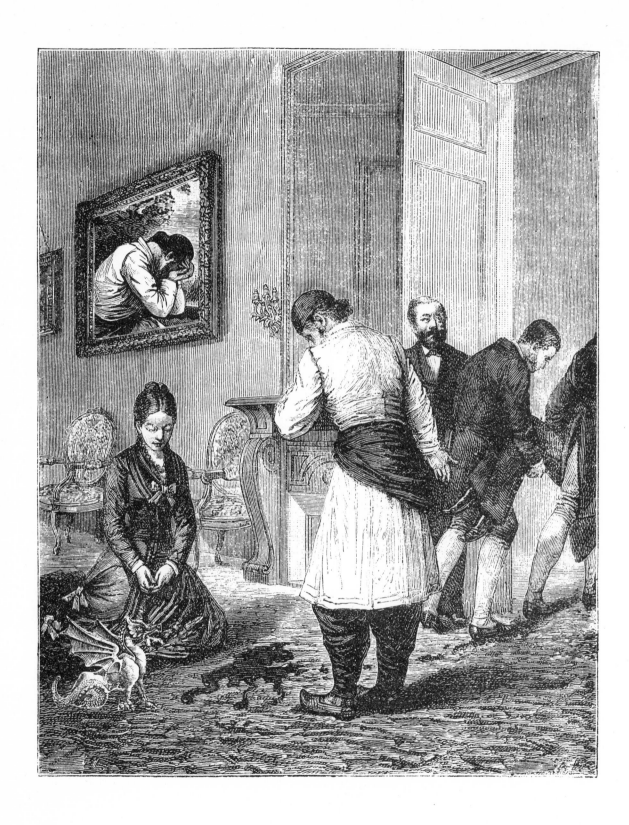

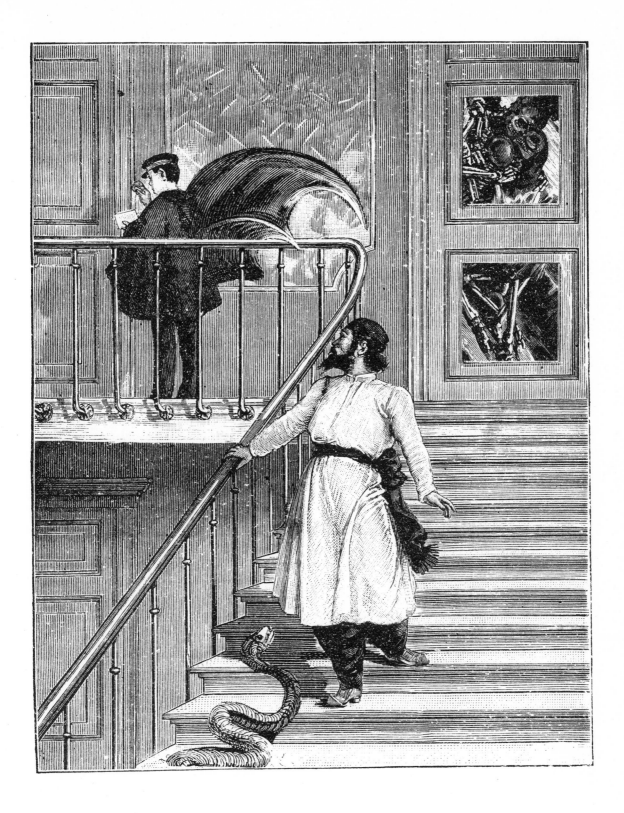

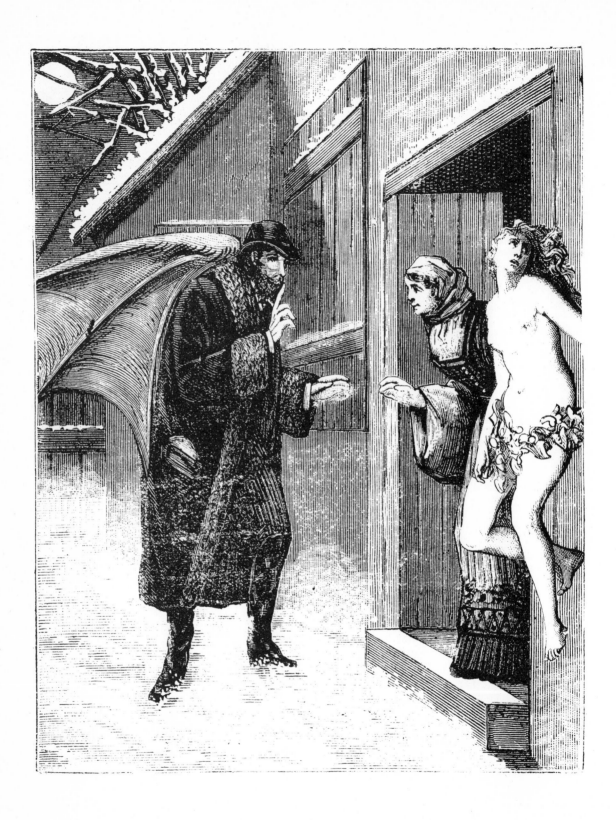

MAX ERNST

UNE SEMAINE DE BONTÉ
OU
LES SEPT ÉLÉMENTS CAPITAUX

ROMAN

QUATRIÈME CAHIER

MERCREDI

ÉLÉMENT :

LE SANG

EXEMPLE :

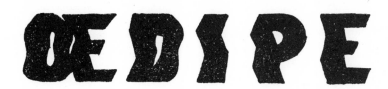

« Grand Dieu, la terre préservez
de jamais porter de tels monstres.
Aucune histoire n'a prouvé
qu'il y en eut jamais de la sorte.
Par le soin de l'autorité,
nul n'y sera plus exposé. »
　　　　　Complainte de Peyrebeille.
« On le nomme aussi MAMAN par erreur »
　　　　Paul ELUARD. (Exemples)

MAX ERNST

A WEEK OF KINDNESS

OR

THE SEVEN DEADLY ELEMENTS

NOVEL

FOURTH BOOK

WEDNESDAY

ELEMENT:

BLOOD

EXAMPLE:

OEDIPUS

"Great God, save the earth from ever bearing such mon-
sters. No history has proved that there ever were any such.
Through the efforts of the authorities, no one will be
exposed to them any longer." (*Complainte de Peyrebeille*)

"It is also called MAMMA by mistake."

(Paul Eluard, *Exemples*)

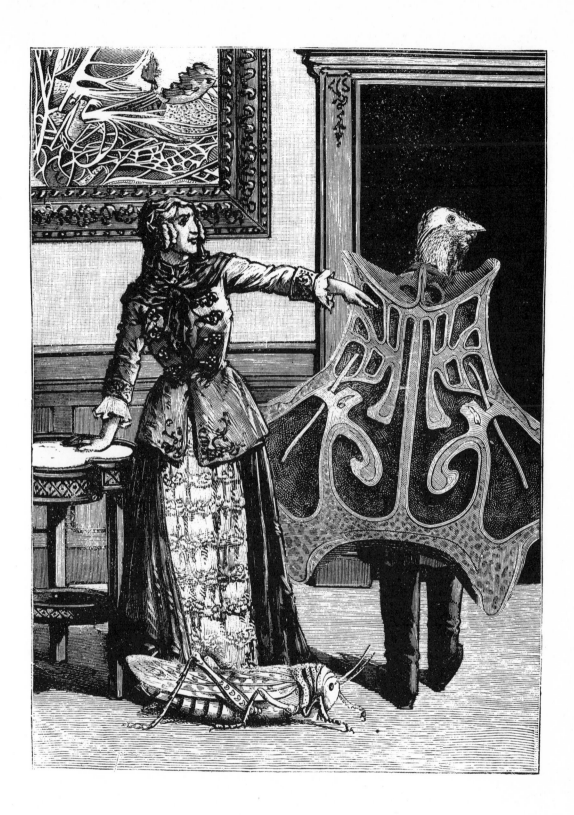

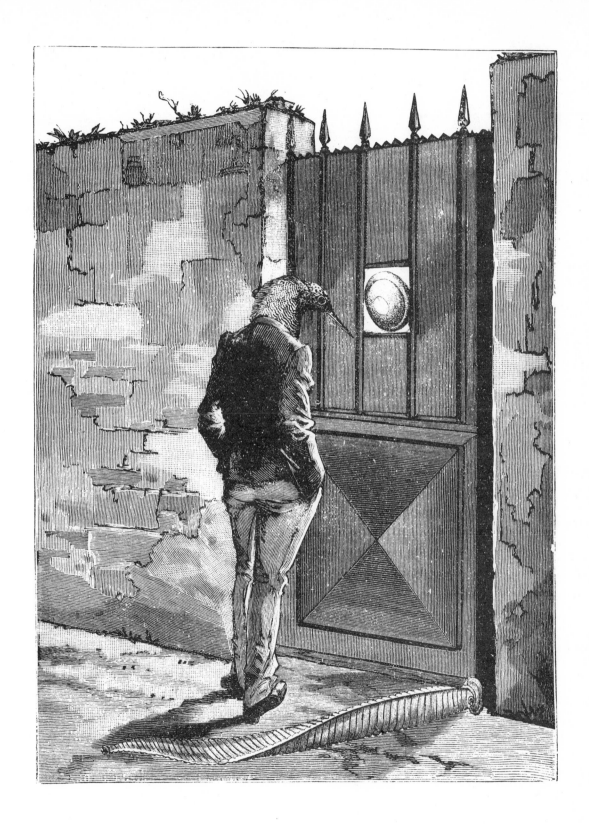

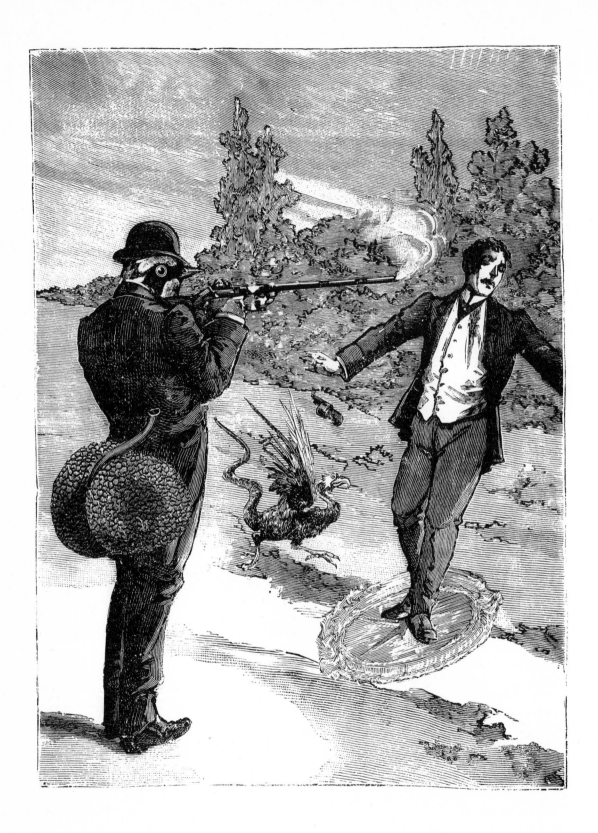

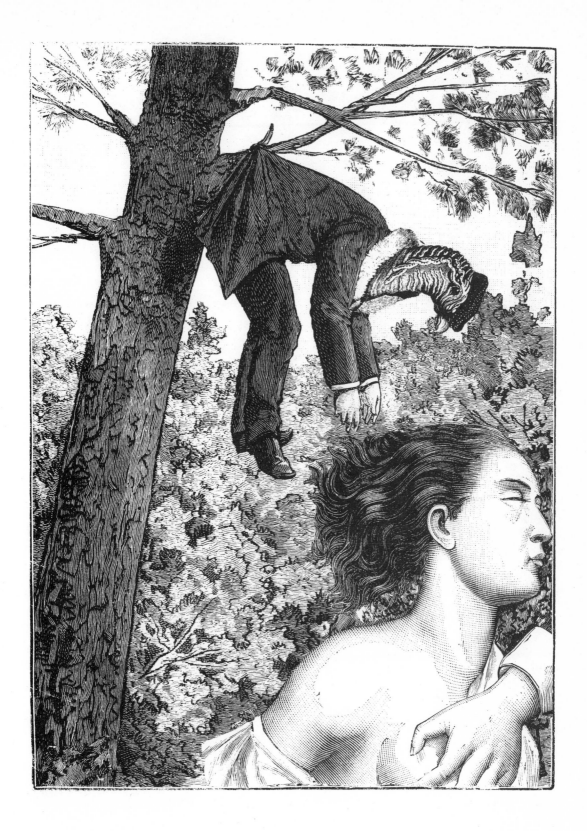

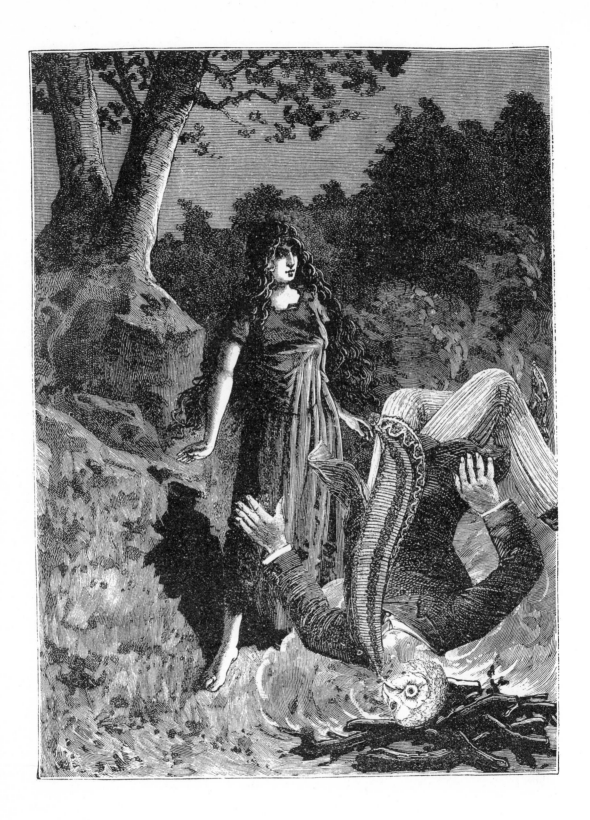

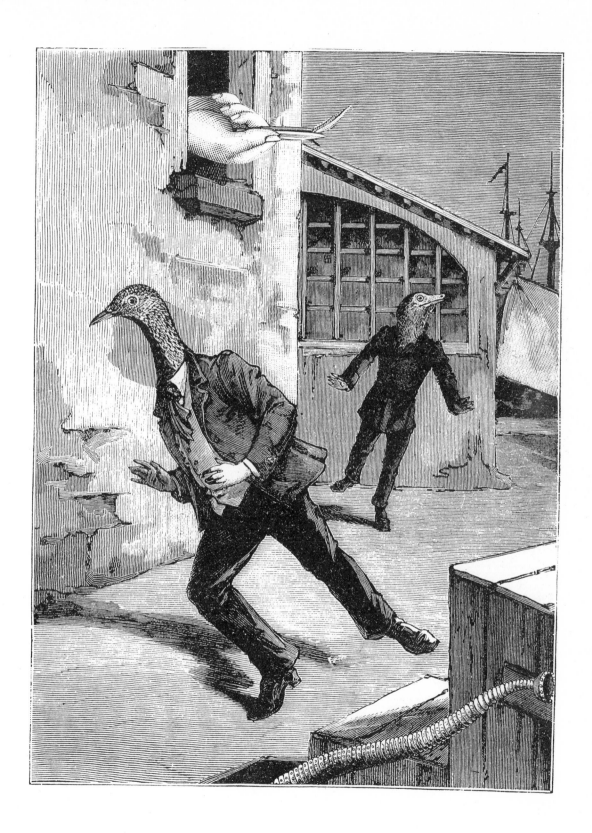

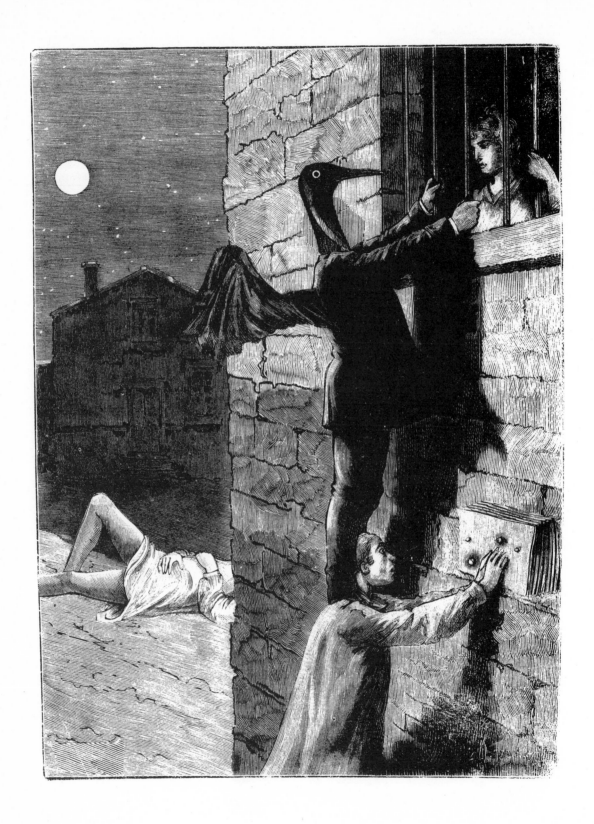

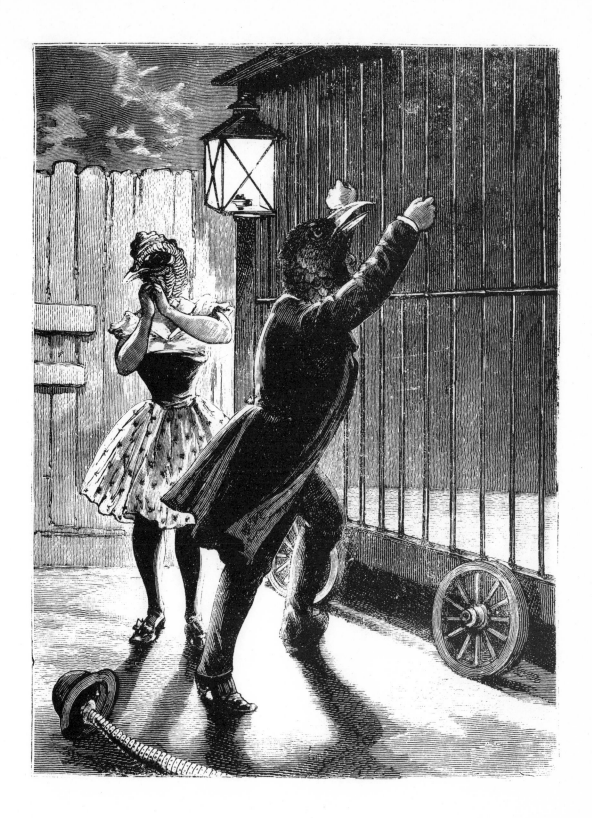

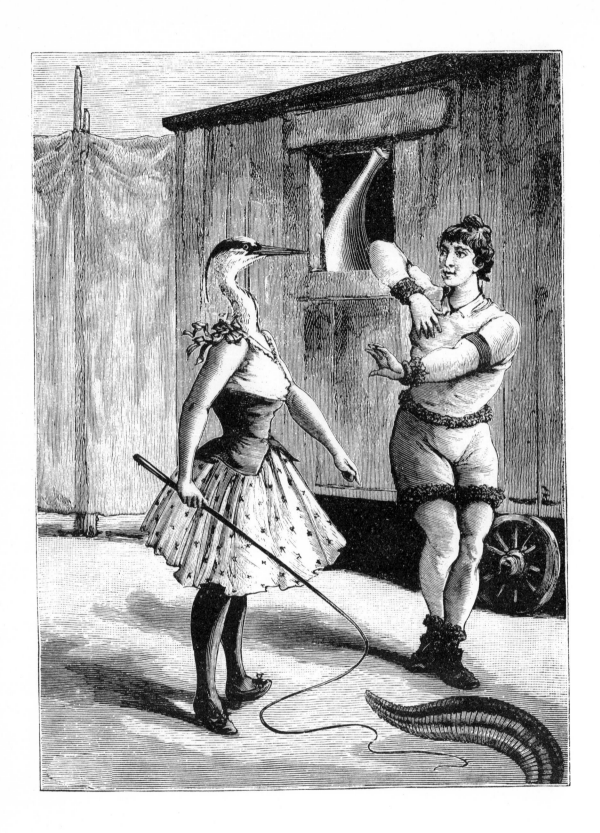

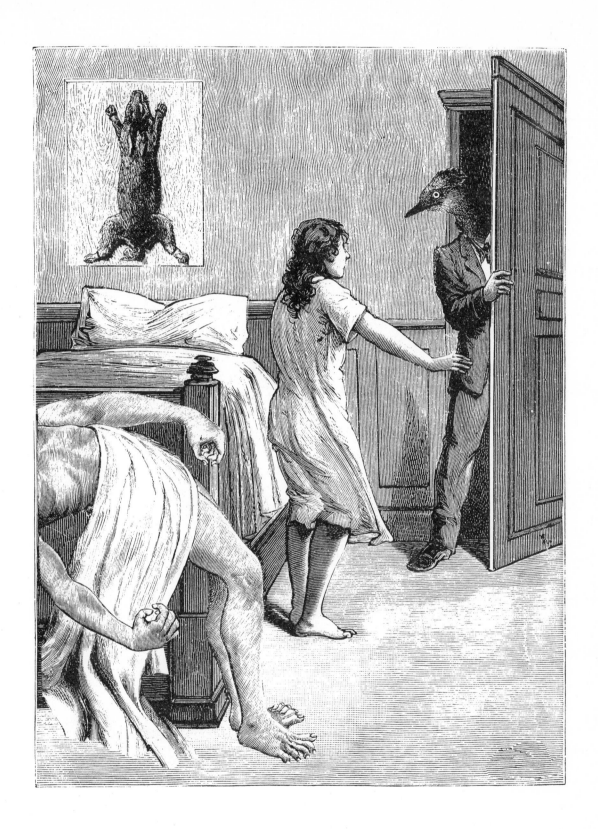

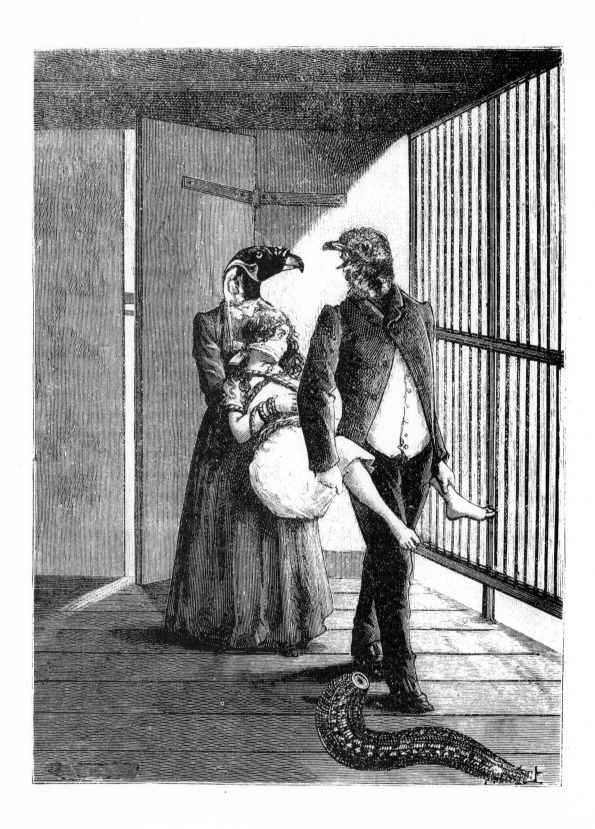

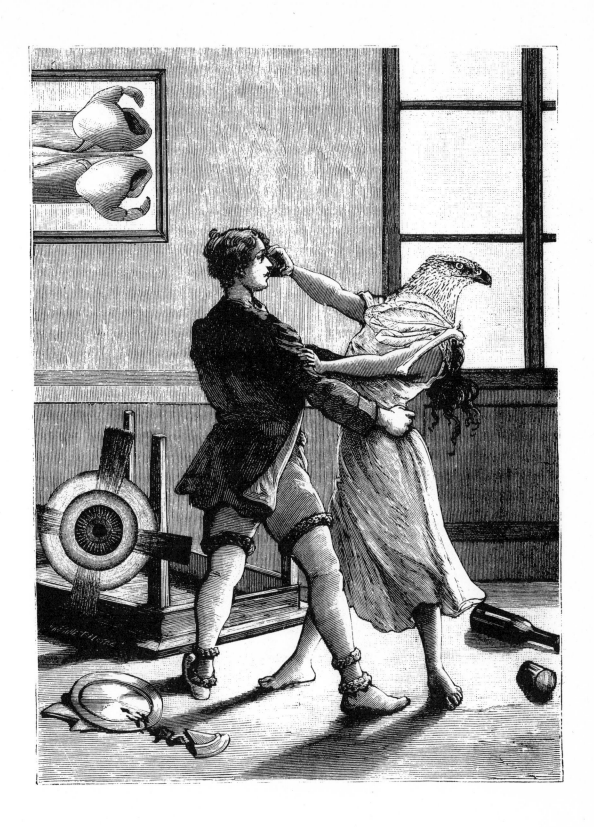

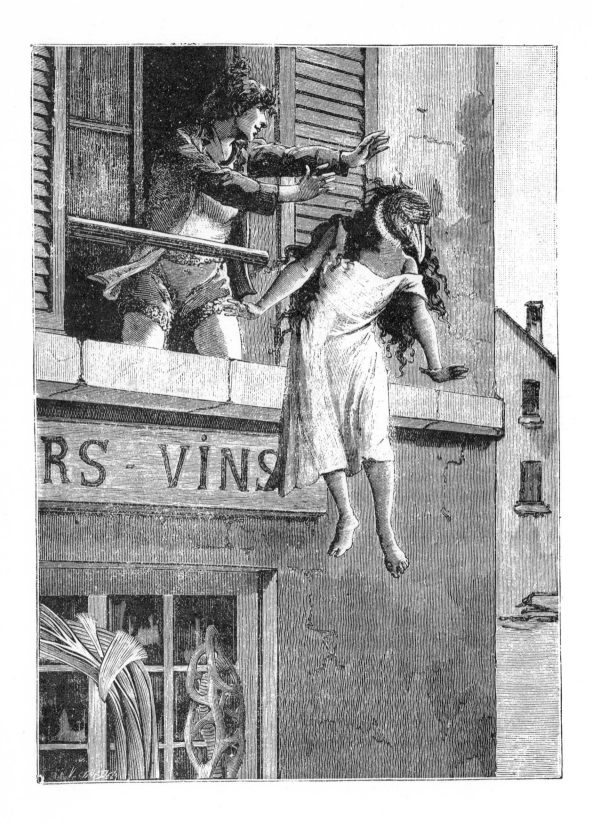

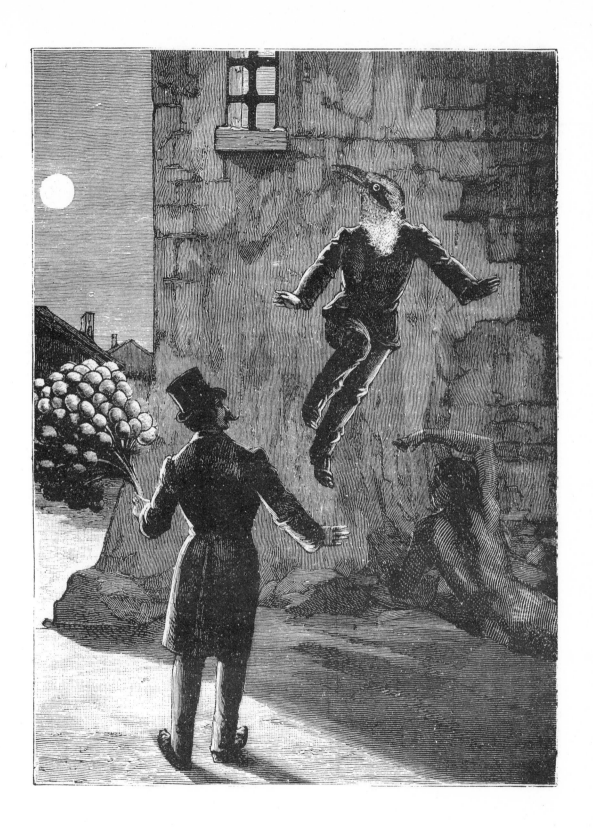

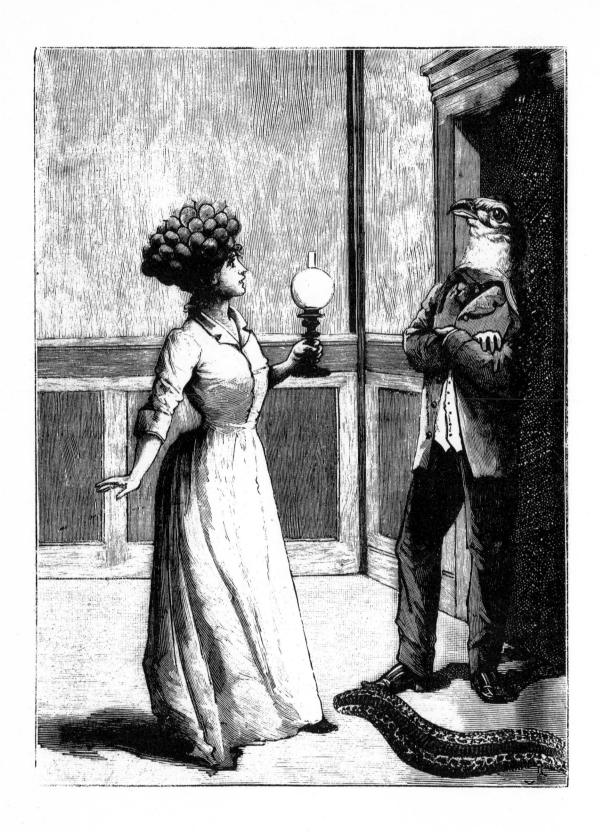

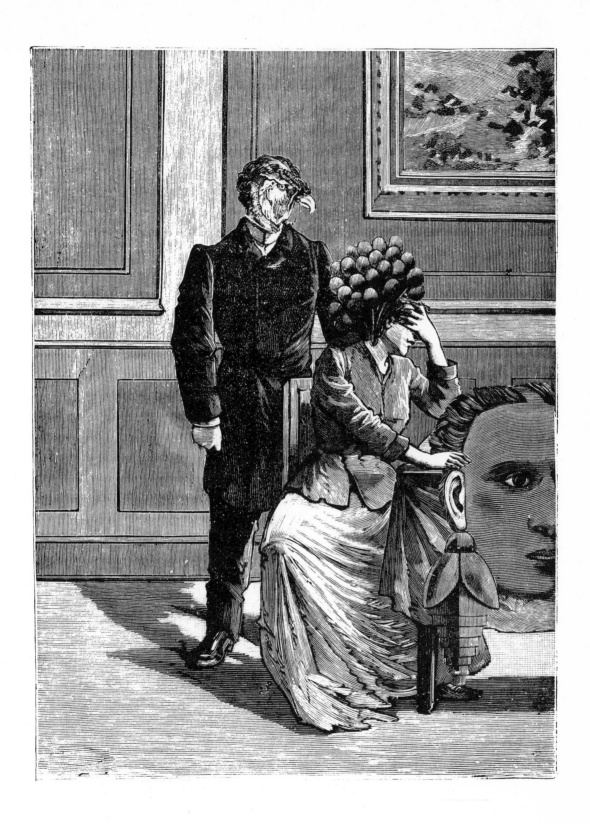

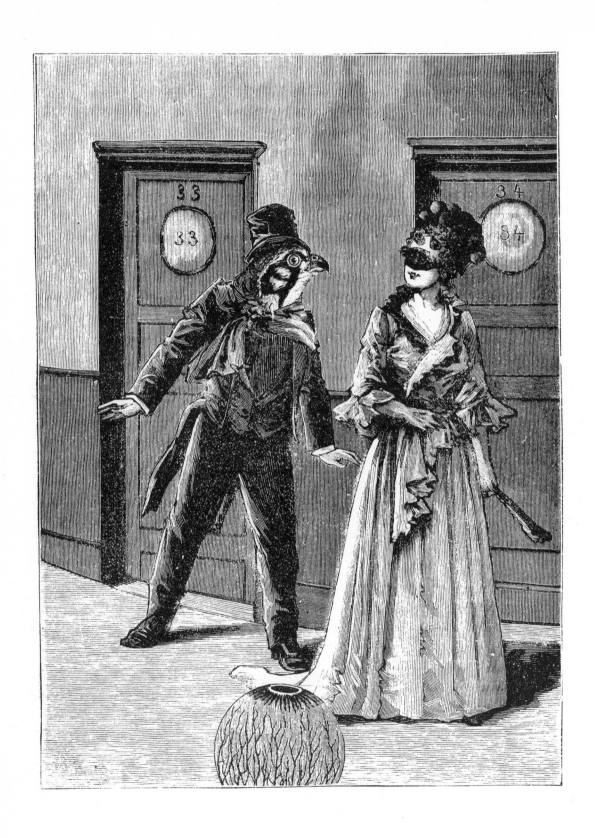

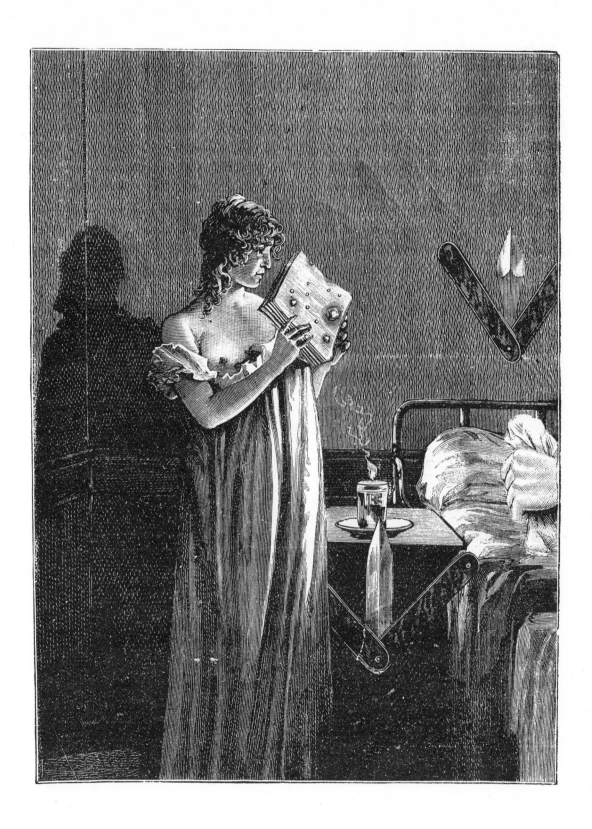

135

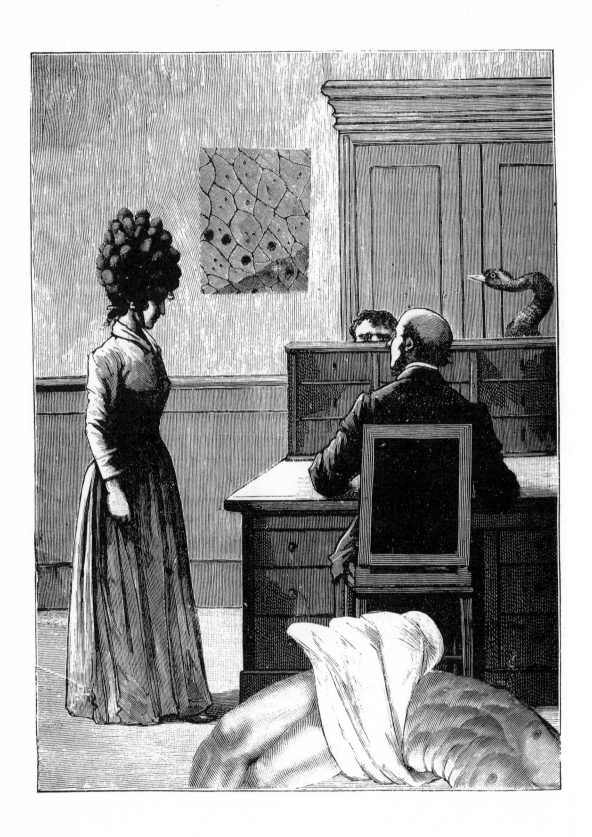

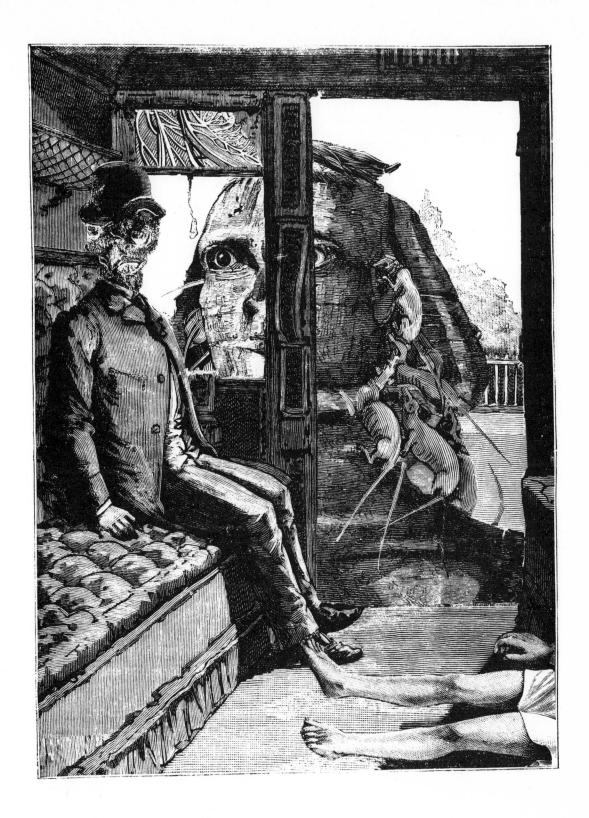

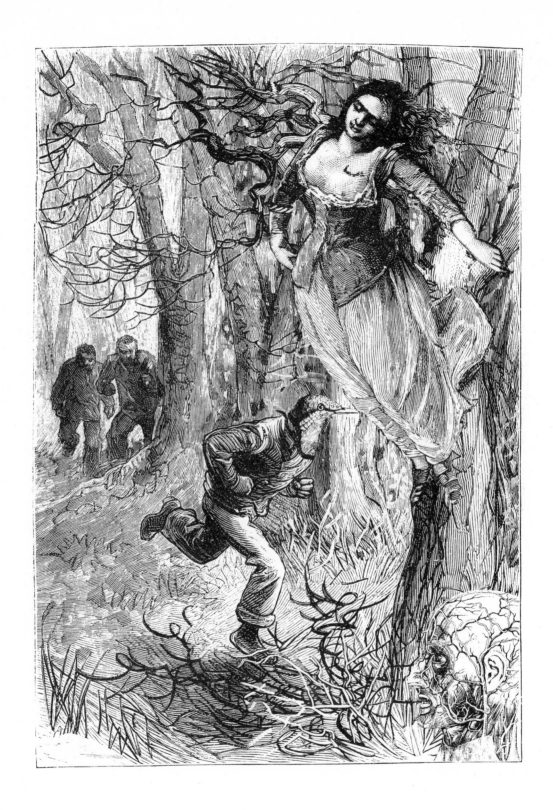

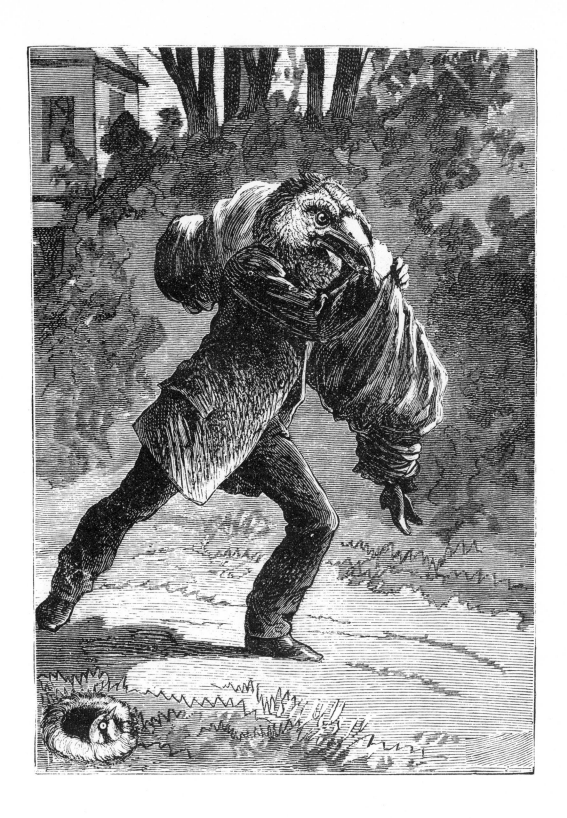

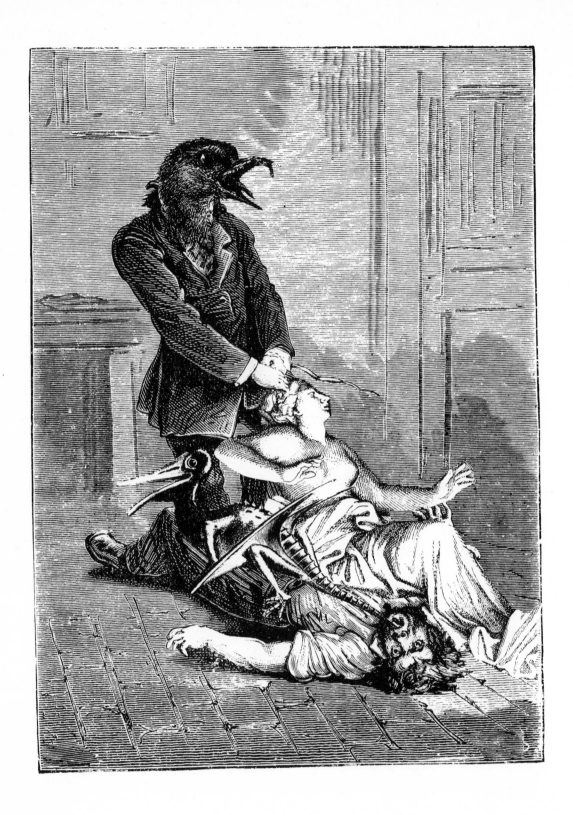

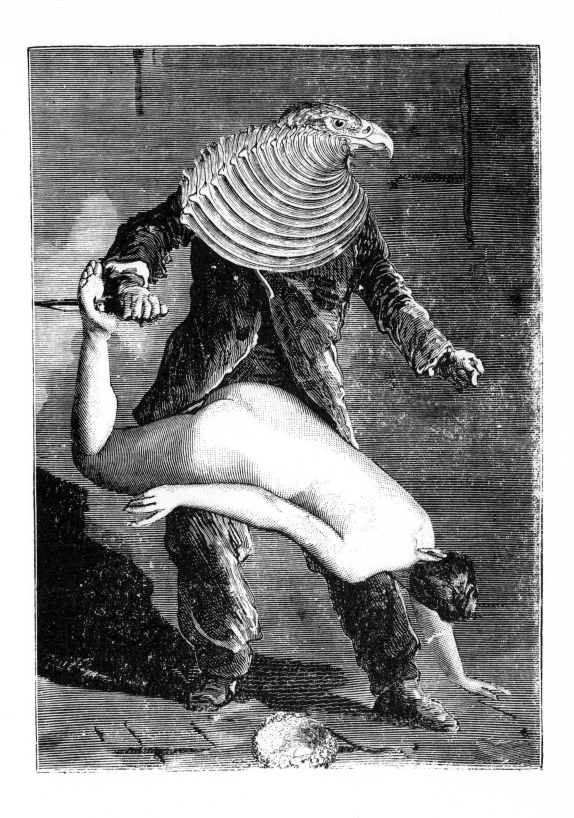

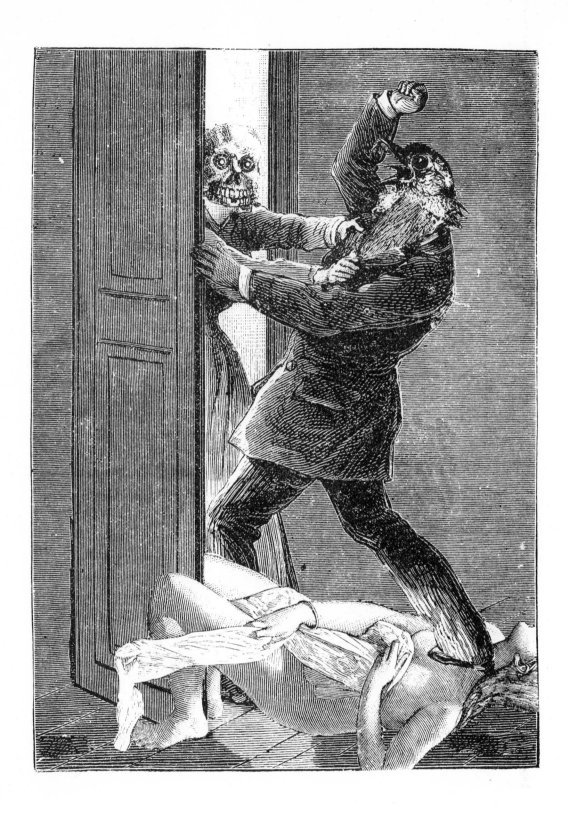

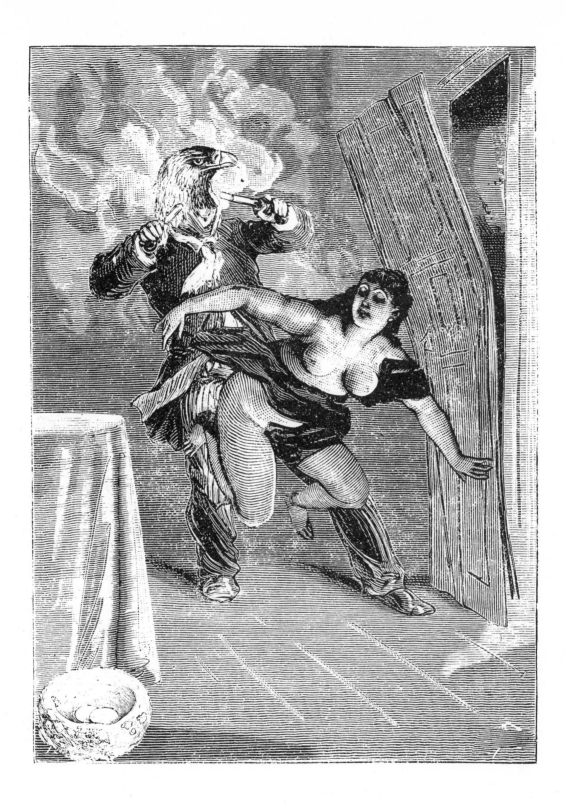

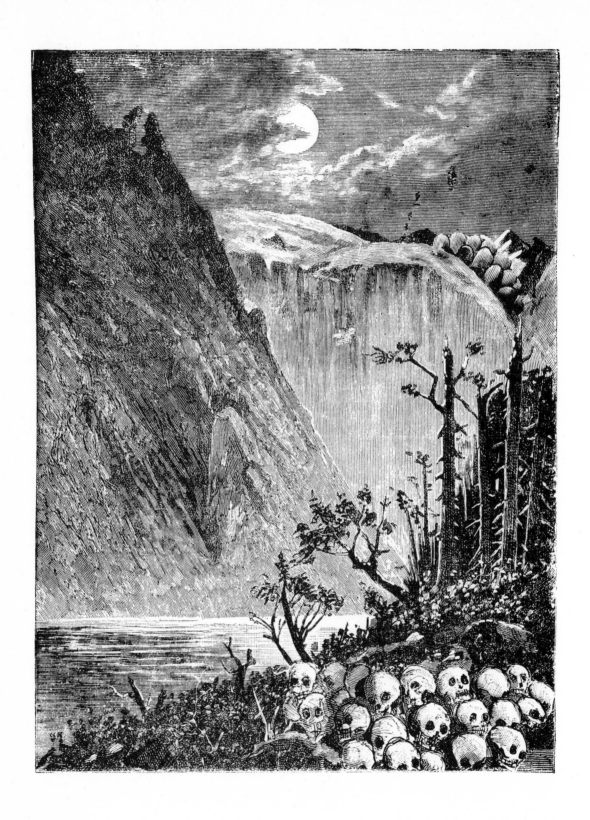

MAX ERNST

UNE SEMAINE DE BONTÉ
OU
LES SEPT ÉLÉMENTS CAPITAUX

ROMAN

DERNIER CAHIER

VENDREDI
ÉLÉMENT :
LA VUE
EXEMPLE :
**L'INTERIEUR
DE LA VUE**

JEUDI
ÉLÉMENT :
LE NOIR
EXEMPLES :
**LE RIRE DU COQ.
L'ILE DE PAQUES**

SAMEDI
L'ÉLÉMENT :
INCONNU
EXEMPLE :
**LA CLE DES
CHANTS**

MAX ERNST

A WEEK OF KINDNESS

OR

THE SEVEN DEADLY ELEMENTS

NOVEL

FIFTH AND LAST BOOK

THURSDAY	FRIDAY	SATURDAY
ELEMENT:	ELEMENT:	ELEMENT:
BLACKNESS	SIGHT	UNKNOWN
EXAMPLES:	EXAMPLE:	EXAMPLE:
THE ROOSTER'S LAUGHTER	THE INTERIOR OF SIGHT	THE KEY TO SONGS
EASTER ISLAND		

JEUDI

ÉLÉMENT :

LE NOIR

PREMIER
EXEMPLE :

LE RIRE DU COQ

« Ceux d'entre eux qui sont gais tournent parfois leur derrière vers le ciel et jettent leurs excréments à la figure des autres hommes ; puis ils se frappent légèrement le ventre. »

Marcel SCHWOB (*L'Anarchie*)

« Le rire est probablement destiné à disparaître. »

Marcel SCHWOB (*Le rire*)

THURSDAY

ELEMENT:

BLACKNESS

FIRST EXAMPLE:

THE ROOSTER'S LAUGHTER

"Those among them who are merry sometimes turn their behinds toward the sky and cast their excrement in the face of other men; then they strike their own bellies lightly." (Marcel Schwob, *L'Anarchie*)

"Laughter is probably doomed to disappear."
 (Marcel Schwob, *Le rire*)

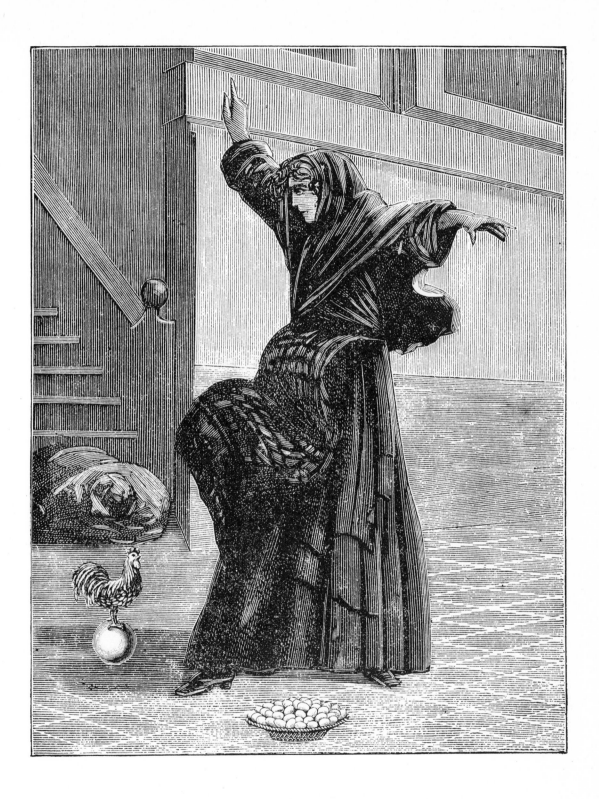

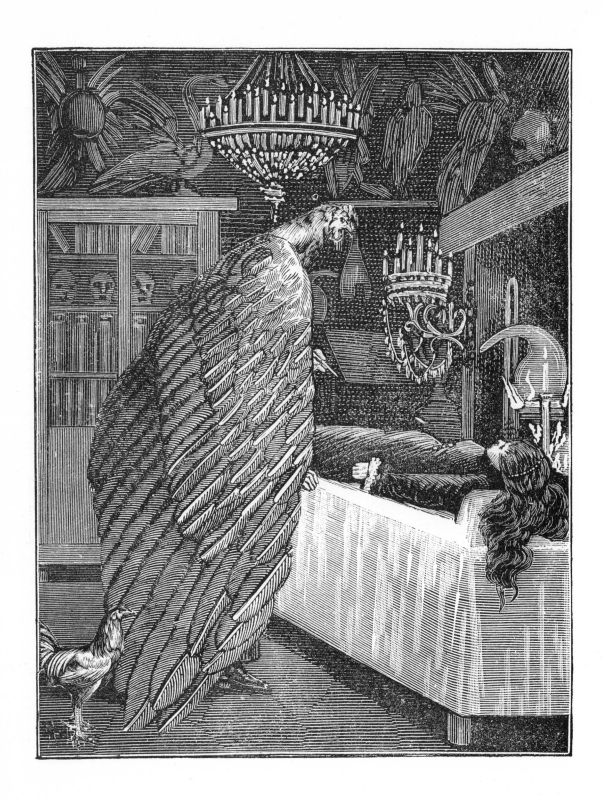

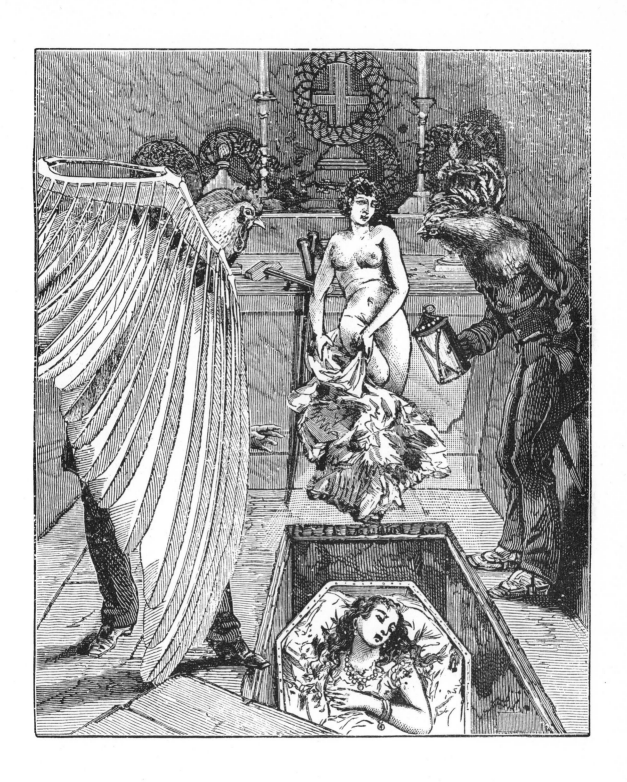

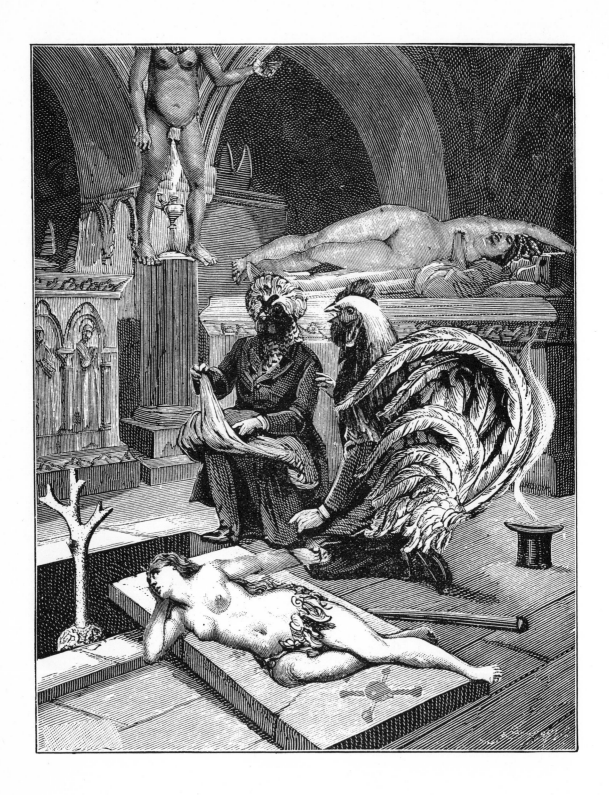

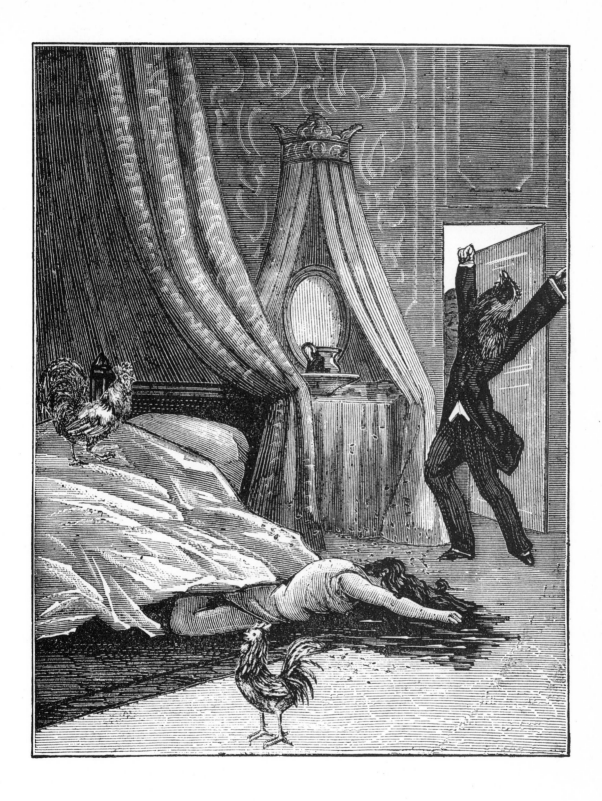

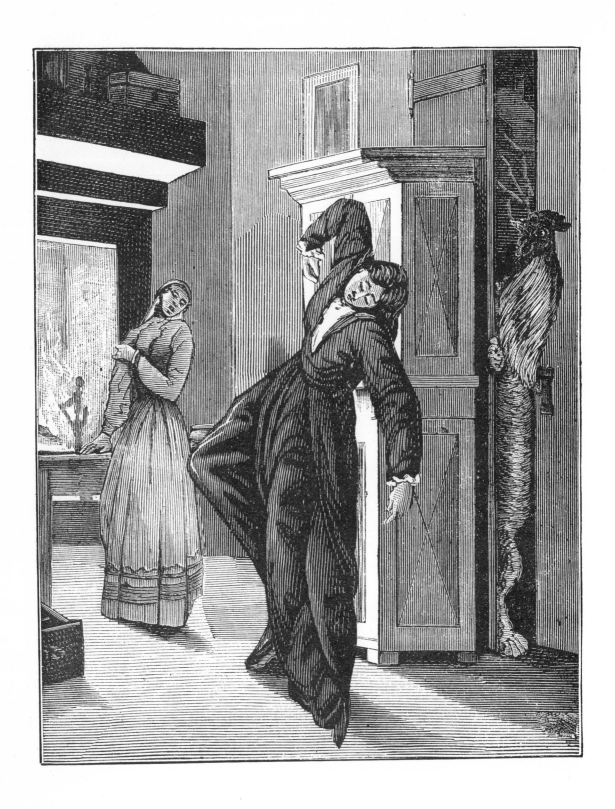

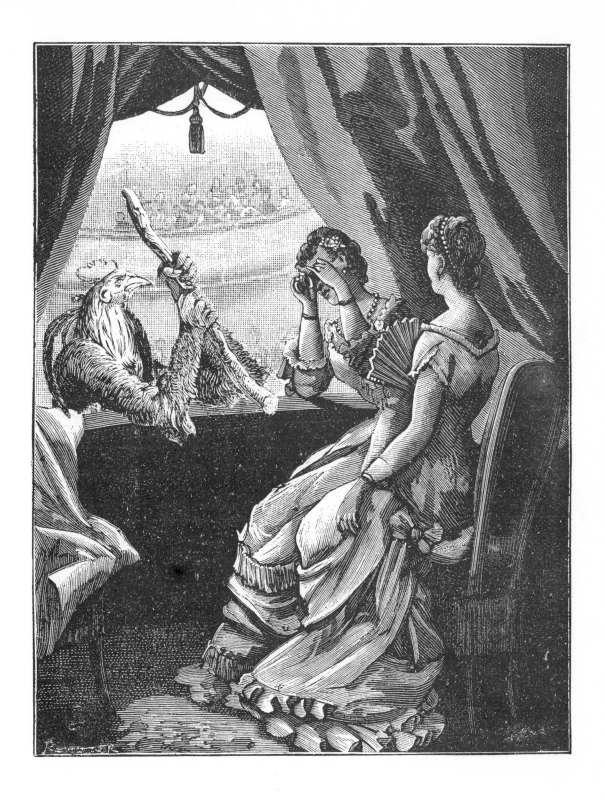

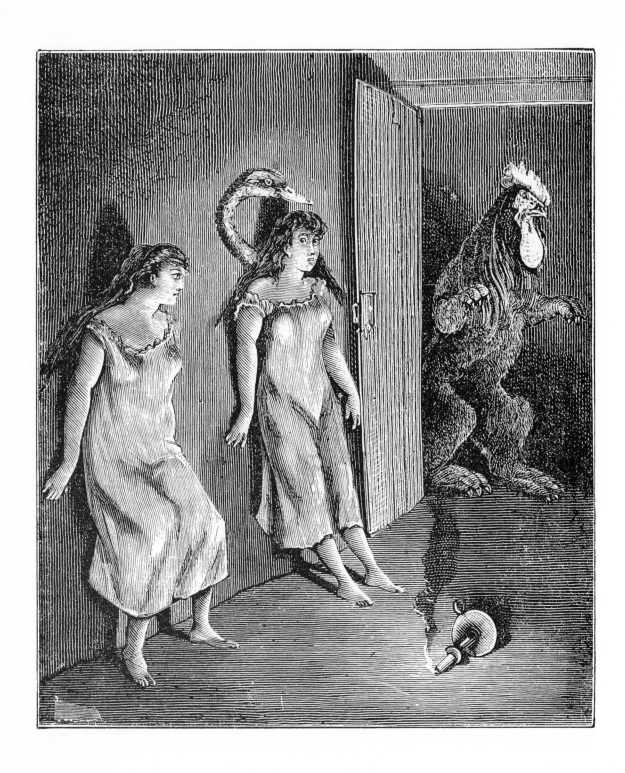

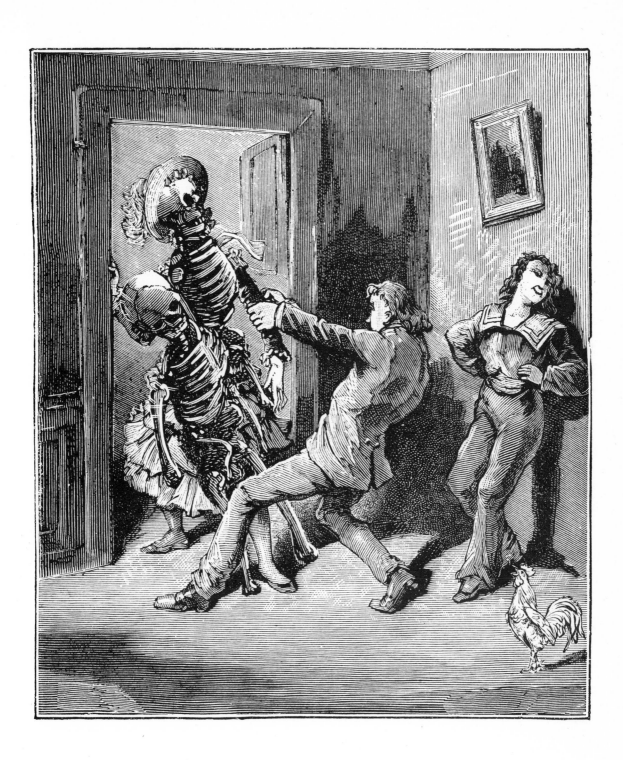

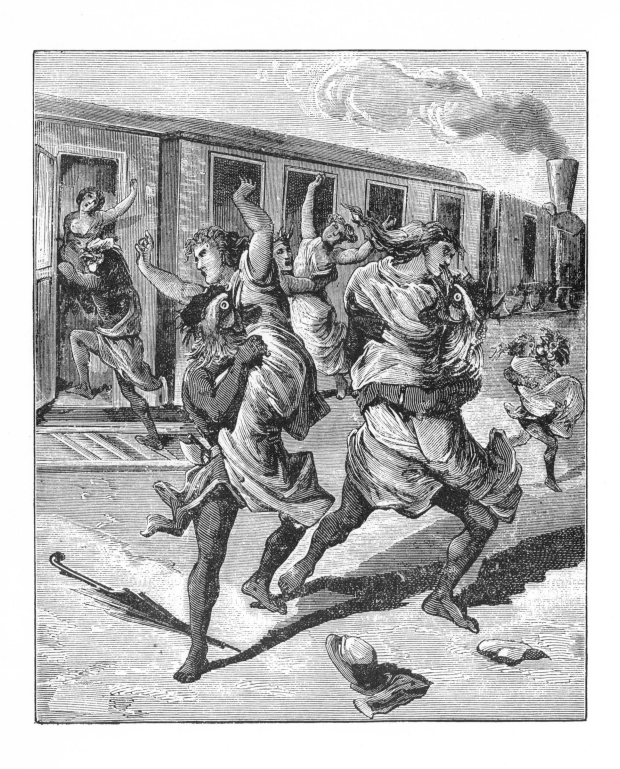

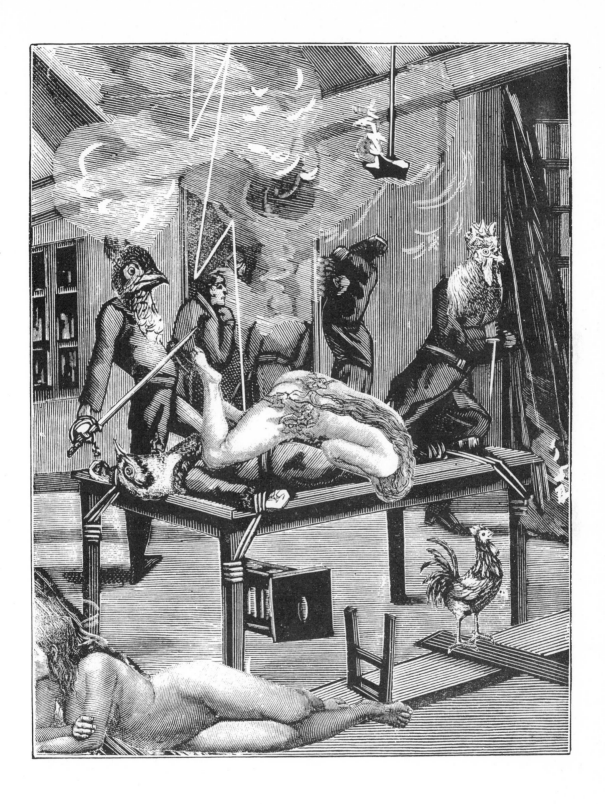

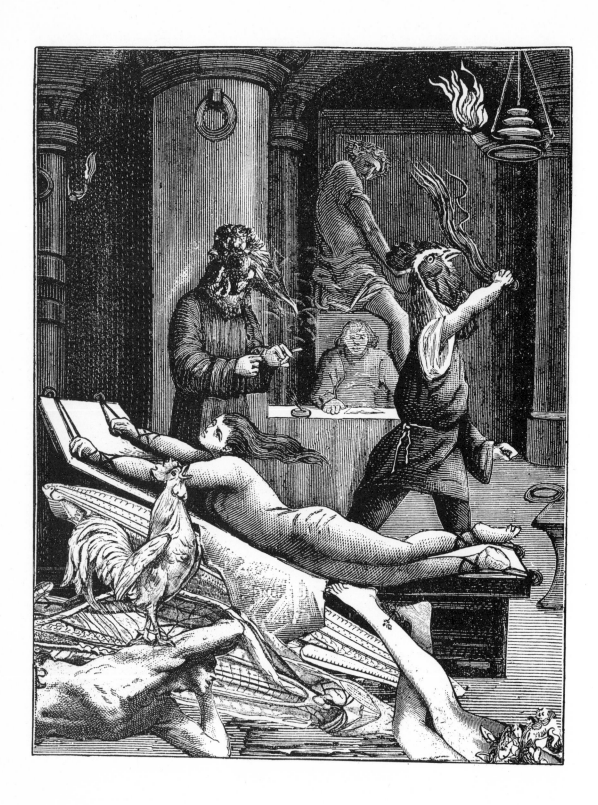

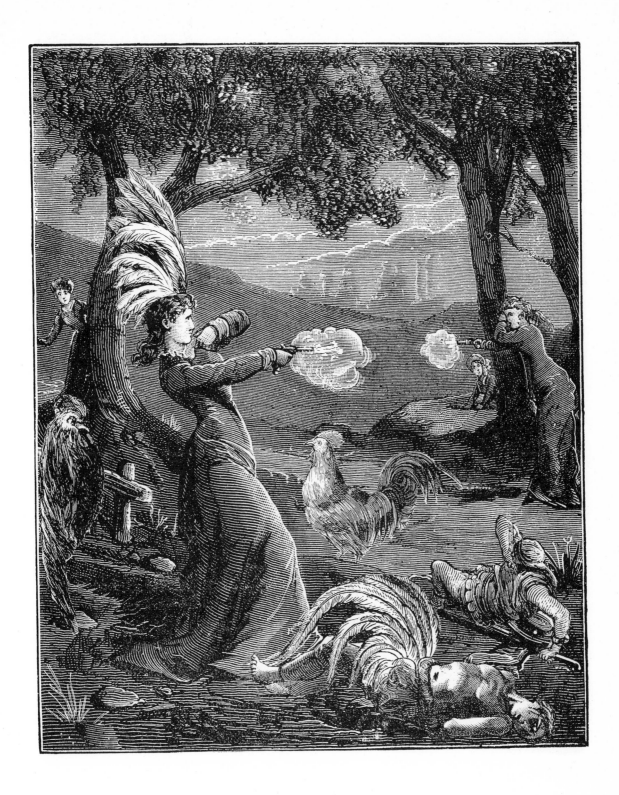

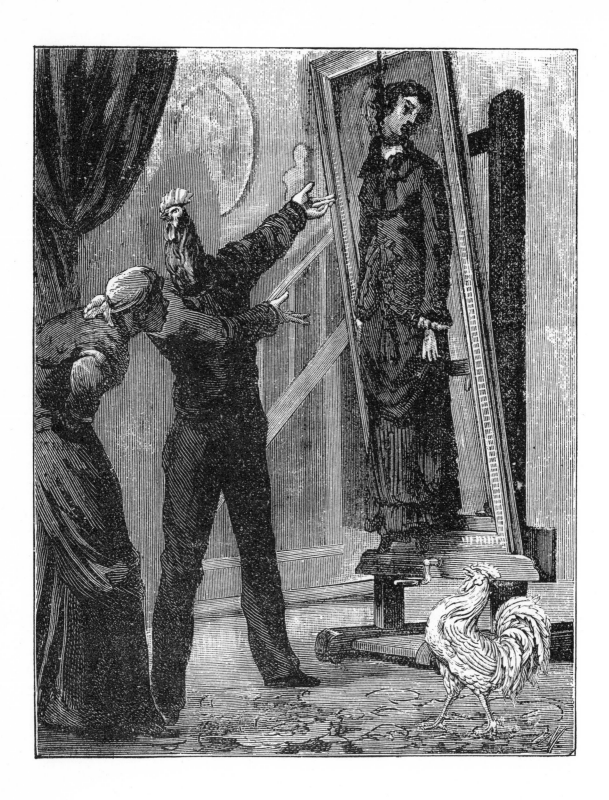

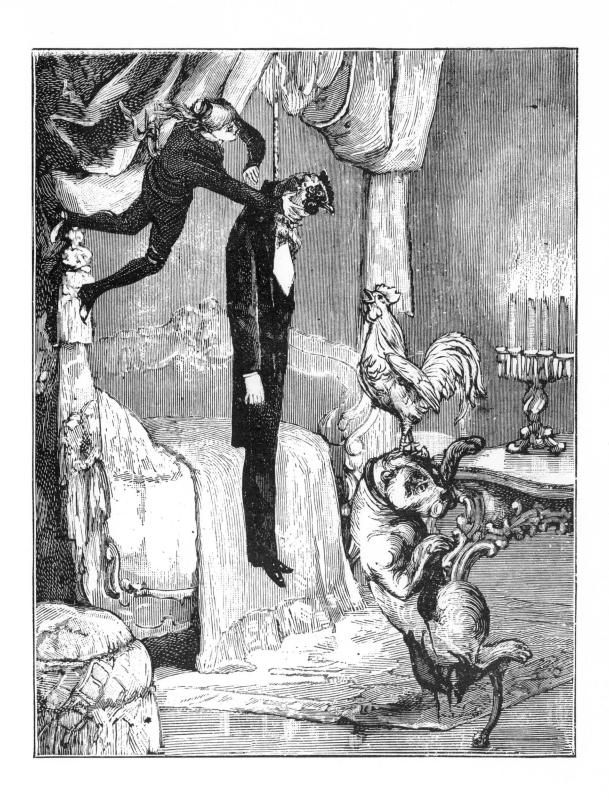

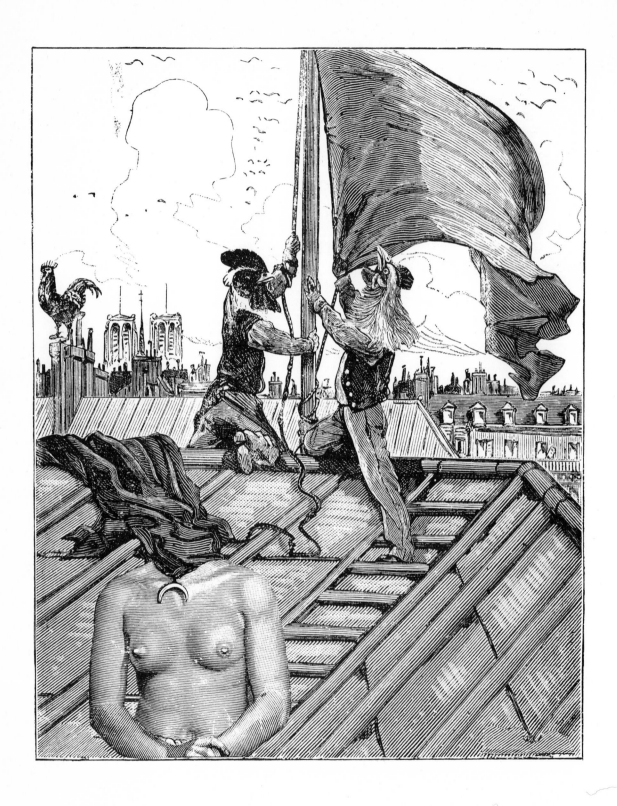

JEUDI
LE NOIR
AUTRE
EXEMPLE :

L'ILE DE PAQUES

« Les pierres sont remplies d'entrailles.
Bravo. Bravo. »

Arp

THURSDAY

ELEMENT:

BLACKNESS

SECOND EXAMPLE:

EASTER ISLAND

"The stones are full of entrails. Bravo. Bravo."

(Arp)

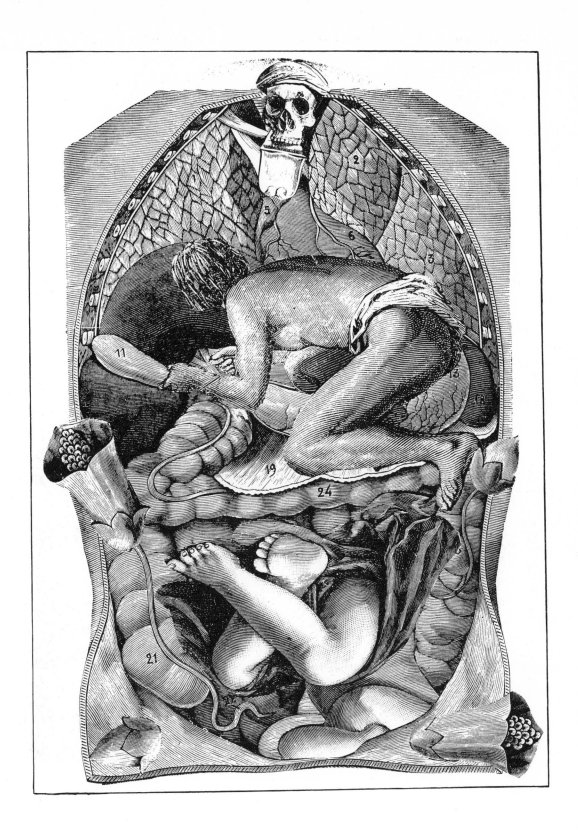

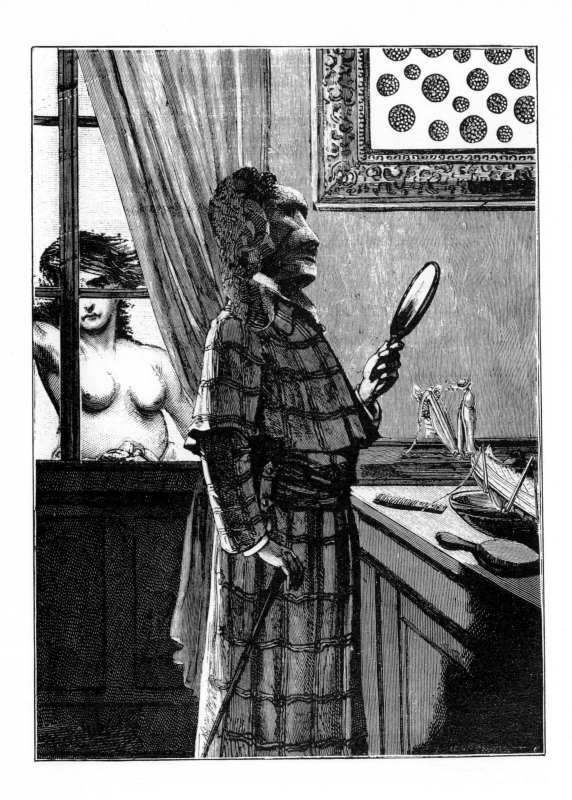

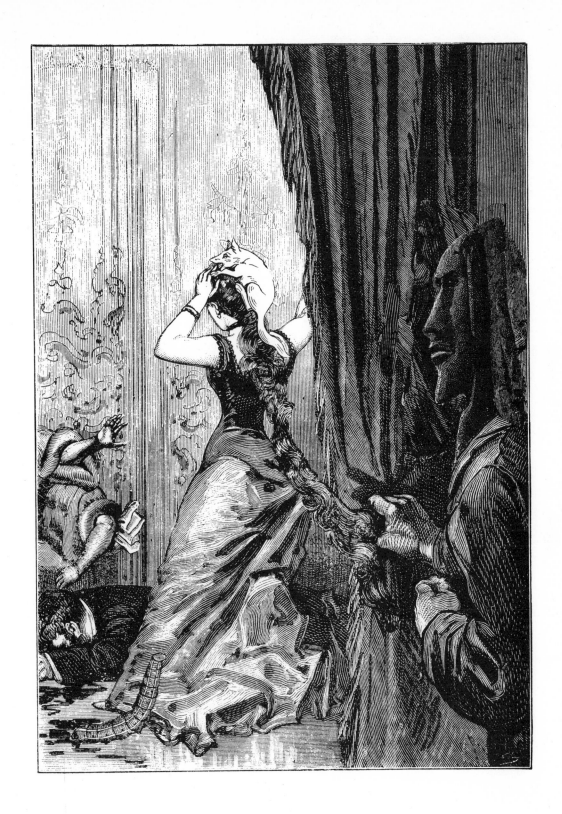

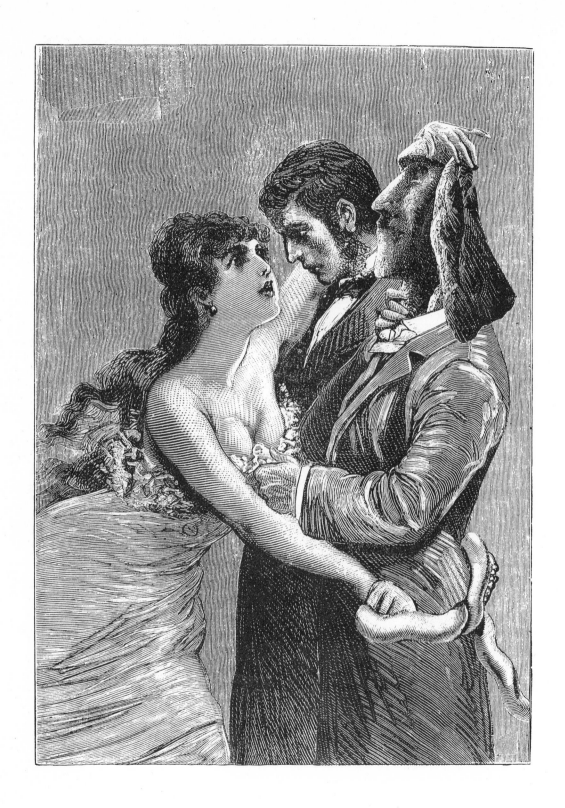

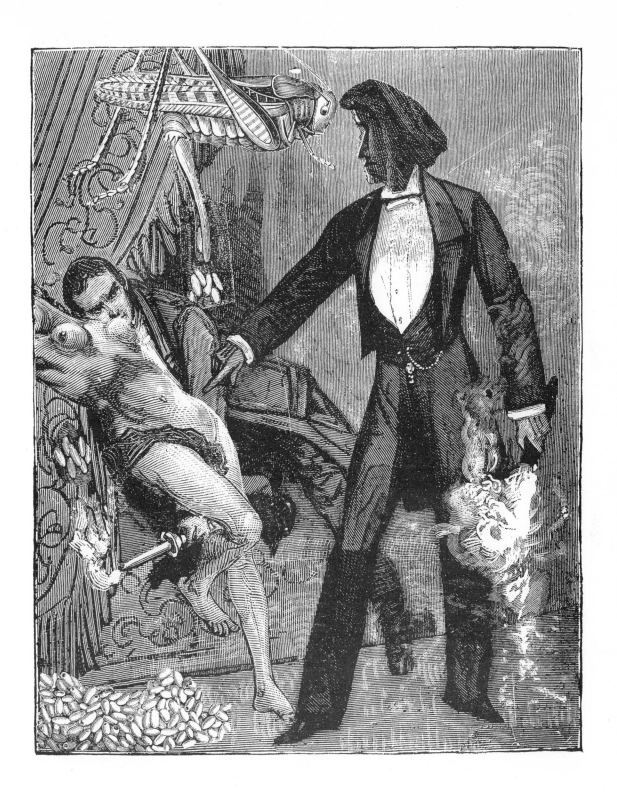

171

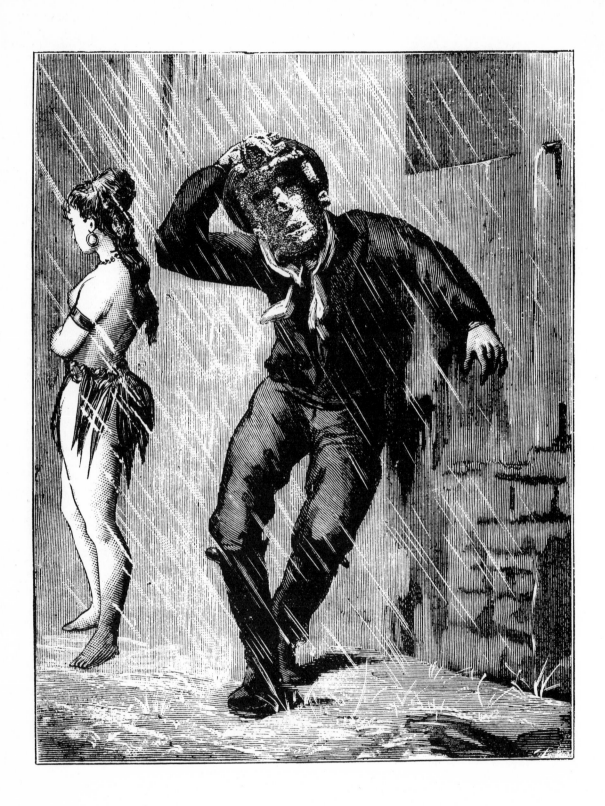

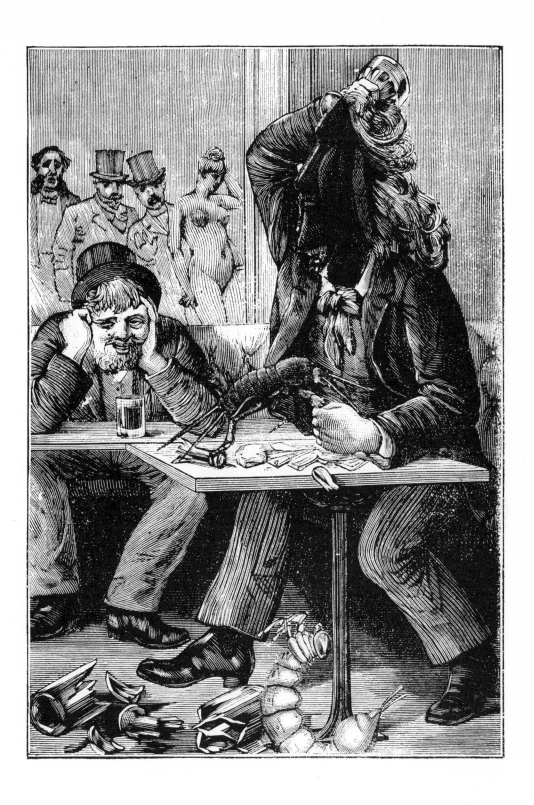

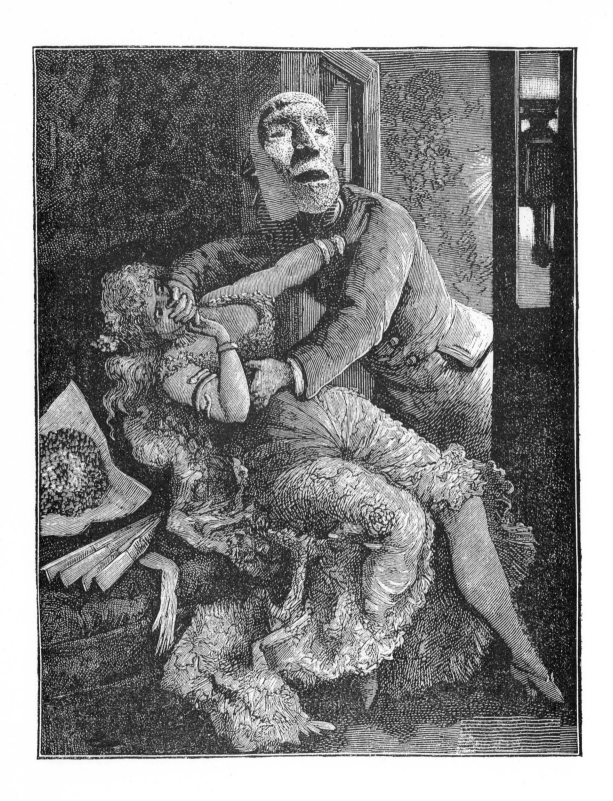

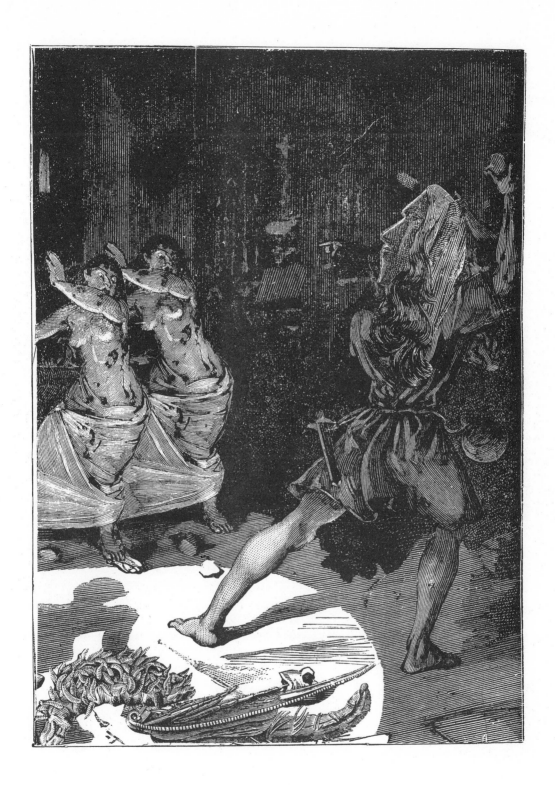

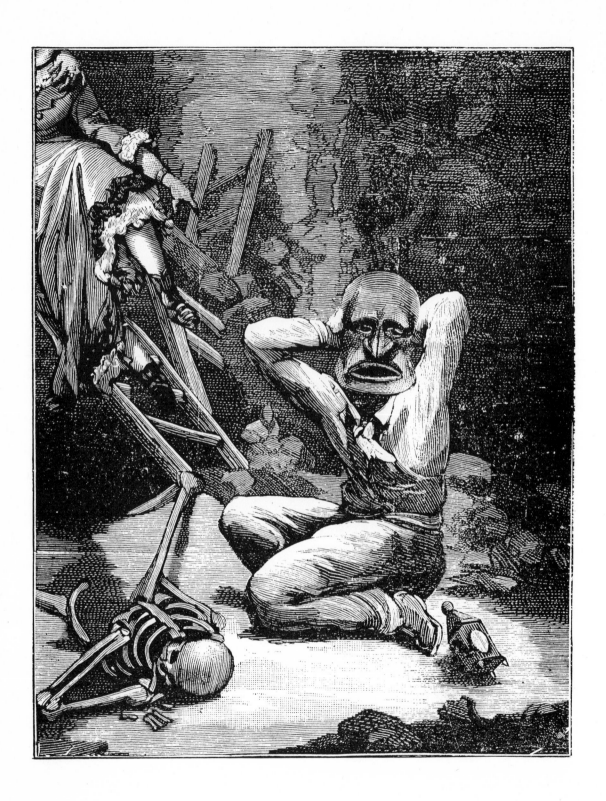

VENDREDI

ÉLÉMENT :

LA VUE

EXEMPLE :

L'INTÉRIEUR DE LA VUE

TROIS POÉMES VISIBLES

> « Si trois est plus grand que 6, faites un
> cercle autour de la croix, et si l'eau éteint
> le feu, tracez une ligne du sceau à la bougie,
> en passant au-dessus du couteau, puis faites
> une croix sur l'échelle. »
>
> Prof. O. DECROLY et R. BUYSE
> (*Les tests mentaux*)

FRIDAY

ELEMENT:

SIGHT

EXAMPLE:

THE INTERIOR OF SIGHT

THREE VISIBLE POEMS

"If 3 is greater than 6, describe a circle around the cross, and if the water extinguishes the fire, draw a line from the bucket to the candle, passing above the knife, then draw a cross on the ladder."

(Prof. O. Decroly and R. Buyse, *Les tests mentaux*)

PREMIER POÈME VISIBLE

« Et j'oppose à l'amour
Des images toutes faites
Au lieu d'images à faire. »

Paul ELUARD (*Comme deux gouttes d'eau*)

FIRST VISIBLE POEM

"And I object to the love of ready-made images in place of images to be made." (Paul Eluard,
Comme deux gouttes d'eau)

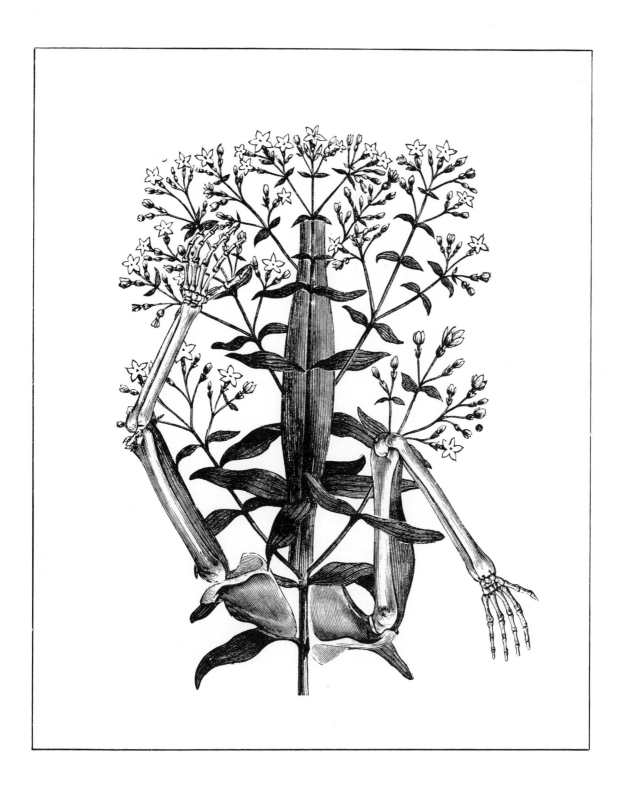

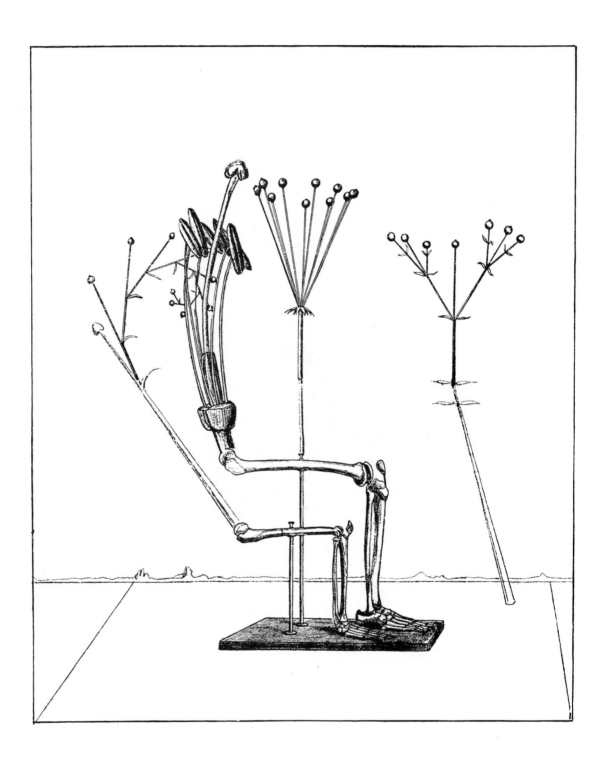

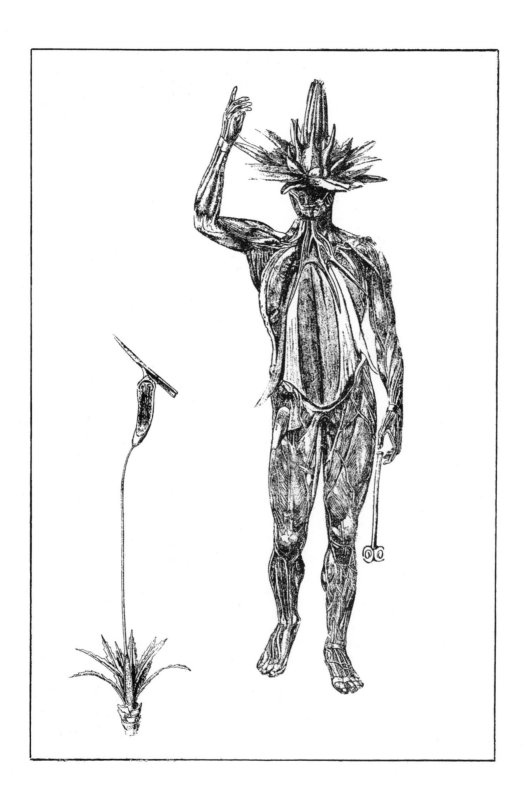

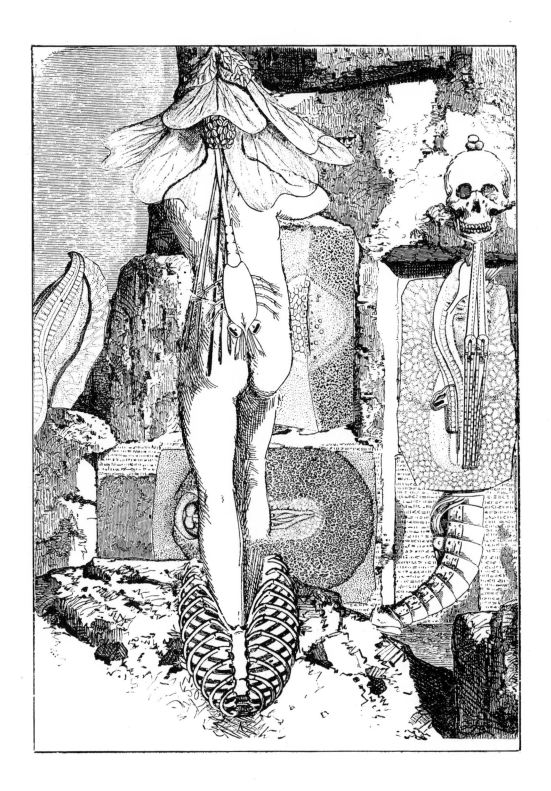

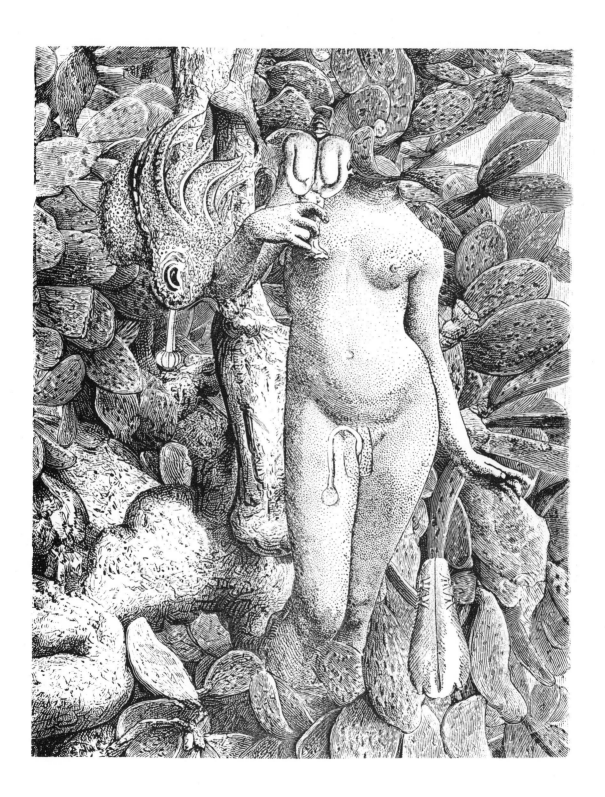

DEUXIÈME POÈME VISIBLE

« Un homme et une femme absolument
blancs. »

André BRETON (*Le revolver aux cheveux blancs*)

SECOND VISIBLE POEM

"A man and a woman absolutely
white. (André Breton,
 Le revolver aux cheveux blancs)

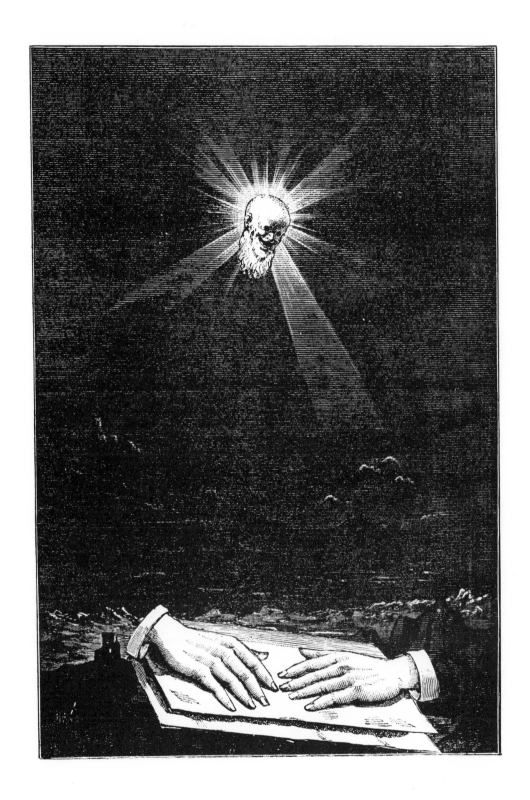

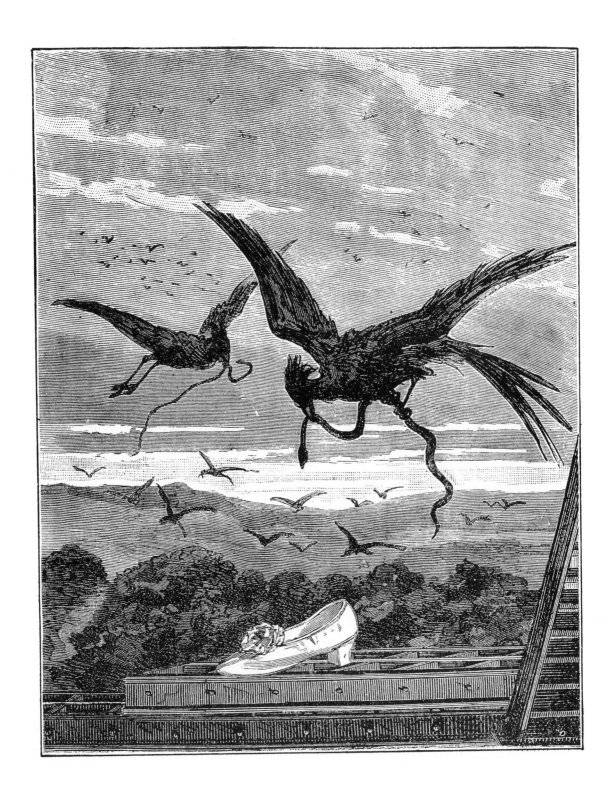

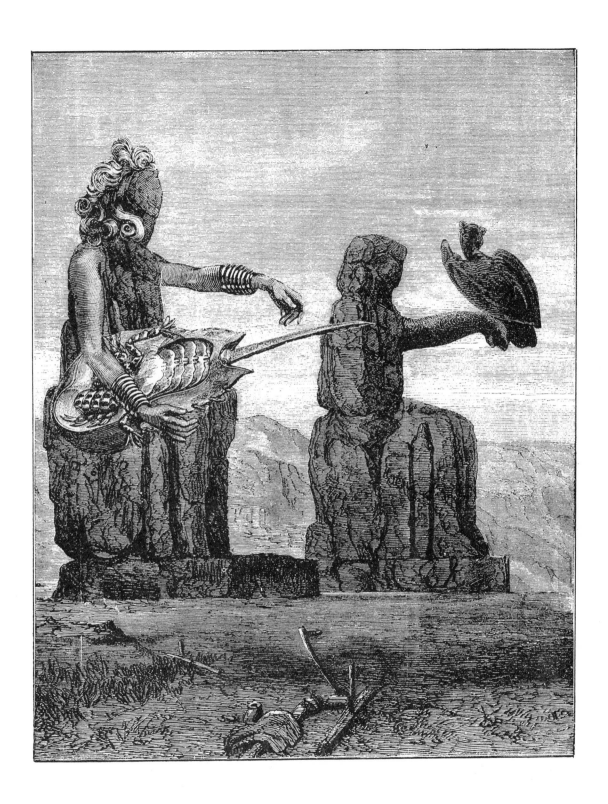

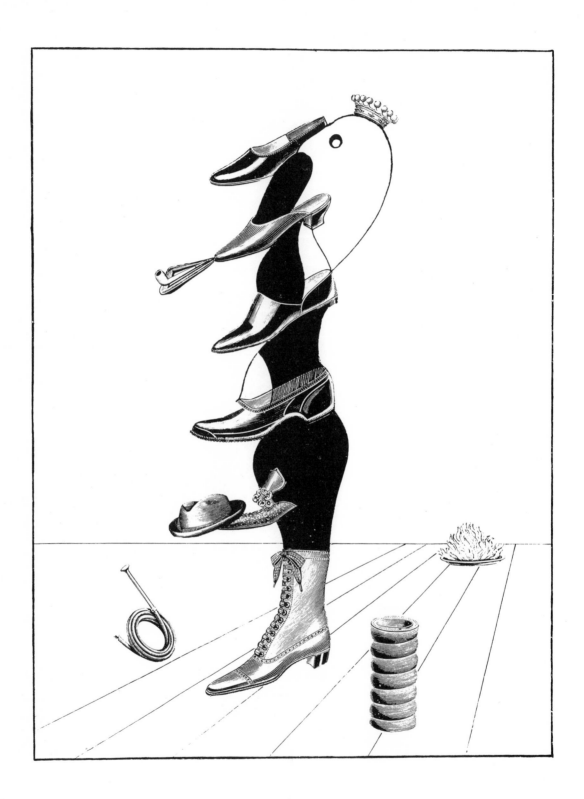

TROISIÈME POÈME VISIBLE

THIRD VISIBLE POEM

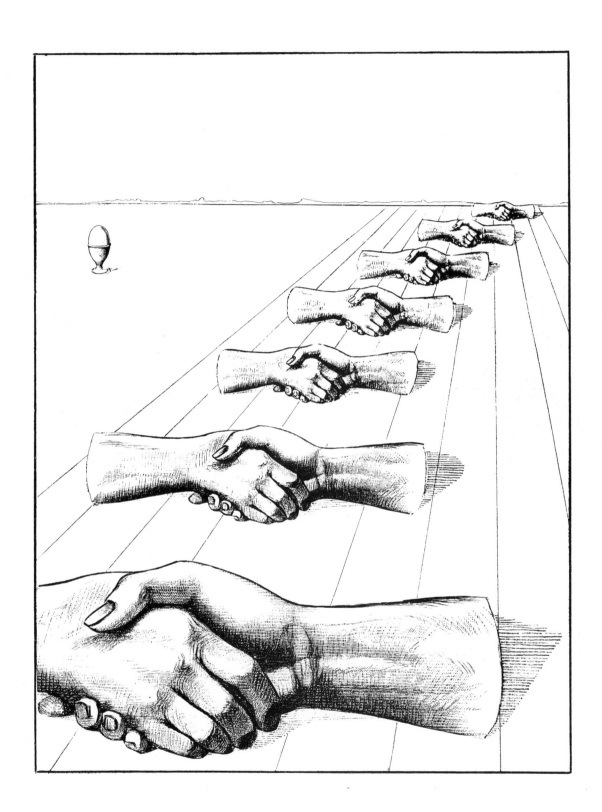

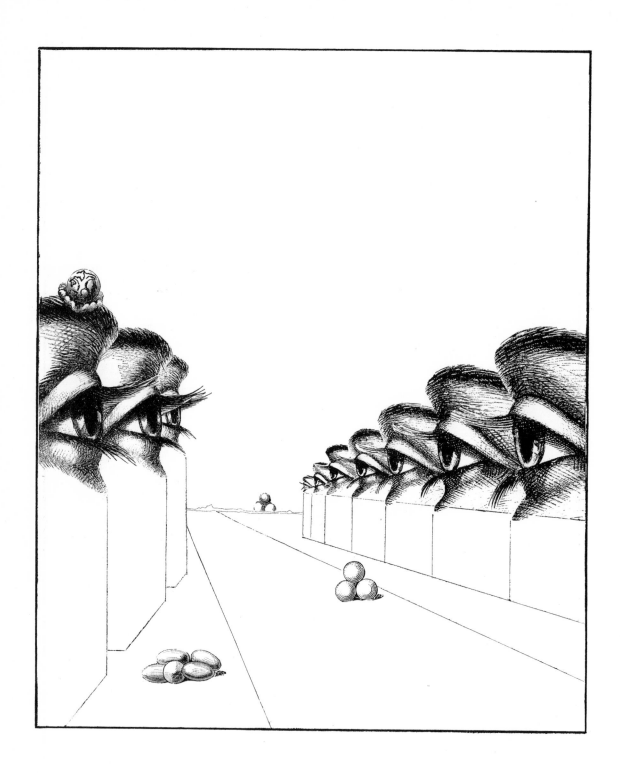

SAMEDI
L'ÉLÉMENT :
INCONNU
EXEMPLE :
LA CLE DES CHANTS

«
.
.
. »

Pétrus BOREL
(*Was-ist-das*)

SATURDAY
ELEMENT:
UNKNOWN
EXAMPLE:
THE KEY TO SONGS

"

.

.

. ”

(Petrus Borel, *Was-ist-das*)

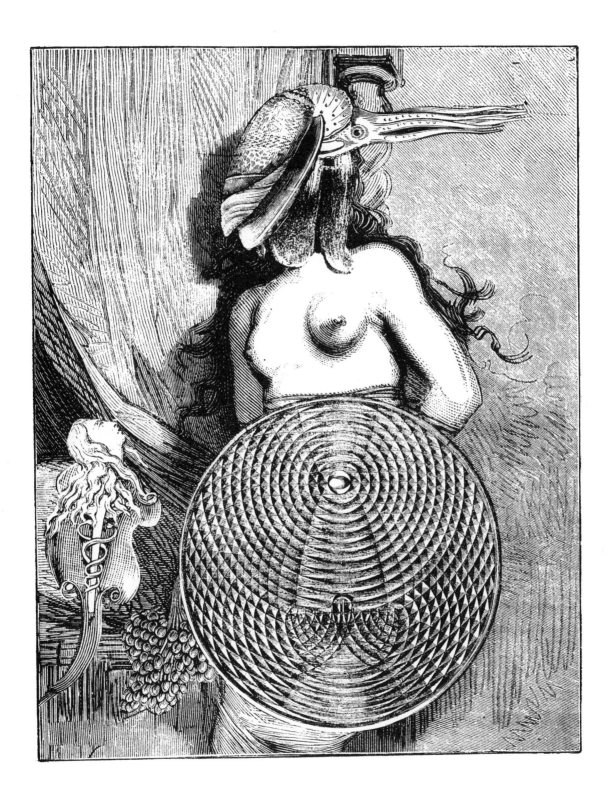

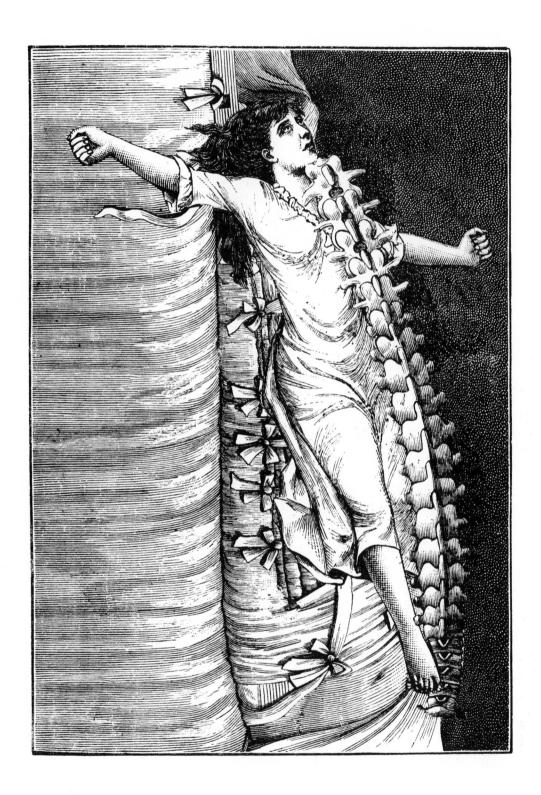

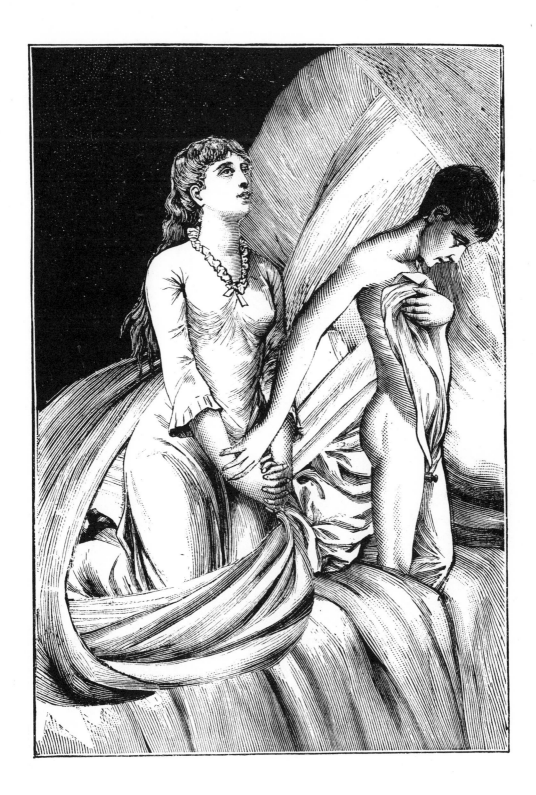

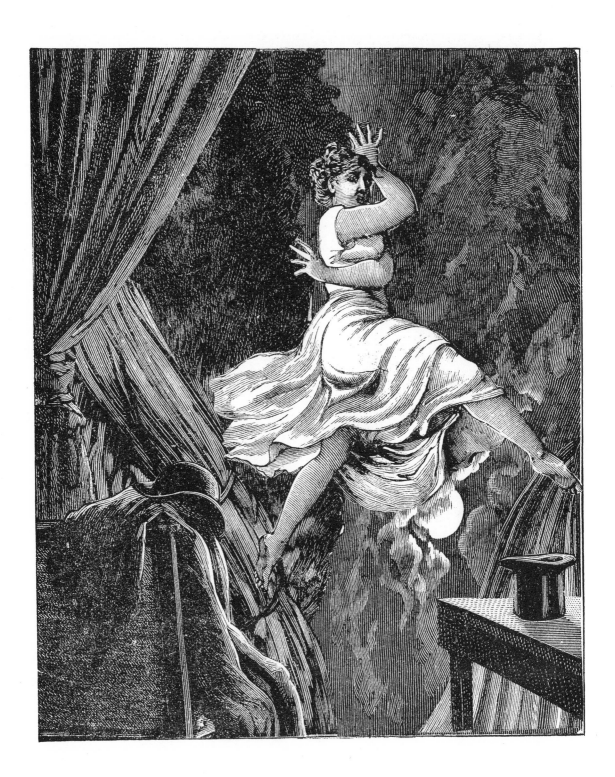

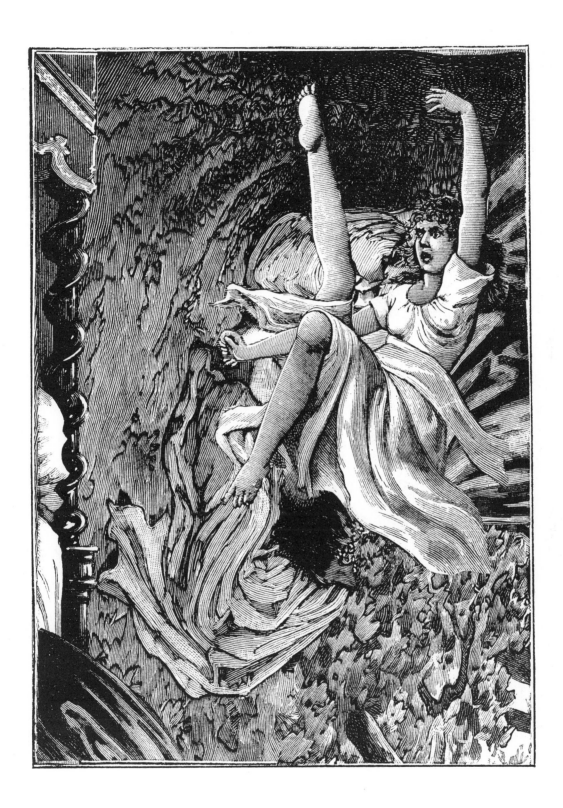

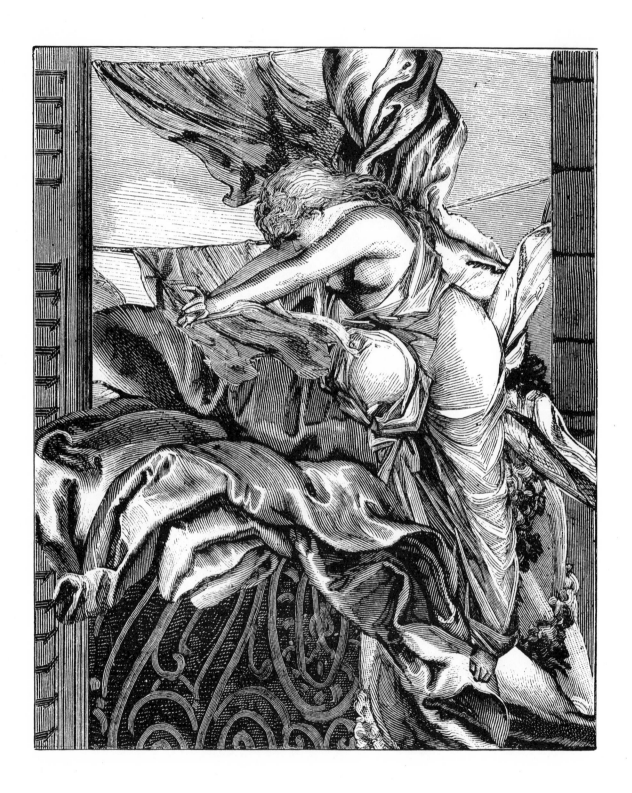

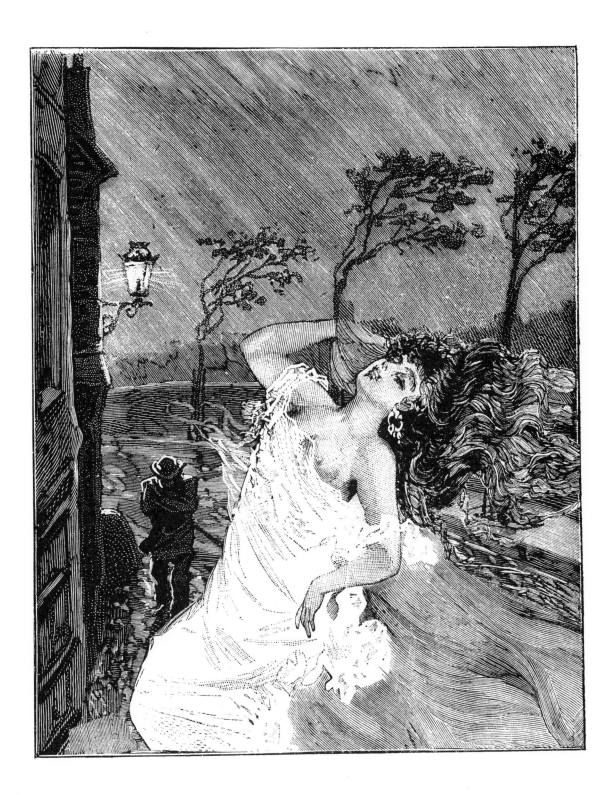

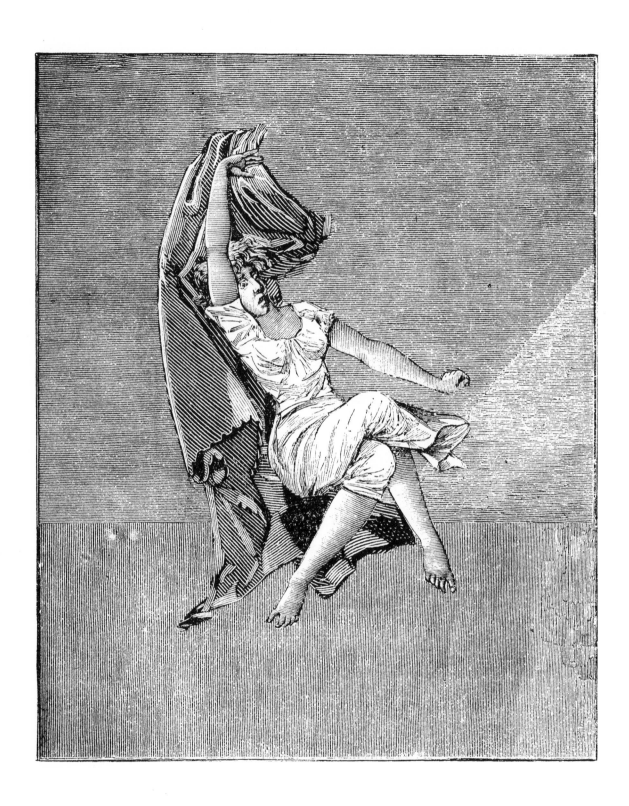

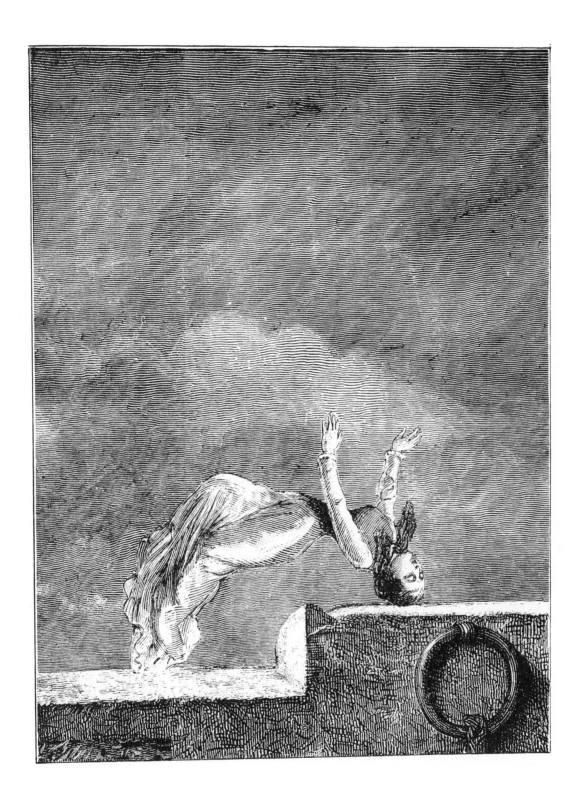

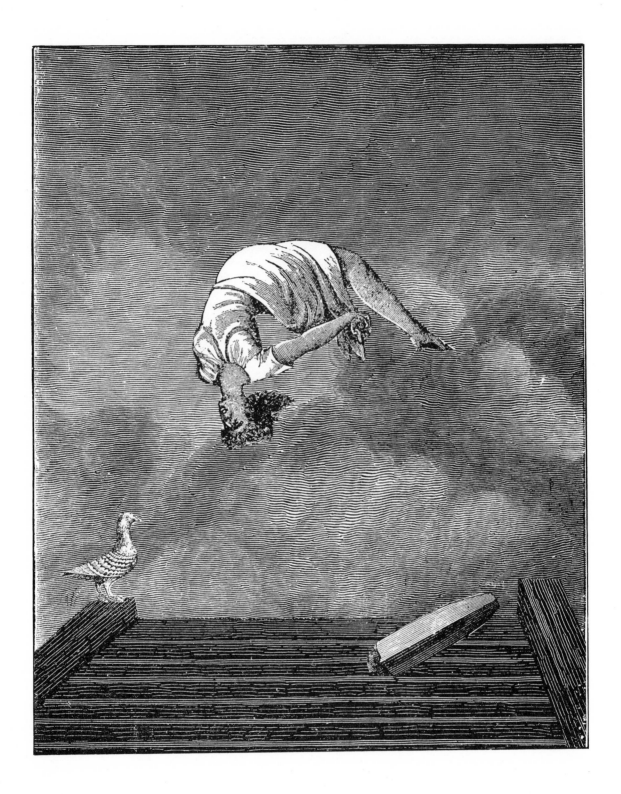